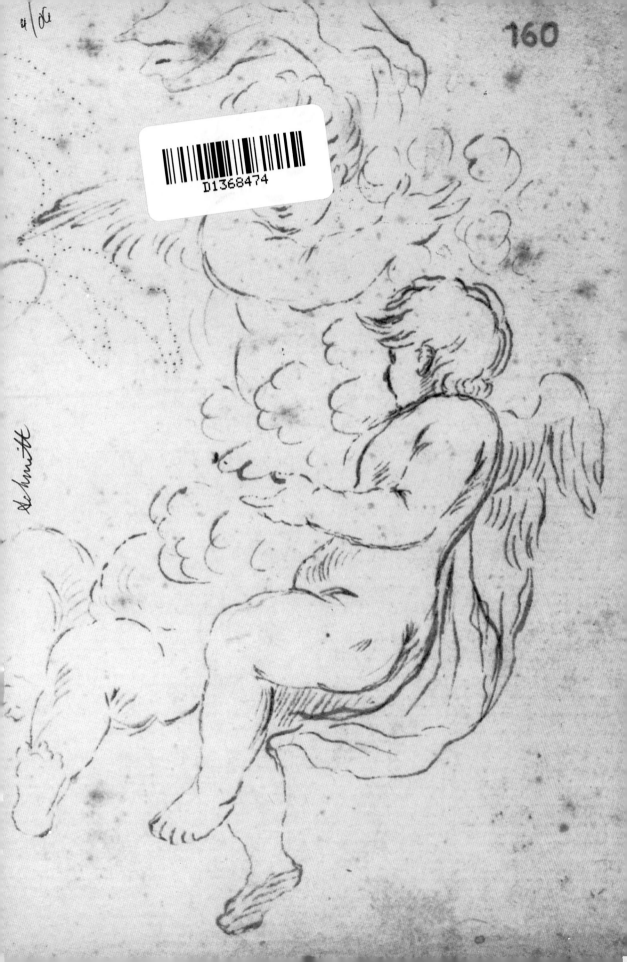

D1368474

Published by the Getty Research Institute for the History of Art and the Humanities

Maiolica
in the Making

Maiolica in the Making:
The Gentili/Barnabei Archive
Catherine Hess

Bibliographies & Dossiers

The Collections of the Getty Research Institute for
the History of Art and the Humanities, 4

St. Louis Community College
at Meramec
LIBRARY

The Getty Research Institute Publications and Exhibitions Program

Bibliographies & Dossiers
The Collections of the Getty Research Institute for the History of Art and the Humanities
Julia Bloomfield, Harry F. Mallgrave, JoAnne C. Paradise, Thomas F. Reese, Michael S. Roth, and Salvatore Settis, *Editors*

Maiolica in the Making: The Gentili/Barnabei Archive
Michelle Bonnice, *Manuscript Editor*

Published by The Getty Research Institute
for the History of Art and the Humanities,
Los Angeles, CA 90049·1688
© 1999 by The Getty Research Institute
for the History of Art and the Humanities
All rights reserved. Published 1999
Printed in the United States of America

03 02 01 00 99 5 4 3 2 1

Cover: Engraving by Johann Georg Merz after an engraving by Charles·Nicolas II Cochin after the painting *Par une tendre chansonnette* by Nicolas Lancret; pricked for transfer (backlit detail). See no. 214.
Frontispiece: Sketches of putti and the verso of a pricked drawing of a putto (detail). See no. 160 verso.

Library of Congress Cataloging-in-Publication Data
Hess, Catherine, 1957–
Maiolica in the making : the Gentili/Barnabei archive / Catherine Hess.
p. cm. — (Bibliographies & dossiers : the collections of the Getty Research Institute for the History of Art and the Humanities; 4)
Includes bibliographical references and index.
ISBN 0·89236·500·5 (pbk.)
1. Gentili family — Archives — Catalogs. 2. Barnabei, Felice, 1842–1922 — Archives — Catalogs. 3. Majolica, Italian — Manuscripts — Catalogs. 4. Majolica, Italian — Italy — Castelli — Sources — Bibliography — Catalogs. 5. Majolica, Italian — 17th century — Italy — Castelli — Sources — Bibliography — Catalogs. 6. Majolica, Italian — 18th century — Italy — Castelli — Sources — Bibliography — Catalogs. 7. Manuscripts, Italian — California — Los Angeles — Catalogs. 8. Getty Research Institute for the History of Art and the Humanities — Catalogs. I. Title. II. Series.
NK4210.G42A4 1999
738.3′0945′715 — dc21 98·45718
 CIP

Contents

Acknowledgments

Of the many people who have aided me in studying the Gentili/Barnabei archive, I would like to thank, in particular, Nicholas Olsberg, formerly Head of Archives for the History of Art at what is now the Getty Research Institute for the History of Art and the Humanities, who was responsible for its inspired acquisition, and Stephen Nonack, formerly Special Collections Curator of Manuscripts, who first encouraged me to publish its contents. At the Getty Research Institute I am beholden to its former Director, Salvatore Settis; Julia Bloomfield and Rebecca Frazier of Publications and Exhibitions; JoAnne C. Paradise of Collection Development and Research; Mary Reinsch-Sackett and Deborah Derby of Conservation; Robert Walker, John Kiffe, and Jobe Benjamin of Visual Media Services; and Wim de Wit, Beth Guynn, and the staff of Special Collections.

The generous guidance of J. V. G. Mallet, formerly Keeper of Ceramics at the Victoria and Albert Museum, London, has been inestimable, as has been the assistance of Ubaldo Grazia, owner of the maiolica factory U. Grazia s.n.c., Deruta; photographer Denise Simon, Los Angeles; and scholar Karen Wolfe-Griffoni, Rome. Special thanks are due to Margherita Barnabei for graciously meeting with me to discuss her father's papers and to Luciana Arbace, Museo e Gallerie Nazionali di Capodimonte, Naples, for acquainting me with the Gentili papers held by the Istituto Statale d'Arte "F. A. Grue" per la Ceramica, Castelli. I am indebted as well to Otto Mazzucato, Museo di Roma, who in the 1980s published the first notes on the Gentili/Barnabei archive, and to several of my Dutch colleagues: Jan Daniel van Dam, Rijksmuseum, Amsterdam; P. B. M. Bolwerk, Nederlands Tegelmuseum, Otterlo; H. P. ter Avest, Gemeentemuseum Hannemahuis, Harlingen; and, especially, Pieter Jan Tichelaar, Tichelaars Koninklijke Makkumer Aardewerk- en Tegelfabriek, Makkum. Insight into the archive's three narratives and their sources was provided by Luisa del Giudice, University of California, Los Angeles, and Christopher Nissen, Northern Illinois University; and Nicholas Goodhue lent his expertise to the Latin translations. Michelle Bonnice helped shape this book's tone and content, and Suzanne Petralli Meilleur skillfully managed its production. My thanks to them for their fine work. Finally, I am grateful to Peter Fusco, Curator of European Sculpture and Works of Art at the J. Paul Getty Museum, for his support. This book is dedicated to my sons—Julian and Elliot—whose births heralded the beginning and the completion of this project.

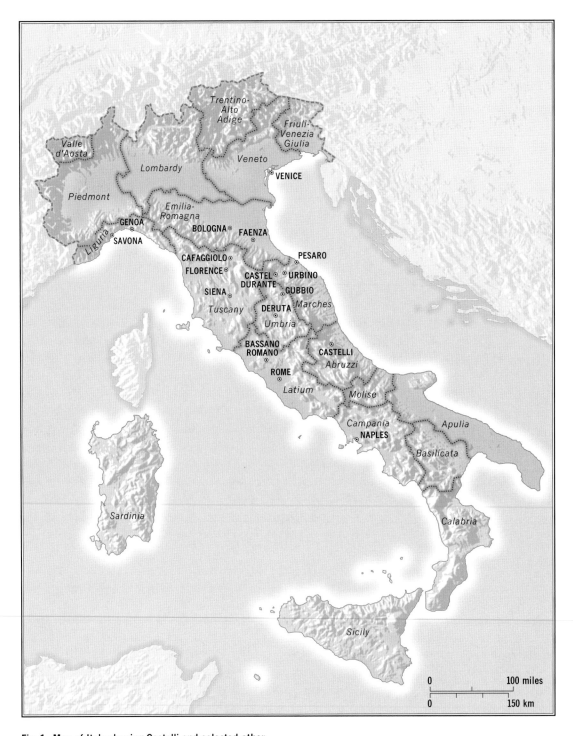

Fig. 1. Map of Italy showing Castelli and selected other
centers of maiolica production, ca. 1600–ca. 1900, and
the modern autonomous regions

Maiolica in the Making: The Gentili/Barnabei Archive

Colorful, spatially illusionistic, and intellectually intricate, *istoriato* (narrative) painting on the tin-glazed earthenware of the Renaissance known as maiolica is arguably the most notable artistic innovation to have come out of the potteries of Italy. Ceramists experimented with and ultimately mastered this style of supremely pictorial decoration—in which most or all of the ceramic surface is covered with scenes from a historical, literary, mythological, or religious narrative—in the first decades of the sixteenth century, under the influence of contemporary fresco and oil painting in the humanist tradition. *Istoriato* decoration captures the Renaissance's delight in erudition united with luxury, and as such it moved maiolica into the domain of high art.

In the seventeenth and eighteenth centuries, at a time when porcelain was beginning to surpass maiolica in popularity, potters from the isolated hilltop town of Castelli d'Abruzzo[1] created wares that constitute the final flowering of *istoriato* decoration. The workshops of the Grue and the Gentili—the two dynasties of Castelli ceramists that dominated this era—produced numerous earthenware pieces with narrative scenes finely painted in a distinctive palette of greens, blues, browns, ocher, yellow, and black on a creamy white ground. Today these wares figure in prominent public and private collections throughout Europe and the United States.

Materials from this era also figure largely in the Gentili/Barnabei archive. This archive was acquired from the estate of Felice Barnabei by Special Collections of the Getty Research Institute for the History of Art and the Humanities in April 1988, via a Swiss dealer.[2] Most of the 276 engravings, drawings, substitute cartoons, and written documents in the archive date to the late seventeenth through the late eighteenth century and originate from three generations of the Gentili family: Ber[n]ardino II (d. 1683); Berardino II's son, Carmine (1678–1763);[3] and Carmine's sons, Giacomo II (1717–1765) and Ber[n]ardino III (1727–1813). Among the documents are various Gentili family papers—marriage contracts, medical prescriptions, property transactions, inventories, notes about debts, letters written by and addressed to members of the family, fable-like narratives, prayer books, and poems—as well as records pertaining to the manufacture of ceramics, such as orders for wares, lists of ingredients for glazes and pigments, and registers of pieces made and sold.[4] These documents provide fascinating glimpses into the social and economic lives of Castelli's potters.

Even more interesting are the approximately 150 engravings, drawings, and substitute cartoons that make up the balance of the Gentili/Barnabei archive. Most were used in some manner for the decoration of pottery, and as such they add to the very sketchy evidence about the use of design sources and transfer patterns by Italian maiolica painters working prior to the nineteenth century. A transfer pattern is either a substitute cartoon, which is a sheet of paper bearing an image that was obtained by pricking or stylus tracing the contours of a drawing or a print onto the sheet, or a pricked or stylus-traced original, whether that original is a drawing or a print. Transfer patterns are ubiquitous in modern ceramic factories, and they were certainly in use by the late sixteenth century in the Turkish potteries in Iznik.[5] The date of their introduction into the ceramic workshops of Italy remains uncertain. What is clear, however, is that Renaissance potters took inspiration from contemporary artwork and on occasion decorated their wares from designs supplied by artists in other media. It is also clear that transfer patterns were used by Renaissance artists working in fresco, tempera, and oils.

Transfer Techniques in Renaissance Italy
In the eighteenth century, Sir Joshua Reynolds declared, "I am...persuaded that by imitation only, variety, and even originality of invention, is produced,"[6] but copying has not always been considered worthy of the best artists. Indeed, in the sixteenth century, Giorgio Vasari allowed only that "poor painters who are not very adept at draughtsmanship can make use at their need" of certain of Marcantonio Raimondi's engravings,[7] and Heinrich Vogtherr the Elder described his pattern book, which was published in 1538 and subsequently went through several editions, as "an anthology of exotic and difficult details that should guide the artists who are burdened with wife and children and those who have not travelled."[8] By 1587 Giovanni Battista Armenini was counseling painters to erase any evidence of having used preliminary drawings so as to maintain the appearance of original and unguided composition.[9] Apparently then, as now, audiences were inclined to view any art produced with the aid of stencils or cartoons not as inspired artistic inventions but as rote products.

The fact remains that many artists did copy, often less for lack of talent and imagination than for the efficient production of artwork. Frequently they copied their own designs, transforming sketches on paper, parchment, or vellum into fully realized stained-glass windows, textiles, frescoes, prints, or paintings on panel or canvas. At the end of the fourteenth century, Cennino Cennini wrote detailed instructions for the execution of textile patterns using parchment cartoons.[10] The writings of later authors and art theorists such as Vasari and Filippo Baldinucci affirm that *cartoni* (cartoons or full-scale drawings) were an essential part of studio practice throughout the sixteenth and seventeenth centuries.[11] Such cartoons are pithily described by Armenini as "the work itself, but for the colors."[12]

For transforming a smaller drawing into a full-scale cartoon, the technique of squaring was available. It involves superimposing a grid on the drawing

and then copying the image, square by square, onto another grid whose squares are larger but of commensurate proportions. For transferring, quickly and faithfully, the full-scale cartoon to another surface, Renaissance painters employed two other techniques: *spolverare* or *spolverizzare* (pouncing) and *calcare* (stylus tracing).[13] During the fifteenth century, pouncing was the more usual technique. It involves pricking small holes through the lines and contours of a cartoon's image with a needle, holding the pricked cartoon (*spolvero* or *spolverezzo*) against the surface to be decorated, and then tapping a cloth bag containing pounce (*spolverizzo*)—commonly pulverized chalk, graphite, or charcoal—against the cartoon. When the cartoon is pulled away, the design's outline remains on the surface in a series of small dots. (See figs. 2–5.) Stylus tracing came into vogue in about 1500. For this technique, the cartoon is placed against the surface and then traced with a pointed instrument, commonly a sharpened piece of ivory or hard wood, so that the design is either incised into or, if the reverse of the cartoon had been rubbed with pounce, visible as dark lines on the surface. Stylus tracing is more rapid than pouncing, but it is ultimately more destructive to the incised cartoon (*calco*), especially when the cartoon is incised repeatedly.

Two technical advances in the fifteenth century seem to have been especially important for the development and spread of transfer techniques during the 1500s. Paper mills, established in Italy by the thirteenth century, began to produce ever greater quantities of ever better quality paper, which meant that paper came into its own as a more pliable and less expensive alternative to parchment and vellum; and painters began to execute their preparatory sketches in black chalk and soft charcoal. Thus, when artists needed efficient methods for transferring preliminary designs to other surfaces so that they could profit from the increased call for their work, paper for cartoons and easily erasable dark powders for pouncing were not only readily available but also within the means of most painters, including the painters of maiolica.

Design Sources and the Decoration of Maiolica

Painting on maiolica demands an unerring hand—because a mistake cannot easily be corrected given that pigments and glaze are immediately absorbed into the porous ceramic—and an eye for which designs are best suited to ceramic forms. The maiolica potters of the early Renaissance developed an admirable set of designs, turning out thousands of ceramic pieces ornamented with single figures, profile heads, and repetitive patterns. Italian ceramists and those who purchased their wares soon developed more sophisticated tastes in decoration, however, as visual media began to show the influence of Renaissance humanism and as the invention and evolution of the printing press led to the wider dissemination of prints and printed books. To meet their customers' demands for large quantities of innovatively painted pieces at moderate prices, maiolica artists without the time, and in some cases the talent, to devise original decoration for every piece began to copy drawings, works of art, prints, and printed book illustrations onto ceramic forms. The *istoriato*

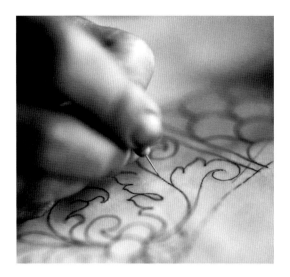

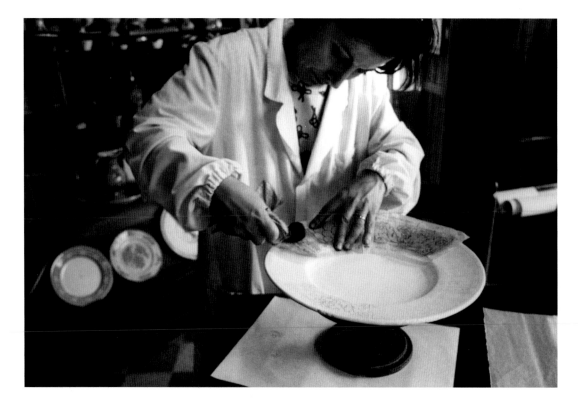

Fig. 2. Pricking the substitute cartoon for a maiolica rim design from the source, 1997
Deruta, U. Grazia s.n.c.

Fig. 3. Giuseppina Favaroni pouncing the pricked cartoon onto a plate, 1997
Deruta, U. Grazia s.n.c.

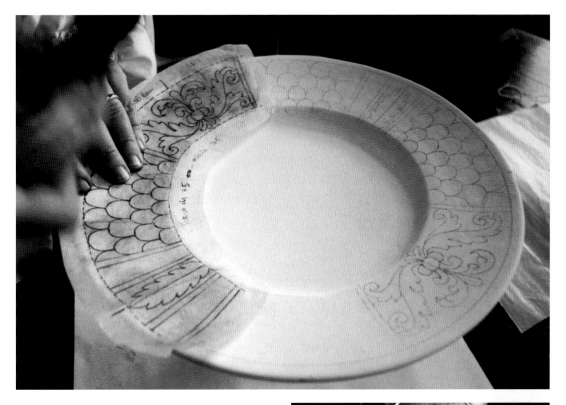

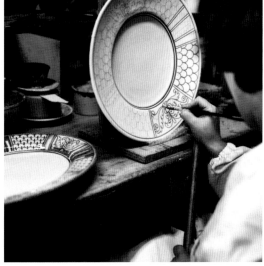

Fig. 4. The pricked cartoon being pounced (left) and the pounced design (right), 1997
Deruta, U. Grazia s.n.c.

Fig. 5. Giuseppina Favaroni outlining the pounced design with pigment, 1997
Deruta, U. Grazia s.n.c.

style of pottery decoration that emerged by the 1520s capitalized on innovations, such as the illusionistic depiction of space and volume, initially developed in other representational art forms.

Artists' drawings that served as designs for maiolica are extremely rare, and rarer still are those that can be matched securely with existing works. For instance, the Uffizi in Florence owns a drawing, dated to circa 1510–1520 and attributed to Giovanni Battista Bertucci, that displays circular shading along one side and appears to have served as the design for a maiolica plate,[14] but no ceramic decorated after this drawing has yet come to light. In another case, the expense ledgers of 1529 show that the painters Dosso and Battista Dossi supplied designs for maiolica while they were at the Ferrarese court of Alfonso I d'Este,[15] but neither the designs nor wares decorated after them have been identified. To date, the earliest drawing for which matching maiolica pieces exist is one from circa 1516 portraying what may be a scene from Roman history—perhaps Fabius Maximus Verrucosus Cunctator ransoming prisoners from Hannibal or Julius Caesar negotiating with Ariovistus over the Aeduan hostages. Executed after a fresco by Girolamo Genga, this drawing is signed "Jacopo da Bologna" and attributed to Jacopo Ripanda. The curved shading at the right-hand corners of the drawing may indicate how the artist envisioned the scene in a circular format, and one scholar has been tempted to identify it as a leaf from a pattern book for the use of ceramists. In any case, it served as the source for four plates, all attributed to Faenza and datable to the 1520s but executed by different ceramists. Probably the drawing was copied freehand onto the plates, for it displays no evidence of pricking or stylus tracing and the images on the ceramics vary both from it and from one another (figs. 6, 7).[16] The earliest series of drawings and matching maiolica plates to be identified are from notable sixteenth-century commissions: two services intended by Duke Guidobaldo II della Rovere as diplomatic gifts, one that was designed by Battista Franco around 1550 and decorated with events from the Trojan War,[17] the other designed by Taddeo and Federico Zuccaro in 1560–1562 and depicting scenes from the life of Julius Caesar.[18]

Most of the drawings copied for maiolica decoration probably were not the work of celebrated artists, however. The drawings in the Gentili/Barnabei archive suggest that less-skilled draftsmen—likely the potters themselves or other craftsmen associated with the workshop—produced many of the models for ceramic painting. Because these drawings were treated as workshop tools rather than valued and protected works of art, the majority have been lost to use and time. In the Gentili/Barnabei archive, there are a few such drawings that have been pricked and pounced, presumably in order to transfer the drawn images onto currently unidentified ceramics (nos. 14, 108, 154, 179, 192, 195, 196). Among the small number of such drawings that have been positively correlated with maiolica pieces are a handful in the Gentili/Barnabei archive (nos. 13, 150v, 156, 157, 159, 160) and several attributed to Carmine Gentili that are among the Gentili papers at the Istituto Statale d'Arte "F. A. Grue" per la Ceramica, Castelli. Some of the Istituto's drawings

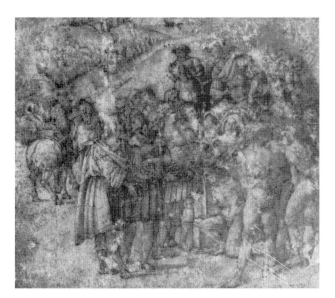

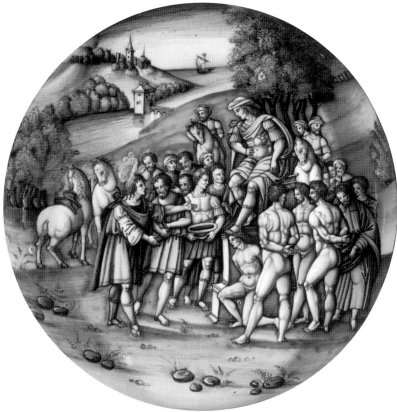

Fig. 6. Attributed to Jacopo Ripanda (after Girolamo Genga)
The Ransom of the Prisoners, pen and dark and brown inks on parchment, 14.3 × 16.5 cm (5⅝ × 6½ in.), ca. 1516
Lille, Musée des Beaux-Arts

Fig. 7. Plate from Faenza decorated after the drawing shown in fig. 6, tin-glazed earthenware, 25.2 cm (9⅞ in.) diam., ca. 1520–1525
London, British Museum

were copied either by Carmine or by Carmine's son, Berardino III, onto a series of plaques depicting the *via crucis* (stations of the cross) which is now in the church of Santa Maria degli Angeli, Bisenti.[19] Judging from the published photographs of the Istituto's drawing of the Crucifixion and the corresponding plaque, the maiolica painter followed the roughly sketched design with fidelity but elaborated and filled in the scene for his finished work.[20] None of the Istituto's drawings is pricked or stylus traced for transfer, indicating that they were copied onto the plaques freehand.

That various maiolica wares are decorated after prominent works of art even though no print source depicting the artwork is known suggests that potters made their own drawings in situ of works that they saw as useful in decorating ceramics. The oft-cited relationship between the female profile heads on Deruta *piatti da pompa* (display plates) and the works of Pietro Perugino (figs. 8, 9) and, especially, Bernardino Pintoricchio supports the idea that Deruta's potters sketched paintings in and around public places in their native Umbria. Indeed, ceramic painters in Deruta strongly preferred these local images,[21] almost never turning to the Raphaelesque print sources that were inspiring the production from nearby potteries in the Marches.[22] Renaissance painters such as Luca Signorelli, Girolamo Genga, and Francesco Francia also seem to have exerted influence on the decoration of maiolica.[23] Ever resourceful and eager for original and easily reproducible models, maiolica painters and designers also copied frescoes, sculptures, medals, and plaquettes onto ceramics by way of intermediary drawings or, in rare cases, directly from the works themselves. A striking example is supplied by a Cafaggiolo plate in the Victoria and Albert Museum, London, which copies Donatello's *Saint George* from Orsanmichele, Florence (figs. 10, 11).[24]

Whether made by or for the potters, drawings played an important and enduring role in the decoration of maiolica from very early on, circulating a variety of sophisticated subjects and styles through the workshops. In the famous illustration of maiolica painters decorating their wares that appears in Cipriano Piccolpasso's mid-sixteenth-century treatise on maiolica production, sheets of paper bearing images are tacked up on the workshop's wall. Given the importance of drawings to the Renaissance ceramist, those images are more likely to be drawings than prints, as Bertrand Jestaz has pointed out.[25]

Often more easy to identify than single drawings, print sources also began circulating through the potteries at an early date. The earliest pairing of ceramic and print source that has been recognized comprises a drug jar of circa 1460–1480 in the British Museum, London, which is decorated after a print of circa 1460. Entitled *El gran Turco* and attributed to Antonio del Pollaiolo, the print probably depicts John VIII Palaeologus, emperor of Constantinople from 1425 to 1448.[26] Other early pairings include a plate dated 1497 in the Musée Céramique de Sèvres which is decorated after a woodcut depicting Aeneas and Delos that appeared in the same year in an edition of Ovid's *Metamorphoses*;[27] a Gubbio dish of circa 1500–1525 in the Ashmolean Museum, Oxford, which is painted after a woodcut illustration to an edition of Aesop's

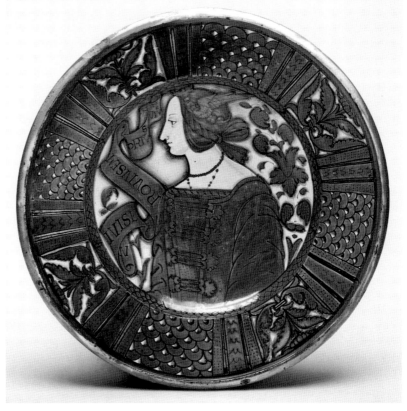

Fig. 8. Pietro Perugino
The Marriage of the Virgin (detail), oil on panel, 234 ×
185 cm (92⅛ × 72⅞ in.), 1500–1504
Caen, Musée des Beaux-Arts

**Fig. 9. Lustered *piatto da pompa* (display plate) from
Deruta depicting a female figure wearing a winged
headdress and a tied bodice, tin-glazed earthenware,
42.8 cm (16⅞ in.) diam., ca. 1500–1530**
Los Angeles, The J. Paul Getty Museum

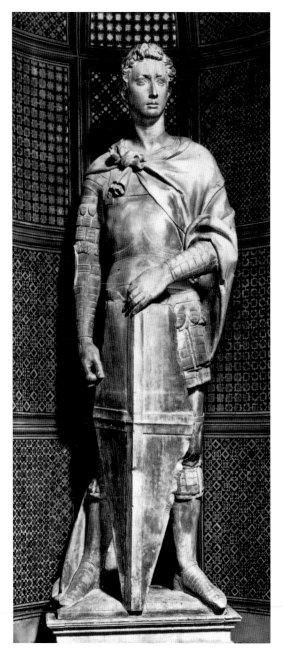

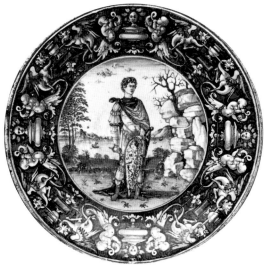

Fig. 10. Donatello
Saint George, bronze, H (without base): 209 cm (82¼ in.),
ca. 1417
Florence, Museo Nazionale del Bargello

Fig. 11. Jacopo di Stefano
Plate from Cafaggiolo depicting Saint George, tin-glazed
earthenware, 32 cm (12⅝ in.) diam., ca. 1510
London, Victoria and Albert Museum

fables published in Naples in 1485;[28] a relief by Giovanni della Robbia of circa 1510–1520 in the Victoria and Albert Museum, London, after Leonardo da Vinci's *Last Supper* which either copies a print of circa 1500 or shares with that print a common source;[29] a plate of circa 1520–1530 attributed to Faenza or Castel Durante in the Wallace Collection, London, which displays elements taken from a Florentine engraving of about 1460;[30] and a plate dated 1521 and identified as "possibly Siena or Deruta" that copies a fifteenth-century German woodcut of the Madonna del Latte.[31]

Later potters such as those of Bassano Romano, Castelli, Savona, and Siena made use of a great variety of graphic sources. These ranged from tarot cards and other popular items to books and individual prints. By the mid-sixteenth century, illustrated books published in Venice, Frankfurt, and Lyons were available throughout Italy, and images from Jacopo Filippo da Bergamo's *De claris mulieribus* (Ferrara, 1497), Francesco Colonna's *Hypnerotomachia Poliphili* (Venice, 1499), and various editions of Cesare Ripa's *Iconologia*, Ovid's *Metamorphoses*, Livy's *Ab urbe condita*, and the Bible, among others, were appearing regularly on maiolica pieces. The prints copied by maiolica painters were even more various. Images after the engravings of Marcantonio Raimondi and his circle, including Giovanni Jacopo Caraglio, Ugo da Carpi, Marco Dente, Agostino Veneziano, and the Master of the Die, appear with notable frequency on maiolica pieces, as do decorations after engravings by Flemings Philipp Galle, Jan I Sadeler, Hendrick Goltzius, and Abraham Bloemaert; Netherlanders Crispijn van de Passe, Nicholas Berchem, and Jan Visscher; Germans Albrecht Dürer, Hans Burgkmair the Elder, and Hans Sebald Beham; Italians Antonio Tempesta, Annibale Carracci, and Pietro da Cortona; and Frenchmen Simon Vouet, Jacques Callot, and Antoine Coypel.[32]

A. M. Hind observed in 1923 that "if engraving in Italy had a practical cause to serve, it was essentially an artist's motive, the desire to multiply designs which might serve as models in the workshops of sculptor, goldsmith, potter, and craftsmen of every type."[33] Without question, maiolica painters took inspiration from the abundance of novel and inexpensive images in prints and illustrated books, and today matching ceramics to print sources is a pursuit enjoyed by many a maiolica enthusiast. This pursuit has its scholarly uses too, of course. For instance, Jestaz has argued that the source used by a maiolica painter reveals more about a ceramic than the "usual game of local-izations on the map," which he dismissed as having more in common with entomology than art history.[34] Identifying an object's print source often does aid in dating the ceramic and naming its subject and artist, and comparing the image on the ceramic to the print source can illuminate the creative process of the artist, his talent and artistic character, and the particular qualities of his work.[35] The value of such identification for specifying an object's origin is limited, however, because prints and engravings traveled freely among the major artistic centers of Italy, with some remaining fashionable or simply useful as workshop tools for a century or more. The trail of a print source is muddied further by the movement of various maiolica painters and pieces of

maiolica between centers of production.[36] Traveling ceramists and their wares disseminated images, subjects, styles, and techniques that might otherwise have remained within a relatively circumscribed community. In any event, such tangles do not prevent the matching of print source to maiolica piece from substantiating the early use of transfer patterns by the potters of Italy.

Transfer Patterns and the Decoration of Maiolica

The use of transfer patterns, especially pounced designs, by maiolica painters of the Renaissance has long been suspected, but corroborating physical evidence has been wanting.[37] In some ways, this dearth seems entirely predictable. No signs of pouncing or stylus tracing should remain on the objects themselves because firing in the kiln would burn away any pounce and fill any incised lines with melting glaze, and changing fashions in ceramic decoration and the wear associated with use made it unlikely that transfer patterns would survive into the modern age. It is disconcerting, however, that the very few contemporary depictions of ceramists decorating their wares show them painting freehand. One such depiction, on a Cafaggiolo plate dated to circa 1510, portrays a ceramist decorating a dish, presumably for the young couple seated before him (fig. 12).[38] Another appears in Piccolpasso's mid-sixteenth-century treatise *I tre libri dell'arte del vasaio* (*The Three Books of the Potter's Art*). In this illustration, several maiolica painters are shown copying freehand from images on paper that are tacked to the wall of the workshop.[39] Still, the accuracy of both of these images is open to debate. The image on the plate clearly glorifies the potter, who is dressed in garb as elegant as that of his patrons, and the illustration is merely consistent with Piccolpasso's text, which makes no mention of transfer patterns. Since his otherwise fairly thorough treatise also ignores *istoriato* painting, Piccolpasso cannot be dealing with the subject of painted scenes in anything but a cursory manner—and the argument for the use of transfer patterns by Renaissance painters of maiolica is made most forceful precisely by reference to this type of ceramic decoration.

That maiolica painters used pricked cartoons or stylus-traced patterns may be deduced by the frequent appearance of print figures, at times extracted from their original settings and occasionally placed wildly out of context, on pieces of maiolica. Selection of print models probably depended as much on which prints were handy as on which the potter favored. Presumably the latter included engravings with loosely structured compositions from which figures could be easily excised[40] or with figures that lent themselves to the creation of "virtuoso-looking" compositions on ceramics.[41] Nicola di Gabriele Sbraghe da Urbino used prints in this manner with great skill for his elegant maiolica painting,[42] yet the master of the technique must surely be his contemporary, Francesco Xanto Avelli. Arguably the most prolific ceramic artist of the early sixteenth century, Xanto often placed figures plucked from favored engravings in collage-like fashion to create new compositions on his ceramics.[43] More than one scholar has reasoned that the exact correlation of size and pose[44] of Xanto's painted figures with their print source originals indicates

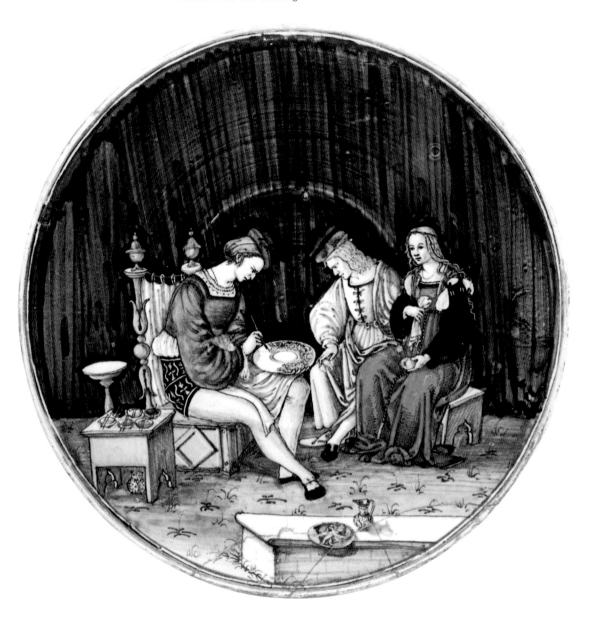

Fig. 12. Jacopo di Stefano
Plate from Cafaggiolo depicting a maiolica painter at work
and a young couple, tin-glazed earthenware, 23.5 cm
(9¼ in.) diam., ca. 1510
London, Victoria and Albert Museum

that Xanto made use of pounced or stylus-traced cartoons.[45] That he was able to completely excise the figures from their prints and disassociate them from their original contexts also argues for his use of such cartoons, which allow an artist to easily and totally isolate details from larger compositions. Further, some scholars believe that only the use of *spolveri* can explain the existence of Xanto's inferior pieces, with their oddly conceived compositions and their lack of finesse or logic in the placement of figures. On one of these "istoriati *aberrants*" (the phrase is Jestaz's), we find the seated figure of Jupiter at the upper right of Marco Dente's *Birth of Venus* transformed into an out-of-scale Perdix falling headlong to his death (figs. 13, 14).[46] On another, Xanto chose the vertical image of a wild Maenad from a print of 1507 for the figure of a despairing Hero throwing herself horizontally into the sea in which Leander's draped corpse floats with the utmost composure.[47]

Whether maiolica painters expected their clients to recognize the print sources copied for their ceramic painting must have depended upon the individual case. For ordinary pieces, the practice of excerpting images from prints was essentially a labor-saving technique. For showier, more expensive objects, it may have served to render an eclectic and sophisticated iconography assembled from various prints, and the identification of the sources may well have constituted a refined and erudite diversion for the owner of the piece and the owner's friends. That Xanto, at a time when there was no lack of print sources, drew upon a particularly notorious set of engravings by Raimondi to formulate many of his ceramic compositions suggests that he intended his clients to recognize the source. Produced in 1524 after Giulio Romano's drawings, the engravings depict sixteen *modi* (ways or positions) of lovemaking. Pope Clement VII was so scandalized by the images that he ordered the prints burned, the engraver imprisoned, and their circulation forbidden.[48] Although erotic subjects are not unusual for maiolica decoration,[49] the manner in which Xanto drew upon Raimondi's prints for several of his plates is noteworthy. Xanto, knowingly or not, circulated the offending images without risking reprisal since his figures were de-coupled and, therefore, freed from their original, overtly sexual contexts.[50] Clearly, these egregious prints provided Xanto with an assortment of figures he preferred for his ceramic compositions—muscular and dynamic, often in dramatically foreshortened poses[51]—but his choices may also have been intentionally provocative, an acknowledgment that his clients would enjoy the wicked game of discovering the forbidden in images of otherwise prosaic subjects.[52]

Whether Xanto was willfully adding an erotic, naughty, or deprecating edge to his ceramic compositions by drawing on these prints remains debatable. Xanto does appear to have invested at least one of his painted figures with a meaning related to its original sexual one. For the personification of Rome on a plate decorated with an allegorical scene of the ruin of the cities of Italy, Xanto chose the female figure from Raimondi's ninth engraving (figs. 15, 16). The figure, excised from what might be considered a degrading sexual circumstance, represents a Rome recently humiliated by Charles V,

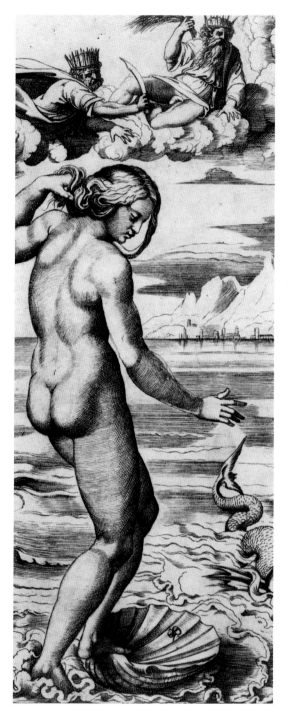

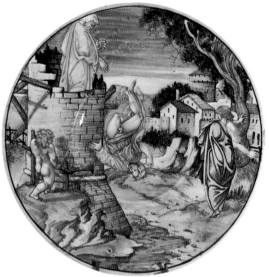

Fig. 13. Marco Dente (after Raphael)
The Birth of Venus (detail), 26.1 × 17.2 cm (10¼ × 6¾ in.),
early 1500s
London, British Museum

Fig. 14. Francesco Xanto Avelli
Plate from Urbino depicting Daedalus and Perdix,
tin-glazed earthenware, 27.2 cm (10¾ in.) diam.,
1530–1540
Milan, Castello Sforzesco, Civiche Raccolte d'Arte Applicata

Fig. 15. After Marcantonio Raimondi (after Giulio Romano)
Position nine from *I modi*, woodcut, 6.1 × 6.6 cm (2⅜ × 2⅝ in.), ca. 1527
Private collection

Fig. 16. Francesco Xanto Avelli
Plate from Urbino depicting an allegory of the ruin of the cities of Rome, Naples, Florence, and Genoa, tin-glazed earthenware, 27.5 cm (10⅞ in.) diam., 1530–1540
Milan, Castello Sforzesco, Civiche Raccolte d'Arte Applicata

who sacked the city in 1527. In addition, Xanto painted below the figure the city's identifying attribute—the *chiavi* (keys) of Rome. That *chiavare* has signified sexual intercourse in Italian vernacular since the fifteenth century possibly adds a double entendre to the scene.[53] How far we should go in this interpretive direction is arguable, since Xanto's own intentions can only be surmised, although it does seem reasonable to conclude that the complicated use of such a notorious source was not accidental. Given the technical challenges of disentangling Raimondi's figures from their embraces and given Xanto's practice of combining figures from various sources without any alteration in scale or pose, it also seems reasonable to infer his use of transfer patterns.

Transfer Patterns and the Gentili/Barnabei Archive

Felice Barnabei's legacy is all the more precious given the paltry evidence for the use of transfer patterns by early Italian maiolica painters. Indeed, the Gentili/Barnabei archive contains only a portion of the materials related to the manufacture of maiolica in Castelli that Barnabei owned at the time of his death. Another group of materials is held by the Istituto Statale d'Arte "F. A. Grue" per la Ceramica, Castelli. Also deriving from the Gentili workshop and numbering approximately 275 sheets, the Istituto's Gentili papers consist almost entirely of substitute cartoons and a small number of drawings; they include very few written documents and no material from Felice Barnabei. Compared to the cartoons of the Gentili/Barnabei archive, the Istituto's cartoons are quite pristine—that is, none of them appear to have been executed over already used pieces of paper, and few have been pounced or at all consumed by use. Yet another group comprising forty-six pounced cartoons and drawings was published by Franco Battistella in 1989, while they were in the possession of Lello Moccia, Pescara. Forty-four of the items appear to derive from the Gentili workshop, with the remaining two being attributed to Carlo Antonio Grue.

The Gentili papers in Castelli and the Gentili/Barnabei archive in Los Angeles clearly are from the same initial set of materials. Not only do they contain similar rare cartoons but, in several instances, a cartoon in one archive displays the same pricking as a cartoon in the other (nos. 27, 161, 214, 217, 236). In addition, each group claims half what was once one complete pounced cartoon (no. 174). The relationship of Moccia's group of materials to the other groups is, at present, unclear. Although Battistella believes that they too must have once belonged to Felice Barnabei,[54] it remains to be seen whether the materials themselves will provide confirmation and whether the line of transmission from Barnabei to Moccia can be traced. The Gentili papers at the Istituto were presumably given to Serafino Mattucci in the 1940s by Barnabei's heirs, possibly to obtain his assessment of them. It appears that Mattucci was responsible for their present organization into twelve folders labeled with broad categories such as "*scuola del Gentili*" (circle of Gentili) and "*disegni di Carmine Gentili*" (drawings by Carmine

Gentili). He published one of the pricked cartoons in 1947 and identified it as belonging to the *"Raccolta Civica della Scuola d'Arte di Castelli"* (the civic collection of the Castelli art school).[55] In the mid-1990s, the Neapolitan maiolica scholar Luciana Arbace heard about the papers and began studying them. Quickly recognizing their importance, she and the Istituto's current director, Vincenzo di Giosaffatte, organized an exhibition and an accompanying catalog for some of the Istituto's Gentili papers and their associated ceramics. The exhibition was held in August and September 1998 at Santa Maria di Costantinopoli, the church next to the Istituto.[56]

These two, and possibly three, groups of materials make up one of the earliest and most extensive collections of transfer patterns to have come to light, and the Gentili/Barnabei archive contains a substantial portion of the whole. Of the nearly seventy prints and drawings in the archive, thirty-four are pricked or stylus-traced for transfer. Among these, biblical, mythological, and genre scenes predominate, as do figures of saints or clergy who appear more closely related to local traditions than to any more widely distributed print source. The choice of subject matter suggests that the Italian tradition of *istoriato* decoration remained influential among Castelli's potters long after its decline and eventual displacement in the early seventeenth century by the predominantly white *compendiario* (sketchy) style of maiolica decoration. It also suggests that the location of the Grue and Gentili workshops—on a hilltop among the rugged Apennines of central Italy—may have encouraged a somewhat insular decorative style. In ceramic factories contemporary with the Gentili workshop where objects in the increasingly fashionable porcelain medium were being produced—Doccia, Meissen, Du Paquier, and Sèvres, for instance—the decoration of choice comprised rocaille and strapwork patterns, as well as chinoiserie, botanical, animal, commedia dell'arte, and panoramic subjects. Their choices were greatly shaped by the publication of model books and collections of figural and ornamental prints, which spread certain subjects and styles across Europe in the 1650s. By the middle of the eighteenth century, important porcelain factories such as Meissen had accumulated vast numbers of prints and drawings for use by their craftsmen.[57] The Gentili workshop was not entirely ignorant of this trend—the archive does include several very fashionable engravings (nos. 9, 206, 215) that were also in use at porcelain factories—but its impact on the maiolica painters of Castelli seems to have been quite limited.

In addition to engravings and drawings, the Gentili/Barnabei archive includes eighty-seven pricked or stylus-traced substitute cartoons. Judging by their degraded condition, many of the pricked cartoons were in frequent use at one time, and, indeed, maiolica pieces—chiefly from Castelli, Siena, and Bassano Romano—decorated with scenes like those on sheets in the archive exist today. The largest group of such wares is held by the Museo di San Martino, Naples. Two of the nineteen objects that make up this group are attributed to Carlo Antonio Grue (1655–1723), and three are attributed to, respectively, Candeloro Cappelletti (1689–1772), Nicola Cappelletti (1691–

1767), and Giacomo II Gentili. The remaining fourteen are attributed to or signed by Carmine Gentili, and six of these fourteen belong to a service with an unidentified coat of arms datable to circa 1740–1760.[58] It is conceivable that most or all of the nineteen pieces in the Museo di San Martino were decorated using the transfer patterns in the Gentili/Barnabei archive, with both the patterns and the ceramics originating from the Gentili workshop at about the same time.

Several inferences about how transfer patterns were made and used by potters may be drawn from the materials in the Gentili/Barnabei archive. They suggest that one or more sheets of paper would be attached to a print source with straight pins and then the print source would be pricked through to produce one or more substitute cartoons, that a substitute cartoon was more likely than an original print to be pounced, and that substitute cartoons often were either sketched in after pricking or rubbed with graphite or pounce on the verso to delineate what would have been a relatively illegible image. Five cartoons, all for emblems similar to coats of arms, were created by drawing half of the image, folding the sheet in half, and pricking the drawn half to obtain a pricked cartoon for the complete image (nos. 108, 179, 192, 195, 196), and four of the substitute cartoons in the Gentili/Barnabei archive were cut radially so that the sheet would lie flat against a curved ceramic surface (nos. 183, 188, 196, 271).

The materials also show that pricking substitute cartoons over letters and other handwritten documents was common workshop practice. This recycling—and the fact that many of the cartoons in the archive have been patched with other bits of paper—bespeaks the relative scarcity and preciousness of paper in the seventeenth century. More important, for a number of the pricked cartoons, the date in the written document on the sheet places a terminus a quo on the cartoon and has implications for its terminus ad quem as well. Among what appear to be the earliest cartoons in the Gentili/Barnabei archive are four that were pricked over letters dating to the late seventeenth century. No. 117, a heavily pounced pricked cartoon of a hunter wearing a hat and standing on a hill, was pricked over part of a letter from Francesco Antonio I Grue with the dateline Castelli, 4 March 1666. No. 145, a lightly pounced pricked cartoon after Tempesta's *Joab Killing Absalom*, was pricked over a letter signed by one Vittoria Santorelli and dated 1667. No. 54, a lightly pounced pricked cartoon of what appears to be a satyr pulling the drapery off a young woman, was pricked on the verso of a letter with the dateline Teramo, 29 July 1672. No. 198, a heavily pounced pricked cartoon after Tempesta's *Moses Ordering the Israelites to Attack the Ethiopians*, was pricked over part of a letter dated 7 May 1688; this cartoon was pricked from no. 230, so by implication no. 230 also dates to circa 1688.

Since it does not seem unreasonable to assume that paper on hand in the workshop would have been re-used for cartoons within roughly a five-year period,[59] these four cartoons are prudently dated to the 1670s–1690s. Of the remaining Italian *spolveri* for ceramic painting of which I am aware—found

in a few private collections and active potteries—the oldest appear to date to the late eighteenth century.[60] Thus, the Gentili/Barnabei archive includes the oldest pricked cartoons for ceramic painting known to be in existence.[61] As such, these cartoons establish an earlier date for the use of *spolveri* by Italian ceramists than was previously verifiable. In other words, although none of them date to the Renaissance era, the cartoons in the Gentili/Barnabei archive move back by about a century the date at which we have physical evidence that transfer patterns were in use in Italian pottery workshops. Further, the pricked cartoons range forward in time to the early 1900s, and all of them are markedly similar in technique to one another and markedly similar as well to the pricked cartoons employed in modern maiolica manufacture (see figs. 2–5). Thus, although the Gentili papers are significant initially and most obviously because they allow us a rare glimpse into the workings of a successful maiolica workshop dating from the mid-seventeenth century, they are probably most important because of what they imply regarding earlier workshop practice. Since they indicate that transfer techniques—specifically, pricked cartoons and pouncing—as used for the decoration of tin-glazed earthenware have changed little over the last three hundred years, it seems probable that these techniques were similarly employed by ceramists in the preceding one hundred years, that is, during the Renaissance.

The Gentili/Barnabei Archive and Felice Barnabei

A fair amount is known about Felice Barnabei thanks to the posthumous publication of his memoirs.[62] Born in Castelli in 1842 to Tito and Concetta Giardini Barnabei, he was graduated from the Scuola Normale di Pisa in 1865 and spent the next ten years as a teacher of Greek and Latin at a boarding school in Naples. He was active in promoting archaeological excavations and publications, and in supervising two organizations involved in managing and preserving Italy's artistic heritage, the Direzione dei Musei e degli Scavi and the Consiglio Superiore delle Antichità e Belle Arti, both headquartered in Rome. During the last quarter of the nineteenth century, Barnabei helped found and curate two museums in Rome, the Museo delle Terme and the Museo di Villa Giulia, and from 1900 to 1919, he served in five legislatures of the Italian parliament.

Born into a family of ceramists, and himself a dilettante potter, Barnabei studied the maiolica of the Italian Renaissance as well as the specific ceramic traditions of his region. Thus, it may be that the Gentili materials were passed on to Barnabei via one of his ceramist forebears, but it is also possible that he gathered the older materials himself, adding relevant documents from his own family and his own time as he went along.[63] In any event, Barnabei's preservation of the Gentili materials betrays his interest in celebrating the artistic heritage of his native town and in encouraging its maiolica industry, which, by the late nineteenth century, was dying out. The death in 1822 of Gesualdo Fuina, a student of Francesco Saverio II Maria Grue and seemingly the last member of Castelli's various ceramics dynasties, marks the beginning of the industry's sharp economic and artistic decline. Two decades later, the general

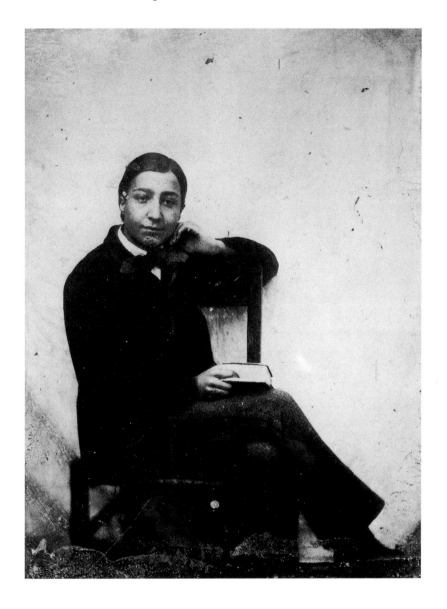

Fig. 17. Felice Barnabei, ca. 1861

Fig. 18. Tito Barnabei and Concetta Giardini Barnabei
with their children, Caterina, Giovanni, and Felice,
ca. 1890–1895

Fig. 19. Central piazza of Castelli, early 1900s

counsel of the province of Teramo hired Gennaro Cioffi, a master ceramist, to teach a few young Castellians the craft of ceramic painting and gilding. This attempt at reviving an important local industry was of limited success, so in the first years of the twentieth century, Felice Barnabei and Beniamino Olivieri, then the mayor of Castelli, decided to establish a proper school of ceramic design in Castelli and founded La Regia Scuola d'Arte Ceramica "Francesco Grue."[64] Barnabei is described as having "brought to the Castelli school all of the diligence and care that his charge [as Director General of Antiquities and Fine Arts] allowed him."[65] The present-day Istituto Statale d'Arte "F. A. Grue" per la Ceramica in Castelli is Barnabei and Olivieri's school, renamed and in another location.

Material such as the kind in the Gentili/Barnabei archive would have been invaluable to this new ceramics school. The school was dedicated to reviving and promoting a local industry by celebrating its past, and historically the Gentili constituted one of the important families of local potters. Indeed, the copying of illustrious works from the past would have been an important activity at the school. That the Gentili materials might have been intended to inspire and instruct the students attending La Regia Scuola d'Arte Ceramica "Francesco Grue" is an interesting idea. No direct connection between the school and Barnabei's interest in these materials exists, however.

After Barnabei's death in 1922, his widow, Corinna, divided most of his papers among three repositories: the Biblioteca Angelica, Rome; the Biblioteca dell'Istituto di Archeologia e Storia dell'Arte, Rome; and the Scuola Normale di Pisa. Why the Gentili materials—the five to six hundred sheets that are now in Los Angeles, Castelli, and, possibly, Pescara—were kept separate from Barnabei's other papers is not known. Perhaps they were not considered important enough to be given to a formal archive; whereas the other papers deal with the details of Barnabei's professional life, not a few of the Gentili materials display meager images and occasionally indecipherable handwriting rendered on homely, ragged scraps of paper. As it turns out, however, these less-than-pristine sheets clarify the elusive history of maiolica in the making. I hope that their publication will serve as a fitting tribute to Barnabei's own commitment to the maiolica industry in Castelli.

Notes

1. Castelli's small size and relatively remote location (about 85 km [53 mi.] northeast of Rome, but politically allied to Naples in the 1600s) belie its prominence as a center of pottery manufacture, a status explained, at least in part, by its proximity to plentiful supplies of good clay, running water (for power), and trees (for kiln fuel). Archaeological remains establish that early forms of maiolica were produced in Castelli from the period of the town's founding, toward the beginning of the fifteenth century. Active from the second half of that century, the Pompei family workshop claimed numerous members, the most noteworthy being Orazio and Annibale Pompei, each of whom signed works datable to the mid-sixteenth century. Also datable to this period,

and in part attributable to the Pompei workshop, are a number of pharmaceutical containers painted in an idiosyncratic style; these are known as the Orsini-Colonna group, after a piece bearing the symbols of those two families. At the end of the sixteenth century, two *compendiario* (sketchy) styles in maiolica decoration emerged in Castelli: one, whose wares are called *le turchine* (the turquoise ones), characterized by gold and white ornamentation delicately painted on an overall cobalt-blue glaze ground; the other, whose wares are called *i bianchi* (the white ones), characterized by scenes painted in only a few brush strokes on a plain white ground, similar to a style popular among Faentine ceramists. Active in the late sixteenth and early seventeenth century, the enigmatic Antonio Lollo has been considered the originator of both the narrative style of ceramic painting in Castelli and the town's signature earth-tone palette—featuring olive green, yellow, and brown—that appeared on virtually all of its subsequent maiolica. In the second decade of the seventeenth century, a group of Castelli ceramists created a tiled ceiling—the only one of its kind in Italy—for the small church of San Donato in Castelli, replacing an earlier one from the sixteenth century. Produced to exemplify the finest of Castelli ceramics, the tiles are painted primarily with portraits and religious images executed in a manner derived from the *compendiario* style. They appear to be the work of the major workshops active at that time, such as the Pompei and Cappelletti. The period of the seventeenth and eighteenth centuries was arguably the most extraordinary for Castelli maiolica, with numerous fine *istoriato* wares being produced by family workshops such as the Grue, Gentili, and Cappelletti. Gesualdo Fuina, a pupil of Francesco Saverio II Maria Grue, was the last great figure in Castelli maiolica production; he died in 1822.

The following is a brief bibliography of the subject: Gabriello Cherubini, *Dei Grue e della pittura ceramica in Castelli (Abruzzo Ultra I.°): Notizie biografico-artistiche* (Naples: R. Università, 1865); Concezio Rosa, *Notizie storiche delle maioliche di Castelli e dei pittori che le illustrarono*, 3rd. ed. (Teramo: B. Gioschi, 1920); Giorgio Baitello, *La Regia scuola d'arte ceramica "Francesco Grue" di Castelli* (Florence: Felice Le Monnier, 1942); Giancarlo Polidori, *La maiolica antica abruzzese: Sotto gli auspici della Società ceramica "Richard Ginori"* (Milan: Luigi Alfieri, 1949); Giancarlo Polidori, ed., *Mostra dell'antica maiolica abruzzese: Napoli, Palazzo Reale, Teramo, Museo civico, 1955: Catalogo* (Cava dei Tirreni: E. di Mauro, 1955); Lello Moccia, ed., *Le antiche maioliche di Castelli d'Abruzzo*, exh. cat. (Rome: Officina Edizioni, 1968); Capitolo Cattedrale di Atri, ed., *Le antiche ceramiche d'Abruzzo nel Museo capitolare di Atri* (Atri: Museo Capitolare, 1976); Jeanne Giacomotti, "Introduction à l'étude de la majolique de Castelli, XVIIᵉ–XVIIIᵉ siècles," *Cahiers de la céramique, du verre et des arts du feu*, no. 59 (1977): 7–21; Claudio Rosa, *I Grue di Castelli, artisti della maiolica: Genealogia* (Rome: Bardi, 1981); Ernesto Paleani, ed., *Antichi documenti sulla ceramica di Castelli* (Rome: Paleani, 1985); Giorgio Baldisseri et al., *Le maioliche cinquecentesche di Castelli: Una grande stagione artistica ritrovata* (Pescara: CARSA, 1989); Teodoro Fittipaldi, *Ceramiche: Castelli, Napoli, altre fabbriche*, 2 vols. (Naples: Electa Napoli, 1992); Luciana Arbace, *Maioliche di Castelli: La Raccolta Acerbo* (Ferrara: Belriguardo, 1993); and Timothy Wilson, Guido Donatone, Sergio Rosa, and Aleardo Rubini, *La sistina della maiolica: Il soffitto maiolicato di San Donato, Castelli* A.D. *1615–1617* (Colledara: Andromeda Multimedia, 1993).

2. Getty Research Institute for the History of Art and the Humanities, Research Library, ID no. 88-A274. The dealer's catalog comprises a brief introduction, an index, and transcriptions of nos. 18, 54, 61, and 208; see *Documents originaux sur la famille Gentili, potiers à Castelli (Teramo, Abruzzes)* (Geneva: L'Autographe, 1984). In the 1980s, Otto Mazzucato published two short pieces on the Gentili/Barnabei archive: "Documenti sui Gentili, boccalari di Castelli," *Faenza* 68 (1982): 100, pl. XLIV; and "Documenti dei Gentili," in *Castelli, ceramiche di cinque secoli*, exh. cat. (Teramo: n.p., 1984), unnumbered pp. 59–62.

3. Carmine Gentili is arguably the most well-known member of the Gentili family. His ceramic paintings are described in a seventeenth-century letter as *"molto stimati, che esso lavorava tanto e non bastava a soddisfare molte richieste di committenti"* (so highly esteemed that he worked much and was not even able to satisfy the requests made by patrons); see Serafino Mattucci, "La *via crucis* in maiolica di Carmine Gentile e sua scuola nella Chiesa Madre di Bisenti in Abruzzo," *Faenza* 33 (1947): 73–74. I am indebted to J. V. G. Mallet, in this particular case, for bringing Mattucci's article to my attention.

4. Of particular interest regarding the professional circumstances of the potter are nos. 3 and 4; regarding his finances are nos. 40, 43, 47, 70, 80–87, 104, 134, and 137; and regarding specific orders and negotiations for maiolica are nos. 8, 18, 33–35, 53, 54, 61, 68, 101, 111, and 145. Nos. 10, 45, 50, 122, and 123 are indicative of literary inclinations; no. 114 is a marriage contract; no. 130 lists medicinal remedies; and no. 144 discusses religious matters. For fascinating and still unsurpassed information about the Italian Renaissance potter from the perspective of a social and economic historian, see Richard A. Goldthwaite, "The Economic and Social World of Italian Renaissance Maiolica," *Renaissance Quarterly* 42 (1989): 1–32.

5. Pounced designs were possibly used by Turkish Iznik potters from the earliest period of the fritware's production, in the late fifteenth century. Their use is implied by the exact reproduction of images or parts of images, occasionally and tellingly with the design reversed (see note 44), on various early pieces from Iznik. Documentary evidence from the turn of the seventeenth century refers to pounced designs for the Iznik tiles decorating a tomb built in the late sixteenth century, and examples of pounced Iznik designs dating to at least the eighteenth century still survive. See Nurhan Atasoy and Julian Raby, *Iznik: The Pottery of Ottoman Turkey*, ed. Yanni Petsopoulos (London: Alexandria Press/Thames & Hudson, 1989), 59–60, figs. 50–52b, 776, 777.

6. Joshua Reynolds, *Discourses*, ed. Pat Rogers (1797; London: Penguin, 1992), 154. Imitation is the topic of the sixth discourse, and in addition to arguing for its positive uses, Reynolds runs through many of the arguments against imitation and explores its dangers.

7. Giorgio Vasari, *Le vite de' più eccellenti pittori scultori ed architettori*, ed. Gaetano Milanesi, 9 vols. (1568; Florence: G. C. Sansoni, 1906), 5: 417: "*Marcantonio intanto, seguitando d'intagliare, fece in alcune carte i dodici Apostoli, piccoli in diverse maniere, e molti Santi e Sante, acciò i poveri pittori che non hanno molto disegno, se ne potessero ne'loro bisogni servire.*"

8. Heinrich Vogtherr, *Ein frembds vnd wunderbars Kunstbuechlin allen Molern,*

Bildschnitzern, Goldschmiden, Steinmetzen, Schreinern, Platnern, Waffen und Messer-schmiden hochnutzlich zu gebrauchen. Der gleich vor nie keins gesehen oder inn den Truck kommen ist (Strasbourg: Heinrich Vogtherr, 1538), as translated in Janet S. Byrne, *Renaissance Ornament Prints and Drawings*, exh. cat. (New York: Metropolitan Museum of Art, 1981), 20; see also Michael Snodin and Maurice Howard, *Ornament: A Social History since 1450* (New Haven: Yale University Press, 1996), 28.

9. Giovanni Battista Armenini, *De' veri precetti della pittura*, ed. Marina Gorreri (1587; Turin: G. Einaudi, 1988), bk. 1, chap. 7, 73: "*Dipoi, divenuto prattico et atto a ritrare qualsivoglia dissegno benissimo, egli è bene che si pervenga a imitar le opere dipinte.*"

10. Cennino Cennini, *The Craftsman's Handbook: The Italian* Il libro dell'arte, trans. D. V. Thompson Jr. (New Haven: Yale University Press, 1933; reprint, New York: Dover, 1960), 87.

11. Vasari (see note 7), 1: 174–77; translated in Giorgio Vasari, *Vasari on Technique*, trans. Louisa S. Maclehose, ed. G. Baldwin Brown (London: J. M. Dent, 1907; reprint, New York: Dover, 1960), 212–15; Filippo Baldinucci, *Vocabolario toscano dell'arte del disegno* (Florence: Santi Franchi, 1681; reprint, Florence: Studio per Edizioni Scelte, [1976?]), s.v. "calcare," "cartoni per far disegni d'opere," "spolverizzare," "spolvero."

12. Armenini (see note 9), bk. 2, chap. 6, 120: "*che quello sia l'istessa opera, fuorché le tinte.*"

13. For an examination of both techniques, but particularly pouncing, in Renaissance Italy, see Carmen Bambach Cappel, *The Tradition of Pouncing Drawings in the Italian Renaissance Workshop: Innovation and Derivation*, 2 vols. in 4 (Ann Arbor: University Microfilms, 1990).

14. The type of composition and the disposition of the figures on this sheet have much more to do with ceramic decoration than with the embellishment of other circular decorative arts such as metalwork, embroidery, and stained glass. The subject of this drawing has been identified as Aeneas and his companions at Thrace with the tomb of Polydorus (Virgil, *Aeneid* 3.61–93). See Timothy Clifford, "Some Unpublished Drawings for Maiolica and Federigo Zuccaro's Role in the 'Spanish Service,'" in Timothy Wilson, ed., *Italian Renaissance Pottery: Papers Written in Association with a Colloquium at the British Museum* (London: British Museum Press, 1991), 166–67, fig. 1.

For a few other rare examples of drawings known or suspected to have served as designs for Renaissance maiolica, see an allegorical drawing of the trial of Socrates attributed to Prospero Fontana (Sotheby's, London, 13 July 1972, lot 23 [drawing no. 80 in an album attributed to Guilio Bonasone]) and a matching *crespina* (fluted dish) from Urbino (circa 1580, 23 cm [9 in.] diam; Sotheby's, London, 16 July 1991, lot 10); and a drawing of a historical scene in the Biblioteca Comunale di Urbania (Lidia Bianchi, *Cento disegni della Biblioteca comunale di Urbania*, 2nd ed. [Rome: Gabinetto Nazionale della Stampe, 1959], 65 [entry no. 65]).

Recently, another name has been added to the list of well-known artists who have designed for maiolica: Francesco Bedeschini, a draftsman of ornament who was active in L'Aquila in the seventeenth century. Two of his drawings in the Victoria and Albert Museum, London, were made for and bear the name of Carlo Antonio Grue, the preeminent maiolica painter in Castelli during the late seventeenth and early eighteenth

centuries and teacher to Carmine Gentili. See Howard Coutts, "Francesco Bedeschini, Designer of Maiolica," *Apollo*, n.s., no. 304 (1987): 401–3; and idem, "Bedeschini and Grue: A Fruitful Collaboration," in Timothy Wilson, ed., *Italian Renaissance Pottery: Papers Written in Association with a Colloquium at the British Museum* (London: British Museum Press, 1991), 183–86.

15. Giuseppe Campori, "Notizie storiche e artistiche della maiolica e della porcellana di Ferrara nei secoli XV e XVI," in Giuliano Vanzolini, ed., *Istorie delle fabbriche di majoliche metaurensi e delle attinente ad esse*, 2 vols. (Pesaro: Annesio Nobili, 1879), 2: 126–27.

16. Genga's fresco was originally executed for the Palazzo Petrucci in Siena and is now located in the Pinacoteca there. The subject may have been taken from Plutarch's *Fabius Maximus*, book 7, or Julius Caesar's *Gallic War*, book 1; see Timothy Wilson, "Girolamo Genga: Designer for Maiolica?" in Timothy Wilson, ed., *Italian Renaissance Pottery: Papers Written in Association with a Colloquium at the British Museum* (London: British Museum Press, 1991), 158–59, 161 n. 15, fig. 3.

Two of the plates have been offered for sale at Sotheby's, London (circa 1520, 24.4 cm [9⅝ in.] diam.; 16 June 1938, lot 75; and circa 1520, 25.5 cm [10 in.] diam.; 21 November 1978, lot 45); the others are at the Musée du Louvre, Paris (1524, 27 cm [10⅝ in.] diam.; Jeanne Giacomotti, *Catalogue des majoliques des Musées nationaux: Musées du Louvre et de Cluny, Musée national de céramique à Sèvres, Musée Adrien-Dubouché à Limoges* [Paris: Editions des Musées Nationaux, 1974], 86 [entry no. 337], fig. 337) and the British Museum, London (see fig. 7; circa 1520–1525, 25.2 cm [9⅞ in.] diam.).

For discussion of the drawing, see J. Byam Shaw, "Iacopo Ripanda and Early Italian Maiolica," *Burlington Magazine* 61 (1932): 18–20, 25; J. Byam Shaw, "Una composizione di Jacopo Ripanda e tre piatti faentini," *Faenza* 21 (1933): 3–9; Bertrand Jestaz, "Les modèles de la majolique historiée: Bilan d'une enquête," *Gazette des beaux-arts*, ser. 6, 79 (1972): 217–22; Timothy Wilson, *Ceramic Art of the Italian Renaissance* (London: British Museum Publications, 1987), 115–17 (entry no. 184); Sybille Ebert-Schifferer, "Nuove acquisizioni sulla personalità artistica di Jacopo Ripanda," in Marzia Faietti and Konrad Oberhuber, eds., *Bologna e l'umanesimo, 1490–1510*, exh. cat. (Bologna: Nuova Alfa, 1988), 237–45; Marzia Faietti and Konrad Oberhuber, eds., *Bologna e l'umanesimo, 1490–1510*, exh. cat. (Bologna: Nuova Alfa, 1988), 311–17 (entry nos. 93–96 by Sybille Ebert-Schifferer); Marzia Faietti, "Jacopo da Bologna: Per una ricostruzione del corpus dei disegni," *Bollettino d'arte*, no. 62–63 (1990): 97–110; and J. V. G. Mallet, "Au musée de céramique à Sèvres: Majoliques historiées provenant de deux ateliers de la Renaissance," *Revue du Louvre* 46, no. 1 (1996): 48.

17. According to Vasari (see note 7), 6: 581–82, services decorated after Battista Franco's drawings of scenes from the Trojan War were sent to Emperor Charles V and to Cardinal Farnese. See A. E. Popham, "Battista Franco: Design for a Majolica Dish," *Old Master Drawings* 2 (1927): 21–22, pl. 26; Timothy Clifford and J. V. G. Mallet, "Battista Franco as a Designer for Maiolica," *Burlington Magazine* 118 (1976): 387–410; Johanna Lessmann, "Battista Franco disegnatore di maioliche," *Faenza* 62 (1976): 27–29; Rita Parma Baudille, "L'Eneide nelle maioliche," in Marcello Fagiolo, ed., *Virgilio nell'arte e nella cultura europea*, exh. cat. (Rome: De Luca, 1981), 245–48; and

Carmen Ravanelli Guidotti, "Battista Franco disegnatore per la maiolica," in Maria Grazia Ciardi Dupré dal Poggetto and Paolo Dal Poggeto, eds., *Urbino e le Marche prima e dopo Raffaello*, exh. cat. (Florence: Nuova Salani, 1983), 474–77.

18. The so-called Spanish Service was ordered for King Philip of Spain and completed in 1562 but never sent. See J. A. Gere, "Taddeo Zuccaro as a Designer for Maiolica," *Burlington Magazine* 105 (1963): 306–15; Myron Laskin Jr., "Taddeo Zuccaro's Majolica Designs for the Duke of Urbino," in Sergio Bertelli and Gloria Ramakus, eds., *Essays Presented to Myron P. Gilmore*, vol. 2, *History of Art, History of Music* (Florence: La Nuova Italia, 1978), 281–84; and Clifford (see note 14), 166–76.

Federico Brandani copied these designs by Taddeo and Federico Zuccaro for the life of Julius Caesar in stucco, thus providing the only known instance of an artist using maiolica designs to create works of art in another medium. Originally located in the Palazzo Corboli in Urbino, Brandani's stucco reliefs were moved to the Palazzo Ducale in Urbino in 1918; see Luigi Serra, ed., *Catalogo delle cose d'arte e di antichità d'Italia: Urbino* (Rome: La Libreria dello Stato, 1932), 37. Study of these reliefs has aided the reconstruction of the Spanish Service, since the compositions on the ceramic plates and the stucco panels are identical. Brandani apparently was in Rome from about 1552 to 1553 and then in Piedmont from 1562 to 1564. Between these periods, he worked intermittently for Duke Guidobaldo II della Rovere in Urbino. One can assume, therefore, that his Palazzo Corboli stuccos were executed during this decade. The Spanish Service can be dated to between 1560 and 1562, according to Vasari (see note 7), 7: 90. Consequently, although it cannot be determined whether the Zuccaros' compositions appeared first in maiolica or in stucco, the plates and reliefs must be very close in date.

19. Mattucci (see note 3), 72–74. In the private apartments of the Palazzo Doria Pamphilj in Rome is a set of fourteen Castelli plaques depicting the *via crucis* (stations of the cross) whose style is very close to the Crucifixion plaque published by Mattucci. The Palazzo Doria Pamphilj set appears to have been pieced together using individual plaques from two or possibly three separate series of the *via crucis*: a few episodes are represented by several different tiles while others, such as the Crucifixion, are entirely lacking. The relation of the plaques in the Palazzo Doria Pamphilj to those in Santa Maria degli Angeli has yet to be determined. I thank Karin Wolfe-Griffoni for her generous help in identifying the subjects of the plaques in Rome.

20. Mattucci (see note 3), pls. XVIIIa, XVIIIb. See also a Castelli plaque attributed to the Grue family workshop which is decorated with the same subject and presumably copies the same drawing (1750–1800, 25.8 × 33 cm [10⅛ × 13 in.]; Christie's, New York, 1 June 1994, part 2, lot 47 [Arthur M. Sackler Collections no. 79.6.26a]).

21. Wilson, 1987 (see note 16), 113. As Wilson notes, that Deruta's ceramists preferred to copy local, Umbrian works of art for their ceramic painting—rather than print sources in circulation at that time—may have something to do with the isolation of this hilltop town from Italian Renaissance courts and important artistic centers. The preponderance of religious images on Deruta maiolica may be related to the town's role in supplying wares to the nearby convent of Saint Francis of Assisi from as early as the mid-fourteenth century. In another article, Wilson discusses the popularity in Deruta's potteries of images drawn from Pintoricchio's works. He mentions both the unproven statement that Pintoricchio married the daughter of a Deruta potter and the interesting

fact that many of the interiors with paintings by Pintoricchio have maiolica tile floors, such as the Borgia Apartments in the Vatican and others in Rome and Siena; see Wilson, 1991 (see note 16), 157.

22. For information regarding the influence of Raphael and his school on maiolica from the Marches, see Alessandro Marabottini Marabotti, "Fonti iconografiche e stilistiche della decorazione nella maiolica rinascimentale," in *Maioliche umbre decorate a lustro: Il rinascimento e la ripressa orrocentesca: Deruta, Gualdo Tadino, Gubbio*, exh. cat. (Florence: Nuova Guaraldi, 1982), 43–57 passim; and Carmen Ravanelli Guidotti, "Iconografia raffaellesca nella maiolica delle prima metà del XVI secolo," in Maria Grazia Ciardi Dupré dal Poggetto and Paolo Dal Poggeto, eds., *Urbino e le Marche prima e dopo Raffaello*, exh. cat. (Florence: Nuova Salani, 1983), 448–73.

23. The influence of Signorelli and his pupil Genga is discussed in Wilson, 1991 (see note 16), 157–65. Francia's influence is visible on an unpublished jar in the Museo Nazionale della Ceramica "Duca di Martina," Naples (inv. no. 955), whose decoration is based on an engraving by Raimondi after Francia.

24. *Frescoes*: At least two Faenza plates copy Michelangelo's Sistine Chapel spandrel frescoes. This source for the plates' decoration appears to have been transmitted via intermediary drawings made on the spot, since the earliest engravings of these images are by Adamo Scultori and postdate the ceramics by close to fifty years. See J. V. G. Mallet, "Michelangelo on Maiolica: An *istoriato* Dish at Waddesdon," *Apollo*, n.s., no. 386 (1994): 50–55. Another noteworthy example is that of a Cafaggiolo plate of the first quarter of the fifteenth century in the Musée de Cluny that copies a fresco depicting Susanna and the Elders by Pintoricchio in the Borgia Apartments in the Vatican for which no print source existed. Given that the fresco was about 250 km (155 mi.) from the plate's center of production, the ceramist probably availed himself either of one of Pintoricchio's own drawings for the fresco or of a sketch made from such a drawing. See Jestaz (see note 16), 217–18; Galeazzo Cora and Angiolo Fanfani, *La maiolica di Cafaggiolo* (Florence: Centro Di, 1982), 96 (entry no. 81); and Marabottini Marabotti (see note 22), 36–37.

Sculptures: For discussion of Donatello's *Saint George* and Jacopo di Stefano's maiolica plate, see Jestaz (see note 16), 217–18; and Galeazzo Cora and Angiolo Fanfani, *La maiolica di Cafaggiolo* (Florence: Centro Di, 1982), 28 (entry no. 7). What may be the most unusual case, however, is that of a plate depicting Apollo and Marsyas in the British Museum, London, for which ceramist Nicola di Gabriele Sbraghe da Urbino appears to have copied for his figure of Apollo a drawing Raphael made, probably between 1504 and 1508, of Michelangelo's *David*. That Nicola's Apollo is reversed relative to the drawing would normally suggest that the ceramist used an engraved intermediary, but no such engraving is known. It is possible Nicola had access to Raphael's drawing or, more likely, to a drawn intermediary of it. If an intermediary source was used, it might have been pricked for transfer as this would explain both the reversal of the figures and the fidelity with which Nicola's Apollo copies Raphael's David, including the unusual inclusion of the small tree stump next to David's leg. See Francis Ames-Lewis, "Nicola da Urbino and Raphael," *Burlington Magazine* 130 (1988): 691–92.

Medals and plaquettes: See, for instance, Galeazzo Cora, "'.Opus. .Sperandei.,'" *Faenza* 36 (1950): 108–10; Jestaz (see note 16), 224–27; and Carmen Ravanelli Guidotti,

"Medaglie, placchette, incisioni e ceramiche: Un itinerario iconografico," in *Piccoli bronzi e placchette del Museo nazionale di Ravenna*, exh. cat. (Bologna: University Press, 1985), 51–69. An exceptional case is that of two plates and a jug which appear to have been decorated by pressing their wet clay into the same mold as that used for a medal made in the fifteenth century by Sperandio Savelli for Giovanni II Bentivoglio. The size of the images on the ceramic (roughly 7.5 cm [3 in.] diam.) relative to that of the medal (8.8 cm [3½ in.] diam.) can be explained by the drying and firing of the clay, which reduces the overall size of the ceramic through the evaporation of water.

25. Cipriano Piccolpasso, *I tre libri dell'arte del vasaio: The Three Books of the Potter's Art: A Facsimile of the Manuscript in the Victoria and Albert Museum, London*, trans. Ronald Lightbown and Alan Caiger-Smith, 2 vols. (1557; London: Scolar Press, 1980), 1: fol. 57v; Jestaz (see note 16), 223.

26. Bernard Rackham, "The Sources of Design in Italian Maiolica," *Burlington Magazine* 23 (1913): 194; Wilson, 1987 (see note 16), 114–15 (entry no. 182), figs. XII, XIII.

27. Giacomotti (see note 16), 43 (entry no. 152). That the plate was painted in the same year that the print was published demonstrates the apparent speed with which sources were diffused and subsequently absorbed by ceramic craftsmen. In general, however, reliance on print sources slowed down the appearance of stylistic innovations and new subject matter on maiolica, especially when images on maiolica are compared to those of contemporary panel, easel, and wall painting. These lags might be explained not only by ceramists' practice of using intermediary sources as their models but also by their preoccupation with demanding technical issues specific to their medium, such as the formulation of various pigments and the effects of different modulations in the kiln's atmosphere.

28. Wilson, 1987 (see note 16), 125 (entry no. 193), fig. XXVI; Carola Fiocco and Gabriella Gherardi, *Museo comunale di Gubbio: Ceramiche* (Perugia: Electa / Editori Umbria, 1995), 29.

29. The relief and print share identical images of a small dog in the lower corner, which is not in Leonardo da Vinci's fresco; see Susan Lambert, *The Image Multiplied: Five Centuries of Printed Reproductions of Paintings and Drawings* (London: Trefoil, 1987), 198 (entry no. 215), 199 (entry no. 218).

30. A. V. B. Norman, *Wallace Collection: Catalogue of Ceramics*, vol. 1, *Pottery, Maiolica, Faience, Stoneware* (London: Trustees of the Wallace Collection, 1976), 108–10 (entry no. C45).

31. Ibid., 162–63 (entry no. C79). Additional versions exist in the Victoria and Albert Museum, London, and elsewhere; see Marabottini Marabotti (see note 22), 41.

32. See, for instance, Jestaz (see note 16), 237; and Anna Rosa Gentilini and Carmen Ravanelli Guidotti, *Libri a stampa e maioliche istoriate del XVI° secolo* (Faenza: Faenza Editrice, 1989). That Tempesta's prints were copied by other printmakers helps explain the great number of ceramics, both within Italy and without, that are decorated after his engravings.

33. Arthur M. Hind, *A History of Engraving and Etching from the Fifteenth Century to the Year 1914*, 3rd ed. (Boston: Houghton Mifflin, 1923), 37.

34. Jestaz (see note 16), 217: "*Les travaux [sur la majolique] les plus récents, toutefois, font maintenant une large place à l'identification des modèles gravés.... [J]'ai la*

conviction que ce mode de recherche peut inspirer des études plus fructueuses que le jeu traditionnel des localizations sur la carte"; and idem, "Les modèles de la majolique historiée. II. XVIIᵉ et XVIIIᵉ siècles," *Gazette des beaux-arts*, ser. 6, 81 (1973): 128 n. 41: *"Ainsi apparait la méthode de classification, par laquelle l'histoire des arts mineurs s'éloigne de l'histoire de l'art pour se rapprocher des sciences naturelles et, plus particulièrement, de l'entomologie."*

The preoccupation with localizing a piece of maiolica is not surprising. It is a common approach in art history in general, and its presence in the field of maiolica in particular stems from Piccolpasso's rudimentary classification of patterns to their centers of production.

35. This argument was presented by Jestaz (see note 16) for the study of Italian maiolica and by Jan Pluis ("Nederlandse gesprenkelde tegels met een geschilderde voorstelling," *Tegel* 5 [1975]: 5–29; *Kinderspelen op tegels* [Assen: Van Gorcum, 1979]) for the study of Dutch tiles.

36. For some famous examples of ceramists of the late fifteenth and early sixteenth centuries who moved from one place to another, see Marabottini Marabotti (see note 22), 27–28. One notable exception to the general dissemination of techniques is the fact that knowledge of the valuable and difficult luster technique seems to have remained a guarded secret of very few centers of maiolica production in Italy.

37. Although few scholars have approached the subject directly, several have briefly explored the possibility that Renaissance ceramists made use of pounced cartoons. See, in particular, Jestaz (see note 16), 230–31; Clifford and Mallet (see note 17), 392, 395–96; Giovanni Conti, *L'arte della maiolica in Italia*, 2nd ed. (Busto Arsizio: Bramante, 1980), entry nos. 176, 184; Patricia Collins, "Prints and the Development of *istoriato* Painting on Italian Renaissance Maiolica," *Print Quarterly* 4 (1987): 228; Timothy Wilson, "Xanto and Ariosto," *Burlington Magazine* 132 (1990): 323–24, 326; and Grazia Biscontini Ugolini and Jacqueline Petruzzellis Scherer, eds., *Maiolica e incisione: Tre secoli di rapporti iconografici*, exh. cat. (Vincenza: Neri Pozza, 1992), 20. Maureen Cassidy-Geiger refers to the use of Raimondi's engravings on sixteenth-century ceramics but mentions pouncing only in reference to Dutch seventeenth- and eighteenth-century delftware and later porcelain; see Maureen Cassidy-Geiger, "Graphic Sources for Meissen Porcelain: Origins of the Print Collection in the Meissen Archives," *Metropolitan Museum Journal* 31 (1996): 99.

38. Cora and Fanfani (see note 24), 27 (entry no. 6).

39. Piccolpasso (see note 25), 1: fol. 57v.

40. Collins (see note 37), 227.

41. Wilson (see note 37), 324.

42. Henry Wallis, *Seventeen Plates by Nicola Fontana da Urbino at the Correr Museum, Venice: A Study in Early Sixteenth Century Maiolica* (London: Taylor & Francis, 1905); Catherine Hess, *Italian Maiolica: Catalogue of the Collections* (Malibu: J. Paul Getty Museum, 1988), 97–100 (entry no. 30).

43. Notable works that exemplify Xanto's practice of reinventing his compositions from various prints include two plates, one decorated with an allegorical scene of the ruin of Rome, Naples, Florence, and Genoa (see fig. 16) and the other with the flood of the Tiber, both at the Castello Sforzesco, Milan. The former combines figures from four

different prints, the latter from twelve. See Jacqueline Petruzzellis Scherer, "Le opere di Francesco Xanto Avelli al Castello Sforzesco," *Rassegna di studi e di notizie* 8 (1980): 321–71, figs. 11–13, 28–33.

44. That figures appear on maiolica in reverse relative to the print source is irrelevant, given that a pricked cartoon could be pounced from either the recto or the verso.

45. See, for example, Ulrich Thieme and Felix Becker, eds., *Allgemeines Lexikon der bildenden Künstler von der Antike bis zur Gegenwart*, 37 vols. (Leipzig: E. A. Seemann, 1907–1950), s.v. "Xanto Avelli"; Jestaz (see note 16), 230–31; Collins (see note 37), 228; and Wilson (see note 37), 323–24, 326.

46. Jestaz (see note 16), 231. The female spectator and Daedalus are from *Martyrdom of Saint Lawrence* by Marcantonio Raimondi after Baccio Bandinelli (Bartsch 14.89.104); Marco Dente's engraving is after Raphael (Bartsch 14.243.323). The plate and its print sources are discussed in Petruzzellis Scherer (see note 43), 344, figs. 19–22.

47. Xanto's plate depicting Hero and Leander is in the Galleria Estense, Modena. This plate and its print sources are discussed in Francesco Liverani, *Le maioliche della Galleria Estense di Modena* (Faenza: Faenza Editrice, 1979), 37–40 (entry no. 9); and idem, "Una maiolica dell'Avelli e le sue fonti iconografiche," *Faenza* 66 (1980): 297–99.

48. In spite of these drastic steps, Pietro Aretino composed erotic sonnets to accompany Raimondi's engravings, and these were added to the second edition of the engravings, which appeared in 1527 and was followed by several counterfeit editions. All trace of these editions has been lost, however, save a mid-nineteenth-century lithographed reconstruction by Count Jean-Frédéric-Maximilien de Waldeck and one counterfeit edition of circa 1527 in a private collection. Nine fragments of woodcuts from what are presumed to be one of the earliest editions are in the collection of the British Museum, London. See Lynne Lawner, ed. and trans., *I modi: The Sixteen Pleasures: An Erotic Album of the Italian Renaissance* (Evanston: Northwestern University, 1988); and Paula Findlen, "Humanism, Politics and Pornography in Renaissance Italy," in Lynn Hunt, *The Invention of Pornography: Obscenity and the Origins of Modernity, 1500–1800* (New York: Zone, 1993), esp. 95–96.

49. See, for instance, Luciana Arbace, "Eros in maiolica," *Antiques* [Edizioni Condé Nast], no. 15 (1992): 68–73; and Giovanni Conti, *Nobilissime ignobilità della maiolica istoriata*, exh. cat. (Faenza: n.p., 1992).

50. Examples include plates at the British Museum, London (Wilson, 1987 [see note 16], figs. 75, 76, 220, 222); the Castello Sforzesco, Milan (Petruzzellis Scherer [see note 43], figs. 11, 28); and the Corcoran Gallery of Art, Washington, D.C. (Wendy M. Watson, *Italian Renaissance Maiolica from the William A. Clark Collection* [London: Scala, 1986], 133 [entry no. 52]).

51. Bette Talvacchia believes that these figures were not, in fact, easily adopted for re-use given the technical difficulty of neatly separating the engaged bodies. Because of this, she maintains, Xanto must have purposely sought out these infamous images for his own purposes. See Bette Talvacchia, "Professional Advancement and the Use of the Erotic in the Art of Francesco Xanto," *Sixteenth Century Journal* 25 (1994): 135.

52. The condemnation and destruction of Raimondi's erotic prints turned them into coveted material. A Venetian bookseller working in Paris in the late sixteenth century is alleged to have sold more than fifty copies of Aretino's erotic sonnets in less than

a year (see Piero Lorenzoni, *Erotismo e pornografia nella letteratura italiana: Storia e antologia* [Milan: Formichiere, 1976], 40, as cited in Findlen [see note 48], 57, 348 n. 18). As a result, although illicit, the source of Xanto's figures would have been recognizable to a certain interested, literate audience.

53. Manlio Cortelazzo and Paolo Zolli, *Dizionario etimologico della lingua italiana*, 5 vols. (Bologna: Zanichelli, 1979–1988), s.v. "chiàve." Another noteworthy example is Xanto's plate depicting the fall of Francis I at Pavia in the British Museum, London. Xanto used the female from position one for the figure of Francis I, and it has been argued that the sexual conversion signifies the fallen king's "emasculation" by having been "taken" by Charles V at the Battle of Pavia in 1525. See Findlen (see note 48), 103–4, fig. 1.13; and Talvacchia (see note 51), 138.

54. Franco Battistella, "Appunti sulla produzione sei-settecentesca delle officine ceramiche di Castelli," *Rivista abruzzese* 42 (1989): 261–67.

55. Mattucci (see note 3), 72–74. Mattucci was the director of Castelli's ceramics school from 1958 to 1978.

56. Luciana Arbace, ed., *Nella bottega dei Gentili: Spolveri e disegni per le maioliche di Castelli*, exh. cat. (Sant'Atto, Teramo: Edigrafital, 1998).

57. See, for example, Rainer Behrends, *Das meissener Musterbuch für Höroldt-Chinoiserien: Musterblätter aus der Malstube der meissener Porzellanmanufaktur (Schulz-Codex)* (Munich: Idion, 1978); Cassidy-Geiger (see note 37), 99–126; and Snodin and Howard (see note 8), 52. Alberto Milano has conjectured that Remondini, the Venetian publisher, bought Martin Engelbrecht's stock of copperplates after the engraver's death; see Mario Infelise and Paola Marini, ed., *Remondini, un editore del Settecento*, exh. cat. (Milan: Electa, 1990), 227 (entry no. 13 by Alberto Milano), as cited in Cassidy-Geiger (see note 37), 115 n. 34. If true, it would help explain the currency of his images in eighteenth-century Italy. Nevertheless, it must be remembered that it was not unusual to find images from earlier prints, especially popular ones that might have been carefully preserved by potters or copied and sold by other printers, on later ceramics; note, for instance, the popularity of images by Antonio Tempesta (1555–1630) on eighteenth-century earthenware and porcelain.

58. See Fittipaldi (see note 1), entry nos. 55, 56, 154, 167, 181, 182, 188, 197, 209–11, 213, 224, 233, 248, 252, 270, 285, 295; for information on the service, see entry no. 166. The thirteen corresponding Gentili cartoons are, respectively, nos. 235, 207, 199, 232, 258, 183, 207, 231, 235, 214, 231, 170, 213, 231, 185, 8, 172, 232, 231.

59. Carmen Bambach Cappel (personal communication, 1990) concurs. The documents—including letters, lists, and contracts—associated with the Gentili and their workshop that are preserved in the Gentili/Barnabei archive indicate a constant, if not abundant, supply of paper from which *spolveri* could be made. This influx suggests that there was no reason to keep already used paper for any long period of time.

60. Nadir Stringa, formerly curator at the Museo della Ceramica, Nove, Vicenza, knows of a private collection of nearly one hundred drawings and watercolors—approximately half of which are *spolveri*—that probably date from the late eighteenth century. This collection belonged, at least at the end of the nineteenth century, to a Faentine family, and the majority of the images are religious figures and scenes, with some mythological and popular subjects as well.

61. The only other examples of comparably early date are Dutch pricked patterns (*sponsen*) for tile decoration dating from around 1680. The survival of early pounced designs in several Dutch factories — indeed, the care with which they were classified and preserved — may say more about Dutch workshop management than about the extent to which transfer patterns were used north of the Alps. See Bambach Cappel (see note 13), 1.1: 250–51; and Jan Daniel van Dam, "A Survey of Dutch Tiles," in *Dutch Tiles in the Philadelphia Museum of Art* (Philadelphia: Philadelphia Museum of Art, 1984), 34.

62. Felice Barnabei, *Le "memorie di un archeologo,"* ed. Margherita Barnabei [Felice's daughter] and Filippo Delpino (Rome: De Luca Edizioni d'Arte, 1991).

63. The first entry in the catalog (nos. 3–5) lists Eusanio, Francesco, and Tito Barnabei among the ceramists active in Castelli in the mid-nineteenth century. As it happens, the Barnabei interest in ceramics continued after Felice's death, since a member of the family is documented as attending La Regia Scuola d'Arte Ceramica "Francesco Grue" in the late 1930s; see Baitello (see note 1), 53.

64. Baitello (see note 1), 20–22. The model for much of this activity, which was clearly fueled by the Industrial Revolution, was London's South Kensington Museum (opened in 1852 as the Museum of Manufacturers and renamed the Victoria and Albert Museum in 1899). Founded by the British government to promote and improve knowledge and appreciation of local manufacturing, its influence was far reaching. One of the efforts inspired by its British predecessor was the Museo Artistico Industriale and its Scuole-Officine in Naples, which were founded in the 1870s by Gaetano Filangieri, prince of Satriano, to celebrate Italy's past glories and to respond to the newly born industrial arts. Ironically, the demise of the Museo and its Scuole-Officine was caused as much by arguments that pitted artistic against industrial issues as by the death of its founder in 1892. The literature on this endeavor includes Gaetano Filangieri, *Il Museo artistico industriale e le Scuole-Officine in Napoli: Relazione a S.E. il Ministro della pubblica istruzione* (Naples: Giannini, 1881); Nadia Barrella, *Il Museo Filangieri* (Naples: Guida, 1988); Francesco Eduardo Alamaro, ed., *Il ritorno del principe: Aspetti ed oggetti nelle foto delle Scuole-Officine del Museo artistico industriale di Napoli (1885–1924)* (Naples: Alberto Greco, 1990); and Alamaro's articles in *Faenza*: 70 (1984): 7–24, 278–96, 556–72; 71 (1985): 189–211; 73 (1987): 66–98; 81 (1995): 129–51.

65. Baitello (see note 1), 21 n. 3: "*prodigò alla Scuola castellana tutte le cure che la sua carica gli consentiva.*"

Catalog of the Gentili/Barnabei Archive

Entries for just over two-thirds of the sheets in the Gentili/Barnabei archive appear in this catalog. Most of the items described pertain directly to the decoration of maiolica, but some peripheral material is included as well—notably old documents, records that name individual potters or provide information about the Gentili family and its milieu, and various sketches that may have served to develop ideas for ceramic decoration even if they were not copied onto ceramics. I have omitted sheets bearing only illegible images or indecipherable handwriting, as well as written documents whose connection to the maiolica industry is obscure.

Before the Gentili/Barnabei archive was acquired by the Getty Research Institute, a member of the Barnabei family or, more likely, the Swiss dealer who handled the sale numbered the sheets individually, 1 through 275 plus 263 bis. The resulting arrangement of the materials is very roughly chronological and very loosely typological: the more recent items tend to occur toward the end, the written documents tend to appear toward the beginning. For this catalog, I experimented with various arrangements. I grouped by type of material, date, workshop, subject, author, recipient, and so on—but each schema had its own difficulties, and all seemed to impose a sense of order not in keeping with the multiple, uncertain, fragmented character of the papers in the Gentili/Barnabei archive. Because the dealer's numbering seemed, in the end, as justifiable as and perhaps less misleading than any other arrangement that I could imagine, the materials are listed in numerical order by the dealer's numbers. I hope that the looseness of this arrangement will encourage readers to make unexpected connections while, at the same time, the headings, illustrations, and index enable readers to access specific items of interest.

Each entry begins with a boldface heading that consists of the dealer's number, a categorizing phrase, and a date. On the next line appear the dimensions of the sheet and observations about its condition. The body of the entry provides a short description and discussion of the item. If relevant, any known ceramics related to the item and any corresponding items among the Gentili papers at the Istituto Statale d'Arte "F. A. Grue" per la Ceramica, Castelli, are identified. Many of the sheets have notations in a twentieth-century hand, often in pencil and in French and presumably the work of the Swiss dealer, which name the owner, artist, or another individual associated with the item.

After mentioning any such notation, the entry closes with a description of the watermark, if one appears on the sheet.

The materials in the Gentili/Barnabei archive necessitate a few caveats about the categorization, dating, orientation, and determination of recto and verso for the entries. The categorizing phrases are self-explanatory and obvious, except for the items that are both drawn and pricked or stylus traced. What appears to be a pricked drawing may, upon examination, turn out to be a substitute cartoon whose image was later delineated by following the pricking. In a few cases, I have categorized an item as a pricked cartoon but noted in the entry itself the possibility that it could be a pricked drawing (nos. 166, 170, 171, 173, 176, 188).

The dating is at best uncertain. The product of a few guidelines and educated guessing, the dates range from a specific year to a century or more. For any sheet bearing a dated written document, the year given in the document appears in the heading, regardless of whether a substitute cartoon or a drawing also appears on the sheet. The reasoning behind this is that the year given in the letter provides a terminus a quo for the execution of the image while workshop practices suggest a terminus ad quem of about five years later. A substitute cartoon or a drawing on an undated and unsigned sheet is dated generally and, if possible, in accordance with the life span of the potter or the known ceramics associated with it, and a pricked engraving is dated using these criteria as well. Unpricked engravings, however, are dated according to the likely time of production of the print, as determined by inscriptions on the engraving itself, a published catalogue raisonné of the engraver's work, the engraver's dates of activity, and so forth.

Unfortunately, the watermarks that appear on seventy-nine of the sheets described in this catalog have not aided significantly with the dating. Only the watermark on no. 196 has been securely identified. Thirteen sheets display watermarks similar to known watermarks from Italy: various watermarks that include an anchor in double outline within a circle appear on nos. 27, 114, 177, and 191; no. 213 displays three crescents of diminishing sizes; split across nos. 247 and 248 is a watermark consisting of a shieldlike design together with the words *ENRICO MAGNANI* and *AL MASSO*; and nos. 240, 243, 245, 249, 261, and 273 bear the name *AND CAMERA* or *AND[RE]A CAMERA* with or without an anchor in double outline with a rope. I have not been able to identify any of the other watermarks that appear on the sheets in the Gentili/Barnabei archive.

The dimensions of the sheets are listed height by width. When the words and the images on a sheet do not run in the same direction, I have observed the following rules: the image (or the dominant image, when there are several on a sheet), whether pricked or stylus-traced cartoon, drawing, or engraving, determines the orientation of the sheet; whenever consideration of the orientation of the writing seems appropriate, and whenever there is no image on the sheet, the orientation of older handwriting is given priority over that of the dealer's notation. Note that for nos. 64, 119, and 139 the orientation of

the image cannot be determined and for nos. 147–56, 225, and 226 the sheet's orientation was dictated by the other sheets with which it is bound.

The image also takes priority in the determination of recto and verso. For the purposes of this catalog, recto refers to the primary side of the sheet, verso to the secondary, and the side on which the (dominant) image appears is considered the recto. When there are images of comparable importance or writing with no obvious starting point on both sides of the sheet, the side with the dealer's number is called the recto. Pricked and stylus-traced cartoons require further discrimination, because the same image appears on both sides of the sheet. For substitute cartoons, then, the side from which the image was pricked or traced is regarded as the recto.

Most of the pounced substitute cartoons were pounced (rubbed with powder) on the recto, with the verso placed against the ceramic surface. As a result, the recto may be heavily dusted with powder, and therefore the image on occasion may be more difficult to read from the recto than it is from the verso. Modern ceramists do not always agree as to which side of a pricked cartoon should be rubbed with pounce. Several have explained to me that pricked cartoons are normally pounced on the verso, with the recto placed against the ceramic, since the paper pushed out around the pinholes on the verso would disturb the glaze ground surface if the verso were to be placed against the ceramic. Others argue that pricked cartoons are normally pounced on the recto, with the verso placed against the ceramic, since the tapping with the bag of pounce would flatten the paper protruding around the pinholes on the verso and thus block the pinholes if the verso were to be pounced. I have found that currently both methods are used in Italy. All but three (nos. 183, 265, 266) of the pounced cartoons in the Gentili/Barnabei archive appear to have been pounced on the recto rather than the verso. Except for the three pounced from the verso, when the verso has been rubbed with pounce or graphite, this seems to have been done to make the pricked image easier to read.

The potters from the Gentili and Grue families whose names appear repeatedly in the entries to this catalog are as follows:

Gentili
Ber[n]ardino II (d. 1683)
Carmine (1678–1763), Berardino II's son
Giacomo II (1717–1765), Carmine's son
Ber[n]ardino III (1727–1813), Carmine's son

Grue
Francesco Antonio I (1618–1673)
Carlo Antonio (1655–1723), Francesco Antonio I's son
Francesco Antonio II Saverio (1686–1746), Carlo Antonio's son
Aurelio (1699–1744), Carlo Antonio's son
Liborio (1701–1776), Carlo Antonio's son
Francesco Saverio II Maria (1731–ca. 1806), Francesco Antonio II Saverio's son

3–4. Document, 1862

31 × 41 cm (12¼ × 16⅛ in.) unfolded. Fair; slight foxing and staining; the third, fifth, and seventh pages of the booklet have a loss to the upper right corner.

Comprising two individually numbered sheets that were placed on top of one another and then folded in half and fastened together along the fold with string to form a four-leaf booklet, this document provides a record, handwritten in pen and ink on the rectos and versos, of a meeting held by the potters of Castelli on 19 April 1862 in an attempt to revive their craft, which is described as having reached "*profondo languore e…quasi totale decadenza*" (deep languor and…almost complete decadence). The document lists "*tutti maiolicari domiciliati in Castelli*" (all maiolica potters living in Castelli)—among the forty-one potters named are Eusanio, Francesco, and Tito Barnabei—and enumerates and describes their 281 kilns. For instance, Tito Barnabei claims that he uses eight kilns for firing in any given year and that each measures 10 × 8½ × 8½ "*pal[o di] leg[no]*" (posts of wood), accommodates seventy-two "*salmette*" (loads), and is fired every forty-nine days. The document also outlines an agreement that includes resolutions to conserve the local forest, limit the size and number of kilns (potters not observing the limits will be fined), restrict the firing of kilns, and notify local officials when a kiln is to be fired (a point enforceable by the mayor of Castelli). All potters are required to sign the agreement, and in addition they pledge to take care of their tools and to reserve them for their own use, although tools (kilns excepted) may be exchanged between potters. Two circular insignia are stamped in ink at the upper left corner of the first and third pages: the larger has the words "*REGNO DELLE DUE SICILIE G. 12*" around a shield displaying three fleurs-de-lis that is surmounted by a crown and flanked by foliate sprays; the smaller has the words "*VIT. EMM. RE D'ITALIA G. 12*" around a shield displaying a cross. The larger has a large cross stamped across it in ink, the smaller has the same cross stamped beneath it.

Watermark: Each sheet has two marks, each consisting of three fleurs-de-lis flanked by two letters, possibly *F* and *L*, and enclosed within two crenellated circles, with the name *F. LUCIBELLO* below between the two marks.

6–7. Document, late 1800s–early 1900s

20.2 × 24.9 cm (8 × 9¾ in.) unfolded. Good.

Comprising two individually numbered sheets that were placed on top of one another and then folded in half to form a four-leaf booklet, this document, handwritten in pen and ink on the first three pages of the booklet, describes the production of maiolica, celebrates its glories, and mentions the names of those who have written on the subject of maiolica. "*Barnabei*" is handwritten in pen and ink at the upper right of the first page, with "*Felice*" added in pencil, presumably by the dealer.

8. **Pricked cartoon and business letter, 1600s–1700s**

13.3 × 19.3 cm (5¼ × 7⅝ in.). Fair, heavily used, cracking along the pricking.

Recto: Substitute cartoon of a seated man leaning back to drink from a jug, with a group of three goats to the right; pricked for transfer; rubbed, especially the figure of the man, with black pounce.

The male figure and the standing goat appear on a Castelli plate attributed to Berardino III Gentili in the Museo di San Martino, Naples (late 1700s, 19.9 cm [7⅞ in.] diam.; Fittipaldi 1992, 1: 146 [entry no. 277], 2: 169 [no. 277]). This cartoon may have been pricked from the same source as that used for the decoration of a Castelli plate with a similar but not identical male figure in the Museo di Palazzo Venezia, Rome (1700s; inv. no. 89), and a Castelli saucer signed "*GENTILI P.*" and attributed to Carmine Gentili in the Museo di San Martino, Naples (circa 1740, 15.2 cm [6 in.] diam.; Fittipaldi 1992, 1: 139 [entry no. 252], 2: 154 [nos. 252a, 252b]). The former depicts a man drinking from a jug seated beside a woman holding a bowl, the latter a seated huntsman drinking from a jug next to a recumbent dog and a horse loaded with game.

Verso: Part of a letter handwritten in pen and ink. It reads,

Da varij mesi sono, che si ritrovano al'ordine li conzaputi quattro piattini solo manca l'occasione per fargiele per venire nelle mani; Gli notifico, che io mi ritrovo di tutta perfettione una matonella coll'istoria di Arianna, e circa per prezzo della medema non di potrebbe dare à meno di docati quattro ma pure a ri[g]uardo di V.S. Ill^{ma} gli si darà il prezzo di Carlini trenta cinque, e di piu mi ritovo due fruttiere che ponno servire anche per inzalata, e le medeme non sono riuscite di tutta perfetione dal foco, ma spero per l'entranto settimana ponerle à foco, e per chè mi ritrovo con qual, che necessità di denari prega la bonta di V.S. Ill^{ma}.

(For several months, the order for the four small plates has been filled and the only thing I lack is the opportunity to get them to you. I would also like to inform you that I have a perfectly executed tile with the story of Ariadne that could not be sold for less than four ducats although, in deference to you, it could be sold for thirty-five *carlini*. In addition, I have two fruit dishes that could also serve as salad dishes and although these are not perfectly executed, I hope this coming week to fire them in the kiln. Since I find myself in financial woes and needing money, I beg your goodness.)

"*Autogr. de Bernardino Gentili*" is handwritten in pencil along the left edge, presumably by the dealer.

This document was published in Mazzucato 1984.

Watermark: Partial mark of a six-pointed star within a double circle surmounted by a bird.

9. **Engraving, late 1600s** (pl. 1)

17.7 × 18.7 cm (7 × 7⅜ in.); print 11.3 × 17.2 cm (4½ × 6¾ in.). Fair, some foxing and staining, tears along the edges.

Engraving by Jeremias Wolff (1663–1724) after Jean Le Pautre (1618–1682) of a decorative shield that is surmounted by a mask and supported by two female figures wearing flowing drapery and holding olive branches who are aided by two putti holding swags of fruit. Inscribed on the shield is "*J. le Pautre invent. Jeremias Wolff excudit Aug. Vindel. No. 69.*" Berardino II Gentili signed the sheet several times in pen and ink below the engraving.

This document was published in Mazzucato 1982, pl. XLIV.

10. Drawings and poem, late 1600s–early 1700s

18.6 × 19.2 cm (7⅜ × 7½ in.). Poor, extensive insect staining, edges frayed, some losses to the left edge.

Three sketches in pen and ink of curious human figures appear at the upper left of the sheet and the words "*Carmine Gentili dalla Terra Castellorum*" at the upper right. Faintly visible below is a poem:

> *Questo libro son di carta*
> *Questa carta son di straccia*
> *Questo straccia son di lino*
> *Questo lino son di terra*
> *Questa terra son di Dio*
> *Questo libro son...*
> *Legete per verso e per canzone*
> *Di fatto trovarete il nome del patrono...*
> *Gentil....*
> (This book is made of paper
> This paper is made of rag
> This rag is made of linen
> This linen is from the earth
> This earth is from God
> This book is...
> Read as verse and as song
> In fact you will find the name of the patron...
> Gentle [or the beginning of the last name Gentili]....)

11–17. Sketchbook, 1715

This sketchbook comprises six individually numbered sheets of various sizes attached to paper flanges bound with string into a grey paper cover (see the next seven entries).

11. Sketchbook cover

16.3 × 43.5 cm (6⅜ × 17⅛ in.) unfolded. Fair, some staining, some losses to the edges that have been stabilized.

Recto: "*Carmine Gentili 1715*" is handwritten in pen and ink on the right half (outside front cover).

Verso: Handwritten in pen and ink on the right half (inside back cover) is 20 July 1717.

12. **Sketchbook leaf**

14 × 21 cm (5½ × 8¼ in.). Good, some staining and foxing.

Drawing in pen and ink of Neptune seated in a chariot drawn by a team of hippocampi.

13. **Sketchbook leaf**

14 × 21 cm (5½ × 8¼ in.). Good, some staining and foxing.

Three drawings in pen and ink of putti in various poses.

These putti, as well as the one drawn above the abduction scene of no. 157 and the nine sketched on the recto and verso of no. 160, have much in common with the putti rendered on four Castelli plaques attributed to Giacomo II Gentili that are in the Raccolta Acerbo, Loreto Aprutino (early 1700s, two 32 × 24 cm [12⅝ × 9½ in.], two 31.5 × 23.5 cm [12⅜ × 9¼ in.]; Arbace 1993, 56–57 [entry nos. 44–47]). The similarity of style suggests that the putti share a common artist, and it may be that these drawings functioned as preparatory sketches for the putti on the plaques in the Raccolta Acerbo or on others like them.

Watermark: Partial mark of a crown within a circle.

14. **Sketchbook leaf**

13.7 × 41 cm (5⅜ × 16⅛ in.). Fragile, tears along the creases.

Drawing in pen and ink of a mythological scene including two couples, each consisting of a Nereid and a Triton, and eight putti; pricked for transfer; rubbed with black pounce.

15. **Sketchbook leaf**

12.5 × 13.5 cm (4⅞ × 5¼ in.). Good, some slight foxing.

Two drawings in pen and ink of putti.

16. **Sketchbook leaf**

14 × 13.5 cm (5½ × 5¼ in.). Good, some foxing.

Drawing in pen and ink of a pair of putti.

Watermark: Partial mark of a crown within a circle.

17. **Sketchbook leaf**

10 × 13.5 cm (3⅞ × 5¼ in.). Good, some staining and foxing.

Recto: Drawing in pencil of four dogs.

Verso: Unfinished and faint image in pen and ink of a standing figure.

18. **Pricked cartoon and business letter, 1685**

26 × 19.2 cm (10¼ × 7½ in.). Good, some water damage.

Substitute cartoon of what appears to be the Holy Ghost above either the baptism of a saint or the coronation of the Virgin; pricked for transfer over a letter, handwritten in pen and ink, with the dateline Scanno, 8 October 1685. At three of the sheet's corners, a short piece of string

knotted at one end is threaded through the sheet, indicating that the sheet was bound with one or more other sheets at one time. The letter is addressed to "*Alessandro Roscellj* [?]" and enumerates

> *Dui baccili belli.*
> *Dui Bocalonj di tre Carrafe.*
> *[T]re altri di tre fogliette.*
> *Dui scodallette e li coverchi di una foglietta pittate l'una.*
> *Quattro taze belli piccole.*
> *Vorrei mi facesse grazie farmi fare dui vasi piccoli di una carrafa l'uno, belli, e storiati al miglior segno, e questi havrebbero a servire per tenere speziale e mitridato, hormaij faccia come li piace.*
> *Quattro scodallette di meza foglietta l'una.*
> *Due Cannatelle di una Carrafa l'uno.*
> *Quattro di una fogliette l'uno.*
> *Quattro altre di meza foglietta l'uno, e sien tutte pittate nel modo che parerà a V.S.; che il costo di manderà cons[eguentemen]te.*
> (Two beautiful basins.
> Two large jugs of the three-carafe size.
> [T]hree others of three small leaves.
> Two small bowls and covers of one small painted leaf each.
> Four small, beautiful cups.
> I would like you to have made for me two small, beautiful vases, each of the one-carafe size and painted by the best hand with narrative scenes. These will serve to hold a spice/drug and mithridate [a drug preparation]; at this point, do as you please.
> Four bowls of half a small leaf each.
> Two vessels of the one-carafe size each.
> Four of one small leaf each.
> Four others of half of a small leaf each, and they should be painted in the manner that you wish; payment will follow.)

The meaning of *foglietta* (small leaf) here is unclear. Perhaps it refers to a leaf of metal foil, since, from the seventeenth century on, touches of gold occasionally were painted and fired onto some Castelli pottery to produce lustrous highlights. It is also possible that the word refers to a sheet of paper, or *foglio*, having a design (specified here as whole, half, or painted) used in decorating the wares. No. 101 mentions "*bocali d'una foglietta l'una*" (jugs of one small leaf each), and in no. 208 the term *foglio* refers in some way to the vessel's quality.

This document was published in Mazzucato 1984.

19–26. Booklet, 1676

9.7 × 12.9 cm (3⅞ × 5⅛ in.) unfolded. Good, some foxing.

Sixteen-leaf bound booklet made of eight individually numbered sheets

folded in half and fastened together along the fold with string. Written in pen and ink at the top of the first page of the booklet is "*S. Michell'Archangelo e il nome di Giesù è di Maria 1676*" (Saint Michael archangel and the names of Jesus and Mary 1676), and below the words "*Qui si nota tutte le messe che si devono dire in detta cappella*" (Here are marked all of the masses to be given in said chapel) the third page is filled with tally marks after the names of the months. Similar notations appear on the second, fourth, and fifth pages. On the ninth page is a pencil drawing of a running figure with the body, wings, and head of an owl and the legs of a man; because its outline is composed of tiny dots, this figure appears to have been transferred to the sheet by pouncing a pricked cartoon or source. All of the other pages in the booklet are blank.

Watermark: Partial mark of a six-pointed star within a circle surmounted by a cross appears on no. 21.

27. Pricked cartoon and document, 1771

20.6 × 27.9 cm (8⅛ × 11 in.). Good, slight insect staining, moderately soiled.

Recto: Substitute cartoon of a Madonna and child; pricked for transfer; rubbed with black pounce such that a curved outline, possibly of the edge of a plate, is discernible. Single pinholes near the edges of the sheet suggest that it and another piece of paper were pinned together at one time.

The same image appears on one of the documents among the Gentili papers at the Istituto Statale d'Arte "F. A. Grue" per la Ceramica, Castelli (Arbace 1998, 30, 145 [Album XXI, 22]). It is either an original drawing that was later pricked for transfer or a substitute cartoon that was later delineated in pen and ink. The prickings appear to match, indicating that the two sheets were placed together and then pricked at the same time.

Verso: Receipt signed by Camillo Cornacchia for payment received from Berardino III Gentili, handwritten in pen and ink and dated 1771.

Watermark: Anchor within a circle, with a six-pointed star above and the letter *V* below. A very similar mark has been dated to 1686 and identified as originating from Fabiano, a commune about 60 km (38 mi.) southwest of Ancona; Mošin 1973, pl. 137 [entry no. 1337]).

28. Pricked cartoon and business letter, late 1600s–early 1700s

20.4 × 27.5 cm (8 × 10⅞ in.). Good, moderately soiled, edges frayed.

Recto: Substitute cartoon of a horse, a cow, and eleven goats and sheep; pricked for transfer; rubbed with black pounce. Single pinholes near the edges of the sheet suggest that it and another piece of paper were pinned together at one time.

This image, with a female figure leaning against a tree added at the right and two sleeping dogs added at the left, appears on an unpublished eighteenth-century plaque attributed to the Gentili workshop in the Museo delle Ceramiche, Castelli (from the collection of Giovanni Fuschi).

Verso: Letter handwritten in pen and ink on the right half of the sheet.

Watermark: Bird in profile above three hills and flanked on each side by the letter *V*, all enclosed within a circle.

29. Pricked cartoon, business letter, and envelope, 1763

19.4 × 13.5 cm (7⅝ × 5¼ in.). Good, moderately soiled, tears along and losses to the left edge.

Recto: Substitute cartoon after the figure of Joab in the engraving *Joab Killing Absalom* by Antonio Tempesta (1555–1630) (Bartsch 17.130.254); pricked for transfer over the lower half of a letter from Berardino III Gentili, handwritten in pen and ink, with the dateline Naples, 6 August 1763 (for the other half, see no. 65); lightly rubbed with black pounce. Single pinholes around the image suggest that this sheet and another piece of paper were pinned together at one time. This cartoon and nos. 65 and 145 were pricked at different times from the same source.

Verso: Half of an address for delivery, handwritten in pen and ink, to Giovanni Ottavio Massei, Teramo (for the other half, see no. 65); very lightly rubbed with black pounce or graphite to delineate the pricked image.

Watermark: Partial mark of a crowned coat of arms within a cartouche, possibly above illegible initials. The remainder of this watermark appears on no. 65.

31. Pricked cartoon and business letter, circa 1772–1774

20 × 13.9 cm (7⅞ × 5½ in.). Good, moderate staining.

Recto: Substitute cartoon of a hard-to-read image, perhaps a crowned Madonna and child; partially and faintly pricked for transfer, possibly under several sheets of paper, over a long letter, handwritten in pen and ink, of circa 1772–1774 (per dates in the text) from Berardino III Gentili to the senior Catholic priest of Castelli. Single pinholes along the top and bottom edges of the sheet suggest that it and another piece of paper were pinned together at one time. "*D. Berardo Gentili*" is handwritten in pencil at the upper left, presumably by the dealer.

Verso: "*Mᵉ Berardᵒ Gentili*" is handwritten in pen and ink at the left.

33–35. Booklet, 1705

19.5 × 26.2 cm (7⅝ × 10¼ in.) unfolded. Fair, moderate staining, slight insect staining, lower two-thirds of the fourth leaf is missing, bottom edges frayed.

Six-leaf booklet made of three individually numbered sheets of paper folded in half and fastened together along the fold with string. In pen and ink on the first page of the booklet are a sketch of a Madonna and child, a mathematical calculation, and the date 20 May 1705. A sketch in pen and ink of a coat of arms appears on the ninth page. Handwritten in pen and ink on the other pages are lists of maiolica, among them an order for a large holy water stoup, four cups, twelve bowls, and cups and saucers with

narrative scenes, and an order by Salvatore Tori for thirty-six flat bread plates, twenty-eight soup plates, twenty-six flat *mezzi reali*, six flat *imperiali*, and six flat *reali* decorated with a specified coat of arms. "*Notes des travaux 1705/1706*" is handwritten in pencil at the bottom of the first page, presumably by the dealer.

Watermark: Six-pointed star within a double circle appears on no. 33.

40. Document, 1816

25.7 × 37.2 cm (10⅛ × 14⅝ in.). Good, moderate foxing, some losses that have been stabilized.

Document regarding a debt and the rental of a house in Castelli, handwritten in pen and ink on the right half of the sheet. It is addressed to Gabriele Rocchi, signed by Giovanni Barnabei, and dated 17 June 1816; along left edge is "*Scrittura di Giovanno Barnabei per la Casa*" (Giovanni Barnabei's document for a house). "*Giovanni Barnabei potier a Castelli*" is handwritten in pencil near the bottom center, presumably by the dealer.

Watermark: Two marks consisting of a shield that is decorated with what may be a bird and surmounted by a crown, with an illegible word below between the two marks.

43. Document, 1805

28 × 40.3 cm (11 × 15⅞ in.). Good, ink bleeding through, some small losses that have been stabilized.

Recto and verso: Document regarding the sale or rental of a house and land in Castelli, handwritten in pen and ink on the right half of the recto and the left half of the verso. It is dated 30 December 1805 and signed by Giovanni Rocchi, Giovanni Barnabei, Filippo de Santis, and Pasquale Paolini.

Watermark: Illegible mark including a crown.

45. Drawings and poem, late 1600s–early 1700s

28 × 10.5 cm (11 × 4⅛ in.). Good, slight staining, edges slightly frayed.

Recto: Sketch of a foliate spray and the first line of a poem, "*Io son regina*" (I am the queen), both in pen and ink.

Verso: Sketch of flowers and the remainder of the poem:

dalle celesti sfere
messagiera di pace io qui discendo
Ad augurarla al mondo
e con ii miai colori
di bia[n]co, pupurino e azurro tinta
e suepliar vengo i cuori
alle allegrezza che sin qui questinta
a riverir intimo à dar honori
o gran la opotro i popoli lontani

alle porpore tuo a tuoi folgori
vengan dunque da lungi
dalle
(from the celestial spheres
a messenger of peace I descend
to bring fortune to the world
with my colors
tinted white, purple, and blue
I come to provide to the hearts
the happiness that had vanished until now
to esteem and give honor
great [?] people far away
to your purple/cardinalate to your brilliant flashes
they come therefore from far/long
from)

"*(Carmine Gentili)*" is handwritten in pencil at the bottom, presumably by the dealer.

47. Document, 1760

14.4 × 20.4 cm (5⅝ × 8 in.). Good, very slight staining.

Recto and verso: Lists of debts, jobs, and things to do, such as "*A dì 8 del 1760 Nicola Grue mi diedi un carlino*" (On the 8th in 1760 Nicola Grue gave me one *carlino*), handwritten in pen and ink. "*Nota del tabacco*" (Tobacconist's note) written along the left edge of the recto.

50. Narrative, 1700s

19.3 × 26.5 cm (7⅝ × 10⅜ in.). Good, moderate staining.

Recto and verso: Fable-like narrative, handwritten in pen and ink, of a woman wrongly convicted of murder who eventually brings the culprits to justice. One night, two young men intent on robbery trick their way onto the grounds of a house where an old man from Brussels lives alone with his maid. While they lie in wait in the garden, the men see the maid undress and deflea herself in her lighted room. Catching sight of her naked body in the mirror, the maid declares, "*Oh quanto è brutta la donna nuda*" (How ugly are naked women). The men then rob and kill the old man. After being tortured, the maid confesses to committing the murder and is found guilty. She maintains that she is innocent, however, and eventually she is set free. Later, one of the murderers sees the now crippled and destitute maid and remarks, "*Oh quanto è brutta la donna nuda.*" Remembering that she had spoken that phrase aloud the night her master was robbed and killed, the maid succeeds in bringing the man to trial and the court "*fece prendere quell'altro, e li fece appiccare tutti e due, come ben meritava il loro misfatto*" (forced him to get his accomplice and had both men hanged as befitted their crime).

"*Carmine Gentili*" is handwritten in pencil on the recto near the bottom center, presumably by the dealer. This narrative and those of nos. 122 and 123 are all written in the same hand.

The narrative employs various motifs found in folktales, such as the false accusation and the ridicule of an old woman's nudity (see, for example, Rotunda 1973, K2125.7; Thompson 1955–1958, nos. K2116.1, H341.3.1).

53. Business letter, 1734

19.7 × 27.1 cm (7¾ × 10⅝ in.). Good.

Recto and verso: Letter from Ermenegildo de Dura, handwritten in pen and ink and bearing the dateline Penne, 5 September 1734. It includes a discussion of his order of maiolica and closes, "*Se si trovasi fatto qualche buona matonella, o tondini, potrà avisarmelo, e se fossero di più d'uno molto le gradirei, ma con personaggi nud[i] che fanno più spicco dell'opere sue*" (If you should find that you have some good tiles or small bowls, let me know, and if there is more than one, I would like some very much, but with nude figures which make your works more eye-catching).

54. Pricked cartoon and business letter, 1672

20 × 18.3 cm (7⅞ × 7¼ in.). Fragile.

Recto: Substitute cartoon of what appears to be a satyr pulling the drapery off a young woman, legs and breasts bared, with a putto above; pricked for transfer; very lightly rubbed with black pounce. Single pinholes near the edges of the sheet suggest that it and another piece of paper were pinned together at one time.

Verso: Letter, handwritten in pen and ink, with the dateline Teramo, 29 July 1672. The writer notes that "*quando fui qui sua sorella gli scrisse che mi l'avesse favorito di due tazze piane, una la figura della madre santissima del Carmine*" (when I was here, your sister she wrote that I would like two flat cups, one with the image of the Holy Mother of the Carmelites).

Watermark: Six-pointed star within a circle, with what appears to be a cross above and the letters G V below.

59. Manuscript cutting, circa 1634 (fig. 20)

14.4 × 20 cm (5⅝ × 7⅞ in.). Poor, extensive staining, some insect staining, tears that have been stabilized.

Recto and verso: Cutting from a manuscript on vellum, partially illuminated, identified along the left edge of the recto in pen and ink in a later script as "*Libro matrimoniale dell'ano 1633.*"

This appears to be one of the oldest documents in the Gentili/Barnabei archive.

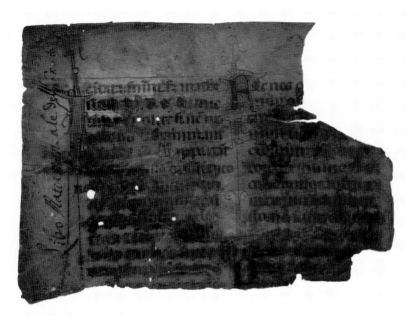

Fig. 20. Manuscript cutting, ca. 1634
See no. 59

61. Business letter and envelope, 1734

21 × 19.5 cm (8¼ × 7⅝ in.). Good, moderate staining, some insect staining, small loss to the top edge.

Recto: Letter to Carmine Gentili from Giambattista Gaudiosi, handwritten in pen and ink, with the dateline Penne, 11 November 1734:

il vasone difettoso procura di aggiustarlo con riponerlo à foco, perche non viene
à tempo à rifarlo nuovamente se pure paresse a V.S. così, sappia che averà una
nuova comissione di centinaia di docati, onde si stia allegramente et attendi à
fatigare, e fate che riescano li vasoni à dovere, se volete aver dè grossi lavori, e
desideroso sentire questi vasoni avete indorati.

(try to fix the defective vase by firing it again, because there is not enough time
to make it again from scratch. If this is all right with you, I will send you a new
payment of one hundred ducats so that you will be happy for attending to this.
You will receive lots of work if you make these vases as you should. I am eager
to hear that you have gilded [presumably lustered] them.)

Verso: Part of an address for delivery, handwritten in pen and ink, to
Carmine Gentili, Castelli.

Watermark: Illegible circular mark surmounted by a star.

64. Pricked cartoon and envelope, 1700s

19.3 × 18.7 cm (7⅝ × 7⅜ in.), or vice versa, depending on the orientation of the image. Good, some losses that have been stabilized.

Recto: Substitute cartoon of an illegible image; partially and faintly pricked for transfer, possibly under several sheets of paper.

Verso: Part of an address for delivery, handwritten in pen and ink, to Giacomo II Gentili, Castelli; lightly rubbed with graphite to delineate the pricked image.

Watermark: Bird in profile above three hills, within a double circle with a cross above and the letter *M* below.

65. Pricked cartoon, business letter, and envelope, 1763

19.4 × 13.8 cm (7⅝ × 5⅜ in.). Good, some losses to the edges that have been stabilized.

Recto: Substitute cartoon after the figure of Absalom's horse in the engraving *Joab Killing Absalom* by Antonio Tempesta (1555–1630) (Bartsch 17.130.254); pricked for transfer over the upper half of a letter handwritten in pen and ink (for the other half, see no. 29); rubbed with black pounce. Single pinholes near the edges of the sheet suggest that it and another piece of paper were pinned together at one time. This cartoon and nos. 29 and 145 were pricked at different times from the same source.

Verso: Half of an address for delivery, handwritten in pen and ink (for the other half, see no. 29); lightly rubbed with black pounce or graphite to delineate the pricked image.

Watermark: Partial mark of a crowned coat of arms within a cartouche, possibly above illegible initials. The remainder of this watermark appears on no. 29.

68. Business letter, 1734

14 × 19.3 cm (5½ × 7⅝ in.). Good, ink bleeding through, edges frayed.

Recto and verso: Letter from Giambattista Gaudiosi, handwritten in pen and ink and bearing the dateline Penne, December 1734, in which he describes his attempts to exact payment for an order of maiolica that includes three dozen teacups and small plates.

70. Document, 1775

13.6 × 19.1 cm (5⅜ × 7½ in.). Fair, extensive staining, tears that have been stabilized.

Recto: List of payments, handwritten in pen and ink, for the shipping of various supplies:

Per trasporto di arena di Napoli da Pasquale Jannotti viaggi cinque a carlini dieci...
Per trasporto di [un?] dieci barili di biancho da mataloni...
Per trasporto di creta di faenza da mataloni cofani...

(For transport of "Naples sand" by Pasquale Jannotti: five trips at ten *carlini*…

For transport of ten barrels of white glaze for clay…

For transport of Faenza clay…)

Verso: "*Turchino No. 61 libbri*" (Turquoise, 61 pounds) and the date February 1775, handwritten in pen and ink.

Watermark: Part of a large and illegible mark including stars and a cartouche.

80–87. Booklet, 1806

13.2 × 18.2 cm (5¼ × 7⅛ in.) unfolded; half sheet 13.2 × 9.1 cm (5¼ × 3⅝ in.). Good, moderate soiling and staining.

Fifteen-leaf booklet made of seven individually numbered sheets folded in half and fastened together along the fold with string plus one numbered loose half sheet. The booklet is filled with various lists, most with prices or weight tallies at the right, handwritten in pen and ink. There are lists of materials, with entries such as "*stagnio libre trendacinque*" (thirty-five pounds of tin), as well as lists of maiolica objects, with entries such as "*per due zuccariere*" (for two sugar bowls) and "*per quattro chicchere*" (for four saucers). The name "*Cornacchia*" appears on four lists, all of which have been canceled. The ninth page of the booklet is entitled "*Lascito*" (Bequest) and includes entries (which continue onto the next two pages) such as the "*per una para di calzoni*" (for a pair of pants), "*per sette libbre café*" (for seven pounds coffee), "*per tre onze garofali*" (for three ounces of cloves), "*per un capotto*" (for an overcoat), "*per un sottonino*" (for an undergarment), and "*per spongie*" (for sponges); Domenico Barnabei is to receive seventy-two *scudi*. The date 23 May 1806 appears on the eighth page. Four of the pages are blank.

Watermark: Hard-to-read mark, possibly of the word TORRETO arranged in an arc above a shield with the monogram *VW* or *WV*, appears on nos. 82–85.

88–92. Document and drawings, 1600s

19 × 25 cm (7½ × 9⅞ in.) unfolded; half sheets 19 × 12.5 cm (7½ × 4⅞ in.). Poor, extensive damage due to the corrosive properties of the ink.

Recto and verso: Three individually numbered sheets and two individually numbered half sheets (nos. 90, 91) that look as if they are leaves from a single, much longer letter or booklet. All of the mostly illegible Latin text, handwritten in pen and ink, is in the same hand. Very similar sketches in brush and ink of a uniformed man standing and holding a staff or sword appear on the recto of no. 90 and the verso of no. 89; the other sketch on the verso of no. 89 is illegible.

Watermark: Bird in profile above three hills, all within a double circle, appears on nos. 88, 90, and 92.

Fig. 21. Pricked cartoon and business letter, 1759
See no. 94 verso

93. **Pricked cartoon, business letter, and document, 1727**

20 × 14 cm (7⅞ × 5½ in.). Good, ink bleeding through, edges slightly frayed.

Recto: Substitute cartoon of a half-length female figure, seated and wearing a shawl or scarf on her head; pricked for transfer over part of letter from Camillo Cornacchia to Signor Piovano, handwritten in pen and ink and headed Chieti, 26 April 1727; very lightly rubbed with black pounce. Single pinholes near the edges of the sheet suggest that it and another piece of paper were pinned together at one time.

Verso: Brief list of payments received and money owed, handwritten in pen and ink.

94. **Pricked cartoon and business letter, 1759** (fig. 21)

13.7 × 19.4 cm (5⅜ × 7⅝ in.). Good, fair amount of insect staining.

Recto: Substitute cartoon of an emblem comprising large flourishing initials surmounted by a crown; pricked for transfer; lightly rubbed with black pounce. A Jesuit monogram is handwritten in pen and ink at the right.

Verso: Letter from Eliseo Carnestale, handwritten in pen and ink and headed Teramo, 16 March 1759; there is also a notation in pen and ink in another hand. "*Eliseo Carnestale*" is handwritten in pencil at the upper left, presumably by the dealer.

95. Pricked cartoon and documents, 1792

23.6 × 18.5 cm (9¼ × 7¼ in.). Good, slight ink staining.

Recto: Substitute cartoon of an elaborately coiffured female figure holding a fan and wearing what appears to be fancy eighteenth-century dress; pricked for transfer over part of a canceled expense list, handwritten in pen and ink and dated November 1792. Single pinholes at the corners of the sheet suggest that it and another piece of paper were pinned together at one time.

Verso: Part of a canceled expense list, handwritten in pen and ink; lightly rubbed with graphite to delineate the pricked image.

Watermark: Crescent moon within a double circle surmounted by a crown.

101. Document, 1700s

10.7 × 19.3 cm (4¼ × 7⅝ in.). Fair, extensive staining and deterioration, some losses that have been stabilized.

Recto and verso: Text, handwritten in pen and ink and addressed to Don Michele, describing payment for an order of maiolica and listing the pieces ordered. In part, it reads

Vi prego di far subito venire detta majolica, che da me sarà ricevuta alli descritti prezzi, e pagata o in danaro o in tant'oglio...e per le sudette majoliche che dovranno venire qui, mi raccomando alla vostra bontà, ed efficacia di pregare l'artefice sopradette che siano di buona qualità specialmente li piatti centinati. ...Bocali d'una foglietta l'una....Due baccili ordinarj...piatti grandi reali da zuppa e piatti più piccoli mezzani ordinarj...tondini centinati....Se l'artefice desidera esser pagato in denaro se conterà subito, se poi crede tant'oglio ci fò sapere, che questo genere appunti ieri sera ricalò da 56 a 55 carlini al metro, che potrà servire di regolamento compatite in fine tant'incomodo che vi reco coll' esercizio dei vostri comandi e compensatelo gli mi farò sempre un piacere.

(Please send me the stipulated maiolica for the established prices, which I will pay either in cash or in olive oil...and for the maiolica that will be sent to me I appeal to your goodness and thoroughness to ask the craftsman mentioned above that the pieces be of good quality, especially the *centinati* plates....Jugs each of one small leaf....Two ordinary basins...large *reali* soup plates and smaller ordinary plates...*centinati* bowls....If the craftsman wants to be paid in cash, this can be calculated immediately; if, however, he would like oil, let me

know, because just yesterday the price of oil dropped from 56 to 55 *carlini* per meter and this number could serve as a measure of value for the oil. And even though it will be difficult to calculate your orders in this way it is always a pleasure doing business with you.)

See no. 18 for discussion of the term *foglietta* (small leaf).

104. Stylus-traced cartoon, letter, and envelope, 1787 (fig. 22)

26.8 × 20.2 cm (10½ × 8 in.). Good, some water damage, loss to lower right corner.

Recto: Stylus-traced image, partially sketched in pencil but relatively illegible, of a saint with either the figure of an angel or a pair of figures in the background on the left. The hesitation of the line suggests that the image was stylus traced from another sheet and loosely sketched in later.

Verso: On the top half is a letter from Signor Barbolano to Signor Piovano, handwritten in pen and ink and headed Tossicia, 18 September 1787, in which a certain Francesco Marrone is discussed; on the bottom half is part of an address for delivery, handwritten in pen and ink, to Berardino III Gentili, Castelli.

105. Document, 1749

22 × 20.5 cm (8⅝ × 8⅛ in.). Good, slight staining.

Part of a list of expenses, handwritten in pen and ink and dated 26 November 1749, cut into an oval.

108. Pricked drawing and business letter, mid-1700s

14.1 × 13.3 cm (5½ × 5¼ in.). Fair, moderate staining.

Recto: Drawing in pen and ink of the left half of the symmetrical elements and all of the nonsymmetrical elements of a coat of arms; pricked for transfer; heavily rubbed with black pounce. To obtain the right half of the symmetrical elements (shield, framing cartouche), the drawing was pricked while the right half of the sheet was folded under the left; the nonsymmetrical elements (bird, two diagonal bands) were pricked while the sheet was unfolded.

Verso: Part of a letter, handwritten in pen and ink and addressed to Giacomo II Gentili, in which Carmine Gentili is mentioned as having received two maiolica jugs.

109. Pricked cartoon and business letter, circa 1779

27.6 × 20.2 cm (10⅞ × 8 in.). Good, some ink bleeding through.

Recto: Substitute cartoon of Saint Andrew, after the engraving by Pietro del Po (1610–1692) after the marble sculpture by François Duquesnoy (1597–1643) in Saint Peter's, Vatican City (Bartsch 20.249.13); pricked for transfer and later lightly delineated in pencil over a letter about legal matters from Pier Francesco della Panarea [?] to Signor Piovano, handwritten

Fig. 22. Stylus-traced cartoon, 1787
See no. 104

in pen and ink and headed Tossicia, 12 May 177[9?]. Single pinholes along the right and left edges of the sheet suggest that it and another piece of paper were pinned together at one time.

Verso: Continuation of the letter from the recto; lightly rubbed with graphite to delineate the pricked image.

111. **Pricked cartoon and business letter, 1747** (fig. 23)

20.7 × 14.5 cm (8⅛ × 5¾ in.). Good, slight staining, slight tears along one edge.

Recto: Substitute cartoon of a Madonna and child; pricked for transfer; rubbed with black pounce. Single pinholes near the edges of the sheet suggest that it and another piece of paper were pinned together at one time.

Verso: Letter from Giuseppe Pandaleone, handwritten in pen and ink, with the dateline Penne, 1747. In part, it reads,

> *Avrei tutta la necessità di mezza donzana di buoni chicheri, e piattini, e precisa-*
> *mente che siano ben pigliati dal fuoco, onde sono a pregare V.S. trovando[?]li*
> *favorirà colla prestezza possibile, ò al più lungo nella congiuntura della*
> *prossima fiera di S. Biagio, e questi devono essere istoriati . . . e nel mede[si]mo*
> *tempo avvisarmi il costo per poterciolo mandare.*
>
> (I would need a half dozen good teacups and saucers, and I would like them to
> be carefully taken from the kiln. I beg you to have them quickly sent to the next
> fair of San Biagio, and these must be *istoriato* ware . . . and at the same time let
> me know the cost for having them sent there.)

Watermark: Partial mark of a shield circumscribed by two necklaces with elaborate links, pendants, and a golden fleece, with two letters, possibly *G* and *W*, below.

113. **Pricked cartoon, business letter, and envelope, 1779**

50.3 × 28 cm (19¾ × 11 in.). Good, some insect staining, some losses.

Substitute cartoon of the portrait of an ecclesiastic, within an oval frame and on top of a pedestal, held up by two female figures, one a crowned angel with a staff and the other next to a putto who holds a caduceus in one hand and a bouquet or a torch in the other; pricked for transfer over, on the top half of the sheet, a letter from Berardino III Gentili with the dateline Castelli, 3 May 1779, and, on the bottom half, an address for delivery to Emilio Coppa, Città S. Angelo, both handwritten in pen and ink; the left side of the putto and the right side of the angel are moderately rubbed with black pounce. The letter reads, in part,

> *Accuso il riceve di carlini dodeci per la mezza donzina de piattini e chichare de*
> *quali inviato al suo dignitissimo suo Signor fratello in Avezano. Sono poi appre-*
> *gare la bontà di V.S. di prestarmi onore d'un cestino di dolci, che serva per la*
> *solennità del sponzalizio di questo suo servitore che accaderà dentra a questa*

settimana...e di quelli dolci inviatomi dal suo Signor fratello poca porzione rimasti, che non basta per detta solennità.

(I acknowledge receiving twelve *carlini* for the half dozen plates and teacups that were sent to your brother in Avezzano. Thank you for the small basket of sweets that you sent me to serve at the celebration of the marriage of this, your servant, which will take place within the week....and I warmly appreciate the sweets that were sent to me from your brother which [were so delicious that very] little remains of them and so that they will not be served at the ceremony.)

Single pinholes near the edges of the sheet suggest that it and another piece of paper were pinned together at one time. "*Berardino Gentili*" is handwritten in pencil at the upper left, presumably by the dealer.

Watermark: Spray of flower buds or pods below three stars, within a cartouche surmounted by a foliate flourish.

114. Document, 1806

26.1 × 38.7 cm (10¼ × 15¼ in.). Good, some staining, some losses that have been stabilized.

Recto and verso: Marriage contract, handwritten in pen and ink and dated 1806, between Giovanni Barnabei and Lucia de Nardis, with Lucia's brother, Silvestro, named as a witness. Included is a discussion of Lucia's dowry (sixty ducats) and its dispersal. In the event Lucia becomes contrary to the detailed division of goods, the contract states that Barnabei must keep his wife "*tacita e contenta*" (quiet and content). It also specifies that "*la casa debbono essere di noce, e il matarazza con lana sufficienta*" (their house must be of walnut and their mattress must be of a sufficient amount of wool).

Watermark: Anchor within a circle, with the letter *L* above and the letter *M* below. Although it has an *L* rather than the characteristic six-pointed star above, this mark is similar to a large group of marks dated to the mid-1600s through the late 1700s and originating from Fabriano, a commune about 60 km (38 mi.) southwest of Ancona (Mošin 1973, esp. pl. 135 [entry no. 1323]).

117. Pricked cartoon and letter, 1666

18.4 × 13.1 cm (7¼ × 5⅛ in.). Fragile, loss to the left edge.

Recto: Substitute cartoon of a hunter wearing a hat and standing on a hill, with three or four smaller figures in the background; pricked for transfer; heavily rubbed with black pounce.

Verso: Lower part of a barely legible letter from Francesco Antonio I Grue, handwritten in pen and ink, with the dateline Castelli, 4 March 1666. "*Francesco Grue (1618–1673)*" is handwritten in pencil at the upper left, presumably by the dealer.

Watermark: Partial mark of a six-pointed star within a double circle surmounted by a cross.

119. **Pricked cartoon and envelope, 1700s**

14.1 × 12.9 cm (5½ × 5⅛ in.), or vice versa, depending on the orientation of the image. Fair, some insect staining, ragged edges.

Recto: Incomplete substitute cartoon of an illegible image; lightly and partially pricked for transfer, possibly through several sheets of paper.

Verso: Part of an address for delivery, handwritten in pen and ink, to Carmine Gentili, Castelli; very lightly rubbed with graphite to delineate the pricked image.

122. **Narrative, 1700s**

13.3 × 19.6 cm (5¼ × 7¾ in.). Good, slight staining.

Recto and verso: Fable-like narrative, handwritten in pen and ink, of a Catholic priest who goes to America as a missionary and encourages three old men to espouse the Catholic faith. In America, a priest discovers a wild old man who declares that he is 150 years old. To the priest's further amazement, the man introduces the priest to his father and his grandfather, who are much older than he, the grandfather being more than 300 years old. When the priest asks the grandfather how he has lived for so long, the grandfather replies that an unseen person has always been good to him. Understanding that the person must be Christ, the priest baptizes all three men, after which the grandfather promptly dies.

"*Dom Ber. Gentili*" is handwritten in pencil at the upper left of the recto, presumably by the dealer. This narrative and those of nos. 50 and 123 are all written in the same hand.

The narrative employs various motifs found in folktales, such as miraculous longevity and sending to the older (see, for example, Thompson 1955–1958, F571, F571.2, F571.7, Q145, V229.2.12). The missionary and the trip to America are elements common in folk narratives of the eighteenth century.

123. **Narrative, 1700s**

19.1 × 26.4 cm (7½ × 10⅜ in.). Good, some staining.

Recto and verso: Fable-like narrative, handwritten in pen and ink, of a woman whose husband orders her death after she is falsely accused of adultery, but who escapes execution and lives in a cave in the wilderness until she is discovered by her husband and exonerates herself. The king of Sweden goes away to war and entrusts his wife's honor to one of his ministers. The minister, however, "*tentò di prevaricare la Regina, la quale non volle acconsentire*" (tried to betray this trust with the queen, who would not comply). To prevent the queen from telling the king of his advances, the minister informs the king that the queen has been unfaithful. The king instructs the minister to have the queen killed. Taking pity on her, the executioners leave the queen free in the woods. She takes refuge in a cave and, for nourishment, drinks the milk from a deer who finds her there. Nearly two years later, the king, out hunting, has his dogs run a

deer, which happens to be the deer suckling his wife. The king discovers his wife when the deer runs into the cave. Asked how she has survived in the wild, the wife responds that *"siccome Iddio mi ha conosciuta innocente, così mi ha proveduta col farmi venire questa cerva, la quale mi nudrisse col suo latte"* (since God has known that I am innocent, he has provided me with this deer who has nourished me with its milk). The king takes the queen back to the palace and promptly *"fece erigere un palco, sul quale fu giustiziato scelerato ministro"* (had erected a scaffold on which the evil minister is punished).

Written in the same hand as nos. 50 and 122, this curious narrative employs several elements also found in Giovanni Boccaccio's *Decameron*. In the sixth story of the second day, for example, Boccaccio's narrator tells of a Neapolitan gentlewoman who, after being separated from her husband and her two sons and marooned on an island, suckles two kids she finds in a cave. One day, visitors to the island and their dogs hunt the two kids. When the fleeing kids arrive at the cave, the gentlewoman beats off the dogs and is discovered. The visitors persuade her to leave the island, and eventually she is reunited with her family. In the ninth story of the second day, the narrator tells of a man who orders a servant to kill his wife after being tricked by a fellow merchant into believing that she is guilty of adultery. The wife convinces the servant to let her live, dresses as a man, and, after several adventures, brings to justice the merchant who slandered her and reconciles with her husband.

The writer of this document may have pieced together the narrative under the influence of the *Decameron* or another literary source; or, what is more likely given the loose association of narrative details with Boccaccio's work, the writer may have simply recorded an anecdote as he remembered hearing it told. This may also be true of nos. 50 and 122. The appearance of a king from Sweden betrays a typically eighteenth-century interest in travel and in trade with northern lands.

127. **Pricked cartoon and letter, 1773**

28.8 × 19.8 cm (11⅜ × 7¾ in.). Fair, some staining, some ink bleeding through.

Recto: Substitute cartoon of a man on horseback wearing a tricorn hat and holding a raised sword; pricked for transfer over a letter from Giuseppe Cappelletti, handwritten in pen and ink and dated 29 February 1773, in which he discusses the deaths of various individuals; heavily rubbed with black pounce. Single pinholes along the right and left edges of the sheet suggest that it and another piece of paper were pinned together at one time.

Verso: Continuation of the letter from the recto; an attempt was made to delineate the pricked image by connecting the pricked holes in pencil.

Watermark: Bird in profile holding a branch in its beak above three hills and the letters *G M*, within a circle with a star above and the word *SOLMONA* below.

128. **Pricked cartoon and personal letter, 1764**

19.2 × 26.9 cm (7½ × 10⅝ in.). Good, some staining.

Recto: Substitute cartoon of what appears to be a pietà; pricked for transfer over a letter, handwritten in pen and ink, from Berardino III Gentili to his brother, namely, Giacomo II Gentili; lightly rubbed with black pounce. "*Dom Berardo Gentili*" is handwritten in pencil at the upper right, presumably by the dealer.

Verso: Continuation of the letter from the recto, with the dateline Naples, 21 July 1764; lightly rubbed with graphite to delineate the pricked image.

130. **Document, 1700s**

14.1 × 25 cm (5½ × 9⅞ in.). Good, some insect staining, some ink bleeding through.

Recto and verso: Instructions, handwritten in pen and ink, presumably by a physician, to "*Sig. Berardino*" regarding food, rest, and medications. For example, "*La detta polvere si prenda con decozzione di Thè, o brodo…e così proseguire ogni mese che se ne vedra il buon effetto secondo il solito. Si a[s]tendi dagli acidi, legumi, salati, e frutta, o almeno con mediazione*" (One takes this powder with a boiling tea or broth…and continue in this way every month and you will see the usual good effects. Abstain from acidic food, legumes, salty foods, and fruit, or at least eat them in moderation).

Watermark: Partial mark of a six-pointed star within a circle.

134. **Document, 1726**

19.9 × 27.1 cm (7⅞ × 10⅝ in.). Good, slight staining.

Receipt issued by Domenico Cornacchia of Castelli, handwritten in pen and ink and dated 14 February 1726, for twenty-five *carlini* received from Carmine Gentili. Due since 1724, the sum represents the rent for a house in Castelli that was owned by Cornacchia. Also mentioned are payments received from Pasquale Carlucci and Nicola Cappelletti.

Watermark: Bird in profile above three hills, all within a circle surmounted by a *V*.

136. **Pricked cartoon and letters, early 1700s** (fig. 24)

13.3 × 23 cm (5¼ × 9 in.). Good, some staining, some losses that have been stabilized.

Substitute cartoon of two figures wearing drapery, one lying on the ground and the other reaching toward him; pricked for transfer over portions of two separate letters, handwritten in pen and ink, one with the dateline 1722, Castelli; moderately rubbed with black pounce. At one edge, "*Io Giacomo Gentili fui presente*" (I, Giacomo Gentili, was present) has been written twice in a third hand.

The image is reminiscent of the fresco depicting Mercury with the apple of Discord and Paris with his dog executed by Annibale Carracci (1560–

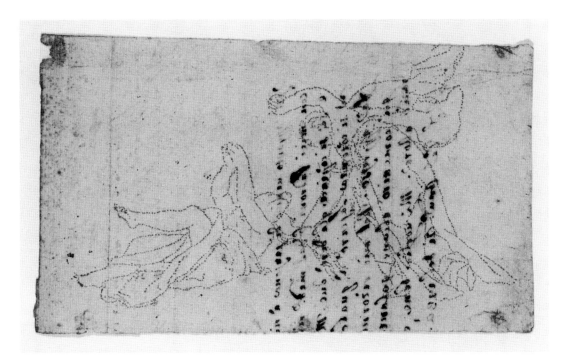

Fig. 24. Pricked cartoon, early 1700s
See no. 136 verso

1609) on the vault of the Galleria Farnese, Rome (see pl. 6). It appears that for the cartoon portions of an engraving or aquatint after the fresco were adapted to create a new subject. Because one figure seems to have been given the head of the dog, the subject might be read as Jupiter changing Lycaon into a wolf.

137. **Pricked cartoon and document, 1736**

19.6 × 26.7 cm (7¾ × 10½ in.). Fair, some insect and other staining, some losses that have been stabilized.

Recto: Substitute cartoon of a mythological scene of a pair of female figures wearing flowing drapery and accompanied by three putti with dogs and two flying putti; pricked for transfer; heavily rubbed with black pounce. Single pinholes near the edges of the sheet suggest that it and another piece of paper were pinned together at one time.

Verso: Declaration regarding Serafino and Stefano Cappelletti, handwritten in pen and ink, signed by several priests, and headed 3 October 1736, Castelli.

Fig. 25. Document, 1578
See no. 144

139. Pricked cartoon and letter, 1764

19.2 × 26.9 cm (7½ × 10⅝ in.), or vice versa, depending on the orientation of the image. Good, slight staining.

Recto: Substitute cartoon of an illegible image; pricked for transfer over a letter from Berardino III Gentili, handwritten in pen and ink, with the dateline Naples, 27 July 1764; lightly rubbed with black pounce. Single pinholes along the top and bottom edges of the sheet suggest that it and another piece of paper were pinned together at one time.

Verso: Continuation of the letter from the recto. "*Dom Berardo Gentili*" is handwritten in pencil at the top of the letter, presumably by the dealer.

144. Document, 1578 (fig. 25)

38.8 × 48.2 cm (15¼ × 19 in.). Good, some losses along the creases.

Recto: Statement, handwritten on parchment in pen and ink and dated 26 January 1578, regarding the construction of the chapel of San Rocco in Castelli and other religious matters. It begins by naming Giacomo Silverio Piccolomini.

Verso: Notations handwritten in pen and ink. The notations "*Giulio Riccio 1581 Vescovo di Teramo (†1592)*" and "*Giacomo Silverio Piccolomini 1553 Vescovo di Teramo (†1581)*" are handwritten in pencil at the bottom, presumably by the dealer.

This appears to be the oldest item in the Gentili/Barnabei archive.

145. Pricked cartoon and business letter, 1667

19.7 × 27.1 cm (7¾ × 10⅝ in.). Fragile.

Substitute cartoon after the engraving *Joab Killing Absalom* by Antonio Tempesta (1555–1630) (Bartsch 17.130.254); pricked for transfer over a letter signed by Vittoria Santorelli confirming receipt of "*piatti in faenza*" (maiolica plates), handwritten in pen and ink and dated 1667; lightly rubbed with black pounce. Single pinholes at the corners of the sheet suggest that it and another piece of paper were pinned together at one time. This cartoon and nos. 29 and 65 were pricked at different times from the same source.

147–56. Pattern book, 1700s

Eleven-leaf pattern book comprising a cover leaf wrapped around nine individually numbered loose leaves (see the next five entries). On the rectos are sketches in pen and ink of male and female saints (apparently stock figures, two per page); one verso is blank and on the others are pencil sketches of flowers or pen-and-ink sketches of rocailles or saints.

147. Pattern book cover leaf (figs. 26, 27)

13.3 × 40 cm (5¼ × 15¾ in.) unfolded. Good, some staining, edges somewhat frayed.

Recto: On the right half (front cover of the pattern book) is an inscription bordered by three straight lines, all in pen and ink. The inscription reads, "*Quanto piu e grave l'importanza di quello che di tratta tanto si debbi procedere piu circonspetto et fare maturamente quelli deliberatione chi errato una volta non si possono piu corregere specialmente ne i casi di guerra. Veronio*" (That which one does is so important that one must go forward with circumspection and deliberate maturely because a mistake cannot be fixed, especially in the case of war. Veronio). On the left half (back cover of the pattern book) are an elaborate rocaille cartouche and the faint drawing of the face of a woman wearing a wimple, both in pen and ink.

Verso: On the left half (inside front cover of the pattern book) is an inscription enclosed in a box that is surmounted by a reclining human figure and a scrolling ornament with a human face, all in pen and ink. The inscription, "*Consola* [?] *Sig. mis dolcissims considirands la prigione non tandu lia castigo ai tristi quantu la gloria ai buoni la virtu di quali non altrimenti che fuoco rinchiuso si rinforza risplendente poi con tanto piu rigore quanto* [*annieni?*] *chegli conseguisca la bramata liberta*" (Console [yourself?] my dearest, consider prison not so much punishment to the

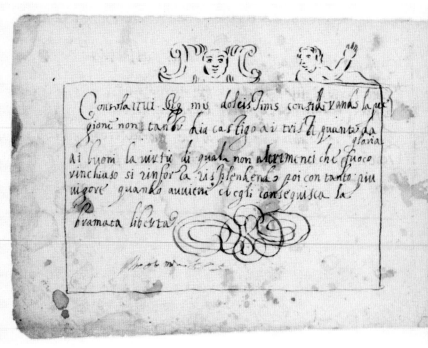

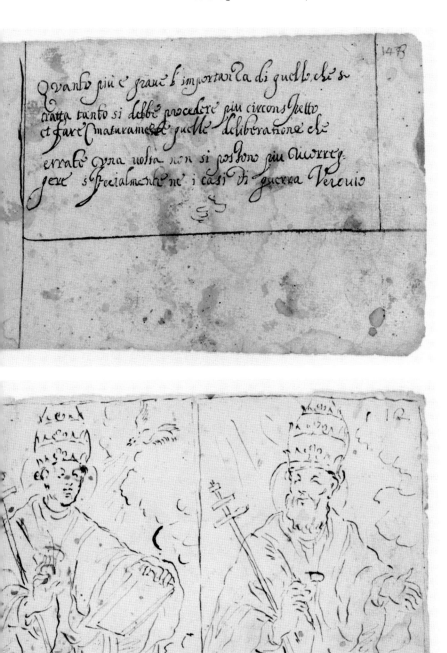

Fig. 26. Pattern book cover, 1700s
See no. 147

Fig. 27. Pattern book cover, 1700s
See no. 147 verso

67

lonely but rather glory to the good whose virtue, when imprisoned, becomes so much stronger [?] that freedom must follow), ends with a flourish and what is probably a signature, both illegible. On the right half (inside back cover) are two drawings in pen and ink of, on the left, the Holy Ghost above a male figure wearing a papal tiara who is holding a tablet or book in his left hand and gesturing in benediction with his right hand while cradling a papal cross in the crook of his right arm and, on the right, a bearded male figure wearing a papal tiara who is gesturing with his left hand and cradling a papal cross in the crook of his right arm.

Watermark: Partial mark of a bird in profile above three hills, within a double circle with a cross above and the letter *V* below. The remainder of this watermark appears on no. 156.

150. **Pattern book leaf** (figs. 28, 29)
13.5 × 19.5 cm (5¼ × 7⅝ in.). Good, some staining.

Recto: Drawings in pen and ink of, on the left, a female saint plunging a dagger into her breast and, on the right, a male saint holding a book and a sword.

Verso: Drawing in pen and ink of a young saint holding an emblematic city and a palm frond, with two cherubim above.

This drawing is very similar to the image of Saint Massimo on a Castelli plaque by Berardino III Gentili in the Raccolta Acerbo, Loreto Aprutino (1775–1800, 24 × 30 cm [9½ × 11¾ in.]; Arbace 1993, 248–49 [entry no. 252]).

Watermark: Partial mark of a bird in profile above three hills, within a double circle with a cross above and the letter *V* below. The remainder of this watermark appears on no. 155.

152. **Pattern book leaf** (figs. 30, 31)
13.5 × 19.5 cm (5¼ × 7⅝ in.). Good, some staining.

Recto: Drawings in pen and ink of two female saints, possibly, on the left, Saint Barbara holding a chalice and, on the right, Saint Dorothea wearing a crown of roses and carrying a basket of roses.

Verso: Drawing in pen and ink of an elaborate rocaille cartouche with masks and scrolls.

154. **Pattern book leaf** (figs. 32, 33)
13.4 × 20.8 cm (5¼ × 8⅛ in.). Good, some staining.

Recto: Drawings in pen and ink of, on the left, Saint Peter with two large keys and, on the right, Saint Joseph holding a flowering rod; the latter is pricked for transfer and very lightly rubbed with black pounce. Given the similarity of the line of this drawing with the line of the other drawings in the pattern book, this seems to be an original drawing that was later pricked for transfer rather than a substitute cartoon that was later delineated in pen and ink.

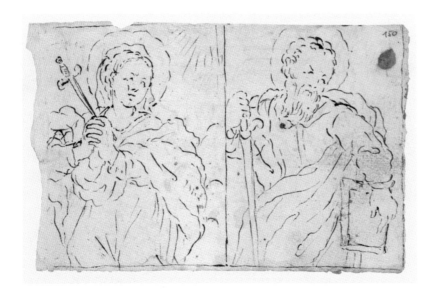

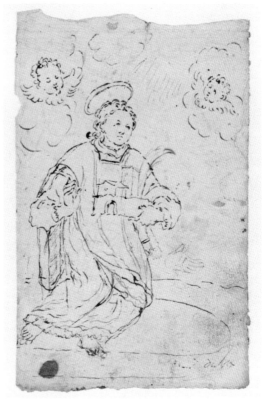

Fig. 28. Pattern book page, 1700s
See no. 150

Fig. 29. Pattern book page, 1700s
See no. 150 verso

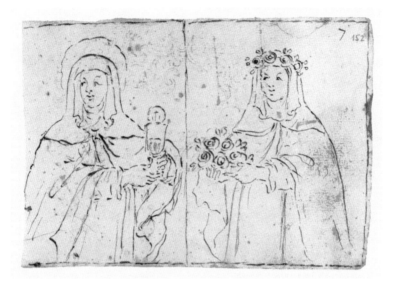

Fig. 30. Pattern book page, 1700s
See no. 152

Fig. 31. Pattern book page, 1700s
See no. 152 verso

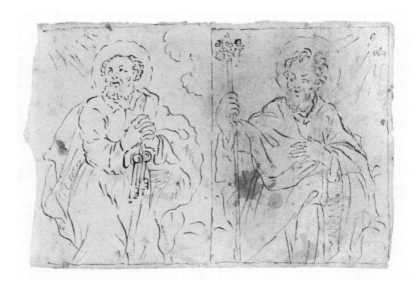

Fig. 32. Pattern book page, 1700s
See no. 154

Fig. 33. Pattern book page, 1700s
See no. 154 verso

Verso: Sketch in pencil of a bouquet of flowers, with a hand grasping a staff drawn in pen and ink to the right.

A very similar sketch of flowers attributed to Carmine Gentili was in the collection of the late Lello Moccia, Pescara (Battistella 1989, fig. 14).

156. **Pattern book leaf** (fig. 34)

13.5 × 19.8 cm (5¼ × 7¾ in.). Good, some staining.

Recto: Two drawings in pen and ink of a saint wearing a bishop's miter and holding a crosier and a square element, most likely an emblematic city.

Similar images appear on a plaque attributed to Francesco Antonio II Saverio Grue in the Museo Nazionale della Ceramica "Duca di Martina," Naples (early 1700s, 24.5 × 16.6 cm [9⅝ × 6½ in.]; Arbace 1996, 144–45, 155 [entry no. 201]); a Castelli footed salver in the Walters Art Gallery, Baltimore (fig. 35; mid-1700s, 30.3 cm [11⅞ in.] diam.; von Erdberg and Ross 1952, 42 [entry no. 83]); and a Castelli plaque by Berardino III Gentili with the inscription "*S. Emidio 1785*" in the Museo Civico, Pesaro (1785, 28.5 × 21 cm [11¼ × 8¼ in.]; *Maioliche del Museo civico di Pesaro* 1979, entry no. 362). Rather different images of Saint Emygdius appear on a Castelli plaque signed "*GENTILI P.*" and attributed to the Gentili workshop in the Musée des Beaux-Arts, Dijon (1700s, 27 × 20 cm [10⅝ × 7⅞ in.]; Barral 1987, 138–39 [entry no. 44]); a rectangular Castelli plaque attributed to Berardino III Gentili in the Museo Capitolare, Atri (1784; Capitolo Cattedrale di Atri 1976, 26 [entry no. 56]); and a Castelli plaque in a private collection, Rome (1700s, 31 × 23.5 cm [12¼ × 9¼ in.]; Ciardi Dupré dal Poggetto et al. 1980, 137 [entry no. 105]). The first bishop of Ascoli Piceno and its patron saint, Saint Emygdius is invoked for protection against earthquakes.

In the drawing on the right side of this page and on the plate in the Walters Art Gallery, the C-shaped scroll at the top of the saint's crosier opens toward the saint's head, while it opens away from the saint on the plaque in the Museo Civico, Pesaro. However, on the two ceramics the saint gazes skyward, while in the drawing he looks to his right; the correspondence between the images on the ceramics might indicate that they are based on an unidentified source and that the drawing also copies the source either directly or indirectly via a ceramic object.

Verso: Very faint drawing in pen and ink of the face of a woman wearing a wimple and gazing upward.

Watermark: Partial mark of a bird in profile above three hills, within a double circle with a cross above and the letter *V* below. The remainder of this watermark appears on no. 147.

157. **Drawing, late 1600s–early 1700s**

13 × 17 cm (5⅛ × 6¾ in.). Good, slight staining and foxing.

Drawing in pen and ink of a Triton abducting a woman, with two putti.

The putto above this scene, as well as the three putti rendered on no. 13 and the nine sketched on the recto and verso of no. 160, has much in

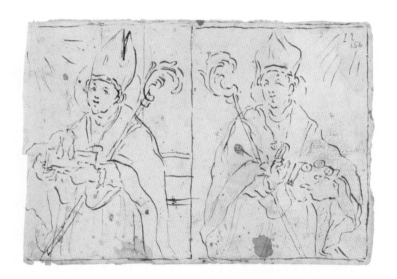

Fig. 34. Pattern book page, 1700s
See no. 156

Fig. 35. Footed salver from Castelli depicting Saint Emygdius, tin-glazed earthenware, 30.3 cm (11⅞ in.) diam., mid-1700s
Baltimore, The Walters Art Gallery

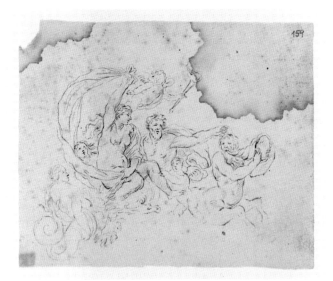

Fig. 36. Drawing, early 1700s
See no. 159

Fig. 37. Plate from Castelli decorated with the scene shown in fig. 36, tin-glazed earthenware, 18.5 cm (7¼ in.) diam., ca. 1750–1760
London, Victoria and Albert Museum

common with the putti rendered on four Castelli plaques attributed to Giacomo II Gentili that are in the Raccolta Acerbo, Loreto Aprutino (early 1700s, two 32 × 24 cm [12⅝ × 9½ in.], two 31.5 × 23 cm [12⅜ × 9 in.]; Arbace 1993, 56–57 [entry nos. 44–47]). The similarity of style suggests that the putti all share a common artist.

158. Drawing, late 1600s–early 1700s

13.5 × 20 cm (5¼ × 7⅞ in.). Good, slight staining and foxing.

Drawing in pen and ink of a Triton abducting a woman. Single pinholes near the left edge of the sheet suggest that it and another piece of paper were pinned together at one time.

159. Drawing, early 1700s (fig. 36)

13 × 17 cm (5⅛ × 6¾ in.). Good, slight staining, loss to the upper left corner.

Drawing in pen and ink of the triumph of Galatea, with two putti, two Tritons, one blowing a bugle-like horn or shell, and two Nereids, one holding a cornucopia.

This unpricked drawing is the source for or was drawn freehand from one of three Castelli plates displaying the same scene or from the source used for their decoration. The plates are in the Gaetano Bindi collection, Museo delle Ceramiche, Castelli (late 1600s, 18.5 cm [7¼ in.] diam.; Proterra 1996, 56–57 [entry no. 23]); the Raccolta Acerbo, Loreto Aprutino (1730, 16 cm [6¼ in.] diam.; Arbace 1993, 80–81 [entry no. 70]); and the Victoria and Albert Museum, London (fig. 37; circa 1750–1760, 18.5 cm [7¼ in.] diam.; Rackham 1940, 1: 387 [entry no. 1167], 2: pl. 187 [no. 1167]).

Watermark: Partial mark of a crowned bird or double-headed eagle within a circle, with a V below.

160. Drawings and pricked drawing, late 1600s–early 1700s (figs. 38, 39)

13.7 × 19.8 cm (5⅜ × 7¾ in.). Good, slight staining and foxing.

Recto: Three sketches in pen and ink of putti in various poses; the upper one is pricked for transfer.

Verso: Sketches in pen and ink of six putti, grouped and in various poses.

The nine putti sketched on this recto and verso, as well as the three rendered on no. 13 and the one drawn above the abduction scene on no. 157, have much in common with the putti rendered on four Castelli plaques attributed to Giacomo II Gentili that are in the Raccolta Acerbo, Loreto Aprutino (early 1700s, two 32 × 24 cm [12⅝ × 9½ in.], two 31.5 × 23 cm [12⅜ × 9 in.]; Arbace 1993, 56–57 [entry nos. 44–47]). The similarity of style suggests that the putti share a common artist, and it may be that these drawings functioned as preparatory sketches for the putti on the plaques in the Raccolta Acerbo or on others like them.

Watermark: Partial mark of a crowned bird or double-headed eagle within a circle.

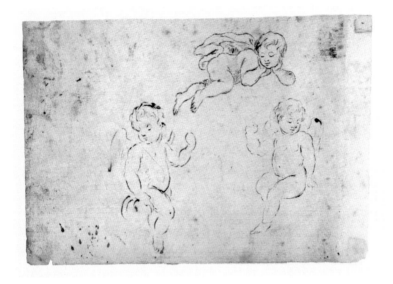

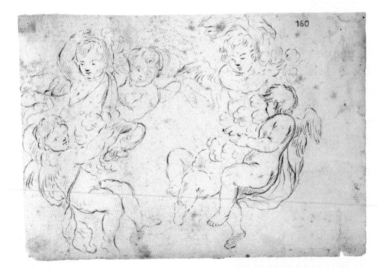

Fig. 38. Drawings and pricked drawing, late 1600s–early 1700s
See no. 160

Fig. 39. Drawings, late 1600s–early 1700s
See no. 160 verso

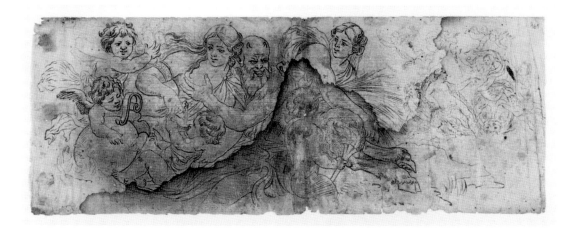

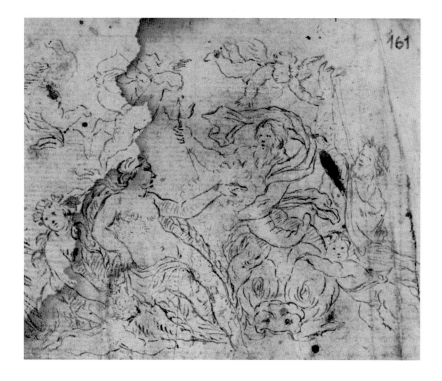

Fig. 40. Pricked cartoon and drawing, late 1600s–early 1700s
See no. 161

Fig. 41. Detail of the drawing shown in fig. 40

161. **Pricked cartoon and drawing, late 1600s–early 1700s** (figs. 40, 41)

15 × 40.2 cm (5⅞ × 15⅞ in.). Good, some water damage, damage along the crease.

To the left is a substitute cartoon of Nessus and Deianira, with four putti and female figure holding a sheaf of grain, possibly Ceres; pricked for transfer and later delineated in pen and ink; some lines are pricked but not drawn, others are drawn but not pricked.

Another pricked cartoon of this image is among the Gentili papers at the Istituto Statale d'Arte "F. A. Grue" per la Ceramica, Castelli (Arbace 1998, 99 [entry no. II/29]). The pricking of the Istituto's cartoon and no. 161 appears to match, indicating that the two sheets were placed together and then pricked at the same time.

This image appears on a Castelli plate attributed to Carlo Antonio Grue in the Museo Nazionale della Ceramica "Duca di Martina," Naples (1670s–1720s, 33.7 cm [13¼ in.] diam.; Arbace 1996, 137, 142 [entry no. 184]); a Castelli plaque by Carmine Gentili (1690s–1760s, 26.5 × 21 cm [10⅜ × 8¼ in.]; Arbace 1993, 176–77 [entry no. 161]) and a Castelli pharmacy vase attributed to Liborio Grue (1700–1750, H: 42.5 cm [16¾ in.]; Arbace 1993, 86–87 [entry no. 78]), both in the Raccolta Acerbo, Loreto Aprutino; and a Castelli roundel that was offered for sale in 1989 (early 1700s, 23 cm [9 in.] diam.; Christie's, London, 3 July, lot 326).

To the right is an unpricked drawing in pen and ink of the triumph of Neptune and Amphitrite, with five putti and one female and one male figure.

Watermark: Part of an illegible image within a circle.

162. **Drawing, late 1700s–early 1800s** (fig. 42)

14 × 10 cm (5½ × 3⅞ in.). Good, slight staining.

Drawing in pen and ink of the risen Christ and two of the disciples on the road to Emmaus. Nos. 162 and 163 were originally one sheet: the outstretched hand holding a staff that appears on the verso of no. 163 belongs to the disciple on Christ's right on the recto of no. 162.

163. **Drawing, late 1700s–early 1800s** (fig. 43)

14 × 10 cm (5½ × 3⅞ in.). Good, some water damage.

Recto: Drawing in pen and ink of Christ and the woman of Samaria at the well.

Verso: Fragment in pen and ink of an outstretched hand holding a staff.

Nos. 163 and 162 were originally one sheet: the outstretched hand holding a staff that appears on the verso of no. 163 belongs to the disciple on Christ's right on the recto of no. 162.

Watermark: Partial mark of a bird in profile above three hills and flanked on each side by the letter V, all enclosed within a circle.

164. **Stylus-traced drawing, stylus-traced cartoons, and envelope, 1700s**

17.5 × 13 cm (6⅞ × 5⅛ in.). Good, edges slightly frayed.

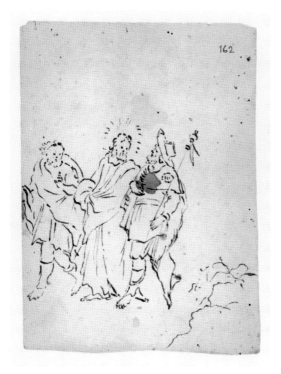

Fig. 42. Drawing, late 1700s–early 1800s
See no. 162

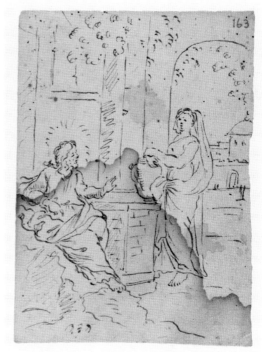

Fig. 43. Drawing, late 1700s–early 1800s
See no. 163

Recto: Drawing in pen and ink of a rearing horse that appears to have been lightly stylus traced, with a stylus-traced image of a horse's head below to the left and the image of a standing horse that was stylus traced and then partially delineated in pencil above; the latter two images are very loosely rendered and hard to read.

Verso: Part of an address for delivery, handwritten in pen and ink, to the "*camerlengo*" (treasurer) of Castelli.

165. **Drawing, late 1800s–early 1900s** (fig. 44)

15 × 16 cm (5⅞ × 6¼ in.). Good, some foxing.

Sketch in pen and ink of a battle scene of several soldiers firing rifles at two men on horseback, with a fallen soldier at the lower right. The top edge of the page appears to have been cut to follow the upper edge of the sketch. "*(Felice Barnabei)*" is handwritten in pencil at the lower left, presumably by the dealer.

Watermark: The name *GIUS[EPP]E B*.

Fig. 44. Drawing, late 1800s–early 1900s
See no. 165

166. **Pricked cartoon, late 1600s–early 1700s** (fig. 47)

13.5 × 18.4 cm (5¼ × 7¼ in.). Fair, some staining, right and left edges frayed.

Drawing or, more likely, a substitute cartoon delineated after pricking, executed in pen and ink with some brown wash over traces of black chalk and depicting two dancing satyrs, one playing pipes and the other blowing a *buccina* (long, curved horn) and balancing a basket of fruit on his shoulder; pricked for transfer; very lightly rubbed with black pounce. Two pinholes perforate the sheet at the center. This page forms a continuous pattern with nos. 170 and 171.

The quality of the line and the fact that certain elements—for example, one satyr's hoof—were drawn but left unpricked suggest that no. 166 is an original drawing, as does the fact that none of the small, delicate, closely placed pricked holes have been disturbed by a pen. However, the occurrence of very similar figures on three Castelli ceramics attributed to Carmine

Gentili and on several pricked cartoons—four among the Gentili papers at the Istituto Statale d'Arte "F. A. Grue" per la Ceramica, Castelli, and two that were in the collection of the late Lello Moccia, Pescara—implies that all of the figures may derive from the same unidentified print source. See no. 170 for discussion of the ceramics and the other pricked cartoons.

Watermark: Partial mark of a crowned bird or double-headed eagle within a circle.

167. Drawing, 1700s

20.2 × 14 cm (8 × 5½ in.). Good, slight staining and foxing.

Drawing in pen and ink of Saint Falco, apparently in rapture and kneeling on a cloud, entitled "*S. Falco Galena*" in pen and ink below. Saint Falco was a hermit saint in the dioceses of Penne and Atri, which are about 40 km (25 mi.) to the east of Castelli.

168. Pricked cartoons, 1700s (fig. 45)

9.9 × 13.4 cm (3⅞ × 5¼ in.). Good, slight staining.

Recto: Substitute cartoon of a putto tying up a baby, possibly Eros binding Anteros; pricked for transfer and later delineated in pen and ink. Single pinholes near the edges of the sheet suggest that it and another piece of paper were pinned together at one time.

Verso: Partially completed substitute cartoon of what appears to be a young boy playing a violin; pricked for transfer. Attached to the right edge is the remnant of a paper flange.

It is likely that the recto and verso cartoons were pricked over one another by mistake.

169. Drawing, 1700s (fig. 46)

11.9 × 17.6 cm (4⅝ × 6⅞ in.). Good, loss to the center of the drawing due to the corrosive properties of the ink.

Recto: Drawing in pen and ink of three putti holding aloft a papal tiara and two keys. The corners of the sheet have been rounded.

Verso: Attached to the right edge is the remnant of a paper flange.

170. Pricked cartoon, late 1600s–early 1700s (fig. 47, pl. 2)

13.7 × 19.7 cm (5⅜ × 7¾ in.). Fair, some insect and other staining, right and left edges frayed.

Recto: Drawing or, more likely, a substitute cartoon delineated after pricking, executed in pen and ink with some gray wash over traces of black chalk and depicting two satyrs blowing *buccine* (long, curved horns) followed by a winged female figure holding a basket of fruit; pricked for transfer; lightly rubbed with black pounce. Single pinholes along the top and bottom edges of the sheet suggest that it and another piece of paper were pinned together at one time. This page forms a continuous pattern with nos. 166 and 171.

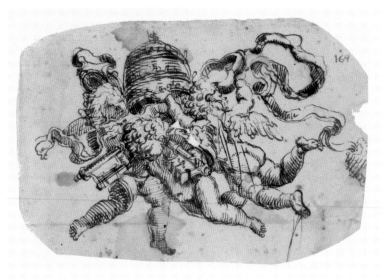

Fig. 45. Pricked cartoon, 1700s
See no. 168

Fig. 46. Drawing, 1700s
See no. 169

The female figure (without wings) and the satyr on the far right appear on a Castelli plate signed "*GENTILI*" and attributed to Carmine Gentili in the Museo di San Martino, Naples (pl. 3; 1690s–1760s, 29 cm [11⅜ in.] diam.; Fittipaldi 1992, 1: 131 [entry no. 213], 2: 134 [nos. 213a, 213b]). Among the Gentili papers at the Istituto Statale d'Arte "F. A. Grue" per la Ceramica, Castelli, is a pricked cartoon for the other figures that appear on this plate: the two hippocampi with their putti riders, and, separately, the standing putto.

On two Castelli ceramics also attributed to Carmine Gentili, a Triton blowing a *buccina* and twisted so that his back is visible appears with Galatea holding billowing drapery and seated, with a putto in her lap, on a shell drawn by two fish; the Triton is very similar to the satyrs of nos. 166 and 170, while Galatea is after the engraving *Venus Accompanied by Cupids, Carried on the Sea by Dolphins* by Agostino Carracci (1557–1602) (Bartsch 18.108.129). On the plate in the Museo di San Martino, Naples (1690s–1760s, 28.8 cm [11⅜ in.] diam.; Fittipaldi 1992, 1: 120 [entry no. 157], 2: 113 [no. 157]), the image is painted on the boss, and the pricked cartoon for this particular rendering is among the Gentili papers at the Istituto Statale d'Arte "F. A. Grue" per la Ceramica, Castelli (Arbace 1998, 72–73 [entry no. II/9]). The two putti who flank Venus in Carracci's print have been added to the image on the other ceramic, a roundel in the Museo delle Ceramiche, Castelli (1730–1740, 18.5 cm [7¼ in.] diam.; Arbace 1998, 72–73 [entry no. II/9B]).

Among the Istituto's Gentili papers are two other pricked cartoons with figures very similar but not identical to the figures on the ceramics and on nos. 166, 170, and 171. One has four seemingly separate scenes: the Triton who appears with Galatea on the two ceramics, a fish similar to those pulling Galatea's shell on the two ceramics, a Triton carrying a basket of fruit who is very like the satyr carrying a basket of fruit on no. 166, and a female figure holding a trident and riding on a hippocampus reminiscent of the one ridden by a putto on no. 171. The other has a satyr carrying a basket of fruit who is, again, similar to that on no. 166, next to two sea creatures pulling a sledge on which only a putto carrying three lilies is visible. Also worth mentioning here are two pricked cartoons that were in the collection of the late Lello Moccia, Pescara (Battistella 1989, figs. 10, 11). One, which was attributed to Carmine Gentili, displays a putto or a small Triton blowing a *buccina* and a seated Triton holding a trident whose torso is twisted so that only his back is visible (cf. the satyr of no. 170, the female satyr of no. 171, as well as the Triton who appears with Galatea on the Istituto's cartoon and the two ceramics). On the other cartoon, this seated Triton appears in the company of Mercury, Neptune, Amphitrite, and two dogs.

The quality of the line on this sheet and the fact that certain elements—for example, the female figure's wings, the feathers in one satyr's hair—were drawn but left unpricked suggest that no. 170 is an original drawing,

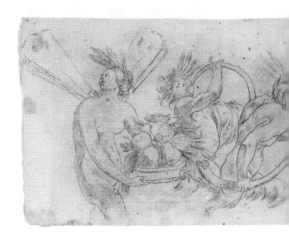

Fig. 47. Pricked cartoons, late 1600s–early 1700s
See nos. 170, 171, 166

as does the fact that none of the small, delicate, closely placed pricked holes have been disturbed by a pen. However, the occurrence of very similar or identical figures on the Castelli ceramics and on the other pricked cartoons implies that all of the figures may derive from the same unidentified print source.

Verso: Attached to the right edge is the remnant of a paper flange.

Watermark: Partial mark of a crowned bird or double-headed eagle within a circle.

171. **Pricked cartoon, late 1600s–early 1700s** (fig. 47)

13.6 × 21 cm (5⅜ × 8¼ in.). Fair, some insect and other staining, tears along the right and left edges.

Recto: Drawing or, more likely, a substitute cartoon delineated after pricking, executed in pen and ink and depicting a female satyr facing a putto who is riding a hippocampus and balancing a basket of fruit on his back; pricked for transfer; lightly rubbed with black pounce. Single pinholes at the corners of the sheet suggest that it and another piece of paper were pinned together at one time. This page forms a continuous pattern with nos. 166 and 171.

The quality of the line and the fact that certain elements—for example, the end of satyr's drapery from no. 166—were drawn but left unpricked suggest that no. 171 is an original drawing, as does the fact that none of the small, delicate, closely placed pricked holes have been disturbed by a pen. However, the occurrence of very similar figures on three Castelli

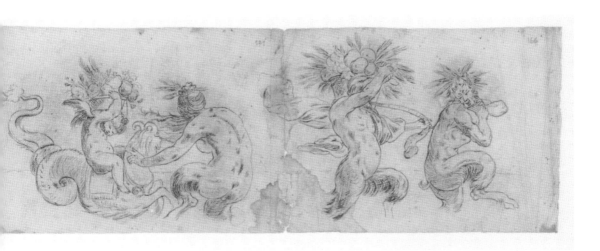

ceramics attributed to Carmine Gentili and on several pricked cartoons—
four among the Gentili papers at the Istituto Statale d'Arte "F. A. Grue"
per la Ceramica, Castelli, and two that were in the collection of the late
Lello Moccia, Pescara—implies that all of the figures may derive from the
same unidentified print source. See no. 170 for discussion of the ceramics
and the other pricked cartoons.

Verso: Attached to the right edge is the remnant of a paper flange.

172. **Pricked cartoon, 1700s**

18 cm (7⅛ in.) diam. Good, slight staining.

Recto: Circular substitute cartoon of Venus and Anchises attended by
Cupid, after an engraving after the fresco executed by Annibale Carracci
(1560–1609) on the vault of the Galleria Farnese, Rome; pricked for trans-
fer and later delineated in pencil; heavily rubbed with black pounce. This
cartoon and no. 191 were taken from the same source and have the same
dimensions but display different prickings; no. 191 also includes a mask in
the foreground (see fig. 56).

Numerous prints copying the Galleria Farnese frescoes have been pro-
duced. The size and disposition of the figures in this cartoon suggest that
it may have been pricked from one of a series of forty aquatints executed
by Carlo Cesi (1626–1686) after the Carracci frescoes and published by
Arnold van Westerhout (1651–1725) (*Annibale Carracci e i suoi incisori*
1986, 129 [entry no. 2]).

Similar images appear on a small Castelli plate attributed to Giacomo II

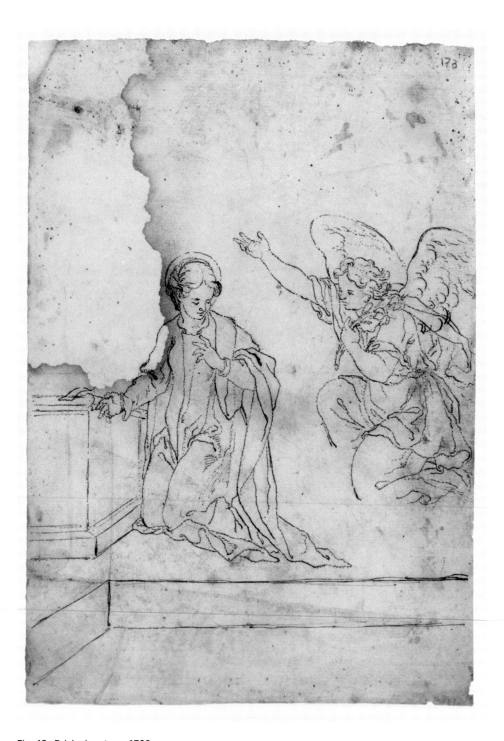

Fig. 48. Pricked cartoon, 1700s
See no. 173

Gentili in the Museo di San Martino, Naples (1700s, 17.9 cm [7 in.] diam.; Fittipaldi 1992, 1: 143 [entry no. 270], 2: 162 [no. 270]) and on a Castelli plaque attributed to Liborio Grue in the Musée Rolin, Autun (1750–1755, 23.7 × 32.2 cm [9⅜ × 12⅝ in.]; Blazy 1992, 15 [entry no. 5]).

Verso: Lightly rubbed with graphite to delineate the pricked image.

Watermark: Illegible mark including four capital letters.

173. **Pricked cartoon, 1700s** (fig. 48)

27.4 × 19 cm (10¾ × 7½ in.). Good, some water damage.

Drawing or, more likely, a substitute cartoon delineated after pricking, executed in pen and ink and depicting the Annunciation; pricked for transfer. Pinholes perforate the sheet at the center of the top and bottom edges.

None of the small, delicate, closely placed pricked holes have been disturbed by a pen, which seems to indicate that this is a pricked drawing; however, with the exception of the Virgin's halo and the edge of the platform in the foreground, the drawing is limited to the pricked image and the line is rather halting relative to the pricking, which suggest that this is a pricked cartoon that was sketched in later.

Watermark: Fleur-de-lis within a double circle.

174. **Pricked cartoon, 1700s**

27 × 20 cm (10⅝ × 7⅞ in.). Fragile, torn and incomplete, tears along the top edge.

Part of a substitute cartoon of the triumph of Galatea, after the right half of the image by Antoine Coypel (1661–1722) engraved by Coypel and Charles I Simonneau (1645–1728) in 1694 (Wildenstein 1964, fig. 46); pricked for transfer and later delineated in pencil; lightly rubbed with black pounce. Single pinholes perforate the sheet along the right side and the top and bottom edges.

The remainder of this cartoon is among the Gentili papers at the Istituto Statale d'Arte "F. A. Grue" per la Ceramica, Castelli (Arbace 1998, 16 [Album XX, 12]). The complete cartoon includes Galatea, four putti, three Nereids, and a Triton. The same group of figures appears on another pricked cartoon at the Istituto (Arbace 1998, 63 [entry no. II/3]), but the prickings of these two cartoons do not match. The pricking of two of the figures (the Triton and the Nereid he is clutching) in the Istituto's cartoon matches that of a third cartoon at the Istituto. In addition to the Triton and his Nereid, this third cartoon displays a group of three Nereids after another section of Coypel's engraving, and this group also appears, together with two Tritons from an unidentified source, on a fourth cartoon at the Istituto; the prickings of these groups of Nereids do not match, however. One more cartoon at the Istituto displays the central group from Coypel's engraving, comprising Galatea, a putto, three Nereids, and a Triton (Arbace 1998, 63–64 [entry no. II/4]), as does no. 189 of the Gentili/Barnabei archive; the figures of this fifth cartoon at the Istituto are

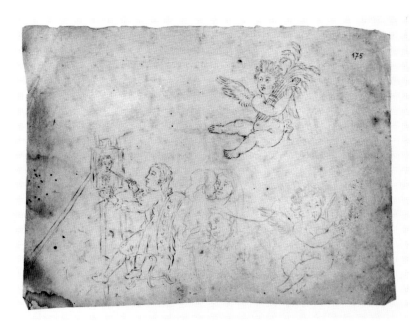

Fig. 49. Drawings, 1700s
See no. 175

Fig. 50. Drawings, 1700s
See no. 175 verso

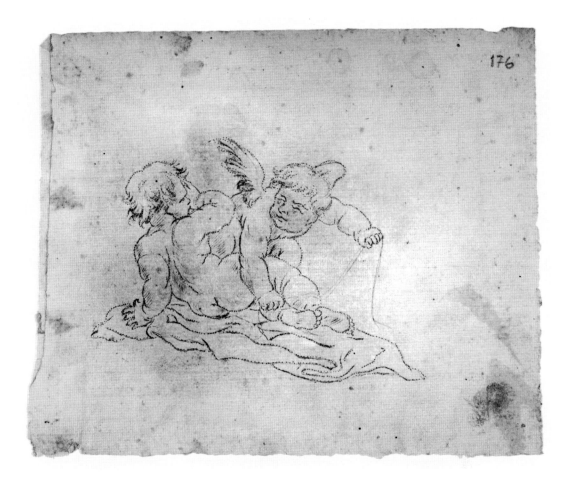

Fig. 51. Pricked cartoon, 1700s
See no. 176

smaller than those of the other cartoons after Coypel's engraving. The prickings of nos. 174 and 189 do not match.

The central figures from Coypel's engraving (Galetea, a putto, three Nereids, and a Triton), with three putti in clouds added in the upper left and four Tritons rearranged from the print source added below, appear on a Castelli plate by Carmine Gentili in the Museo Civico, Padua (1700s, 48.8 cm [19¼ in.] diam.; Polidori 1949, pl. 29 top).

175. **Drawings, 1700s** (figs. 49, 50)

20 × 27 cm (7⅞ × 10⅝ in.). Fair, some staining and foxing.

Recto: Sketches in pencil of two putti, an artist painting seated at an easel, and two versions of a couple kissing; the artist and one putto were drawn again later in pen and ink.

Verso: Sketches in pencil of three goat heads, three horse heads, five couples kissing, a pair of legs, and a church steeple and a tree.

Watermark: Crowned shield with illegible letters below.

176. **Pricked cartoon, 1700s** (fig. 51)

13.5 × 16.5 cm (5¼ × 6½ in.). Good, some staining, edges somewhat frayed.

Recto: Drawing or, more likely, a substitute cartoon delineated after pricking, executed in pen and ink and depicting a putto tying up a baby, possibly Eros binding Anteros; pricked for transfer; moderately rubbed with black pounce. Single pinholes near the edges of the sheet suggest that it and another piece of paper were pinned together at one time.

None of the small, delicate, closely placed pricked holes have been disturbed by a pen, which seems to indicate that this is a pricked original drawing; however, the hesitation of the ink line relative to the pricking suggests that this is a pricked cartoon that was sketched in later.

Verso: Attached to the right edge is the remnant of a paper flange.

177. **Pricked cartoon, 1700s**

13 × 19.7 cm (5⅛ × 7¾ in.). Good, some water damage.

Recto: Substitute cartoon of Venus with a putto and Eros blindfolding Anteros, after the engraving *Venus in a Garden with Putti* by Pietro Testa (1611–1650) (Bartsch 20.222.26); pricked for transfer and later delineated in pen and ink; moderately rubbed with black pounce. Single pinholes at three of the sheet's four corners suggest that it and another piece of paper were pinned together at one time.

Two identical but reversed substitute cartoons of the same scene augmented with four more of the putti from Testa's engraving appear on a sheet among the Gentili papers at the Istituto Statale d'Arte "F. A. Grue" per la Ceramica, Castelli (Arbace 1998, 44 [entry no. I/7A]). The images were produced by pricking the source over the folded sheet; one of these substitute cartoons has been delineated in pen and ink with more shading and more hesitation of line than no. 177 displays.

Pl. 1. Engraving, late 1600s
See no. 9

91

**Pl. 2. Backlit view of a pricked cartoon,
late 1600s–early 1700s**
See no. 170

Pl. 3. Attributed to Carmine Gentili
Plate from Castelli decorated after the cartoon shown in
pl. 2, tin-glazed earthenware, 29 cm (11⅜ in.) diam.,
1690s–1760s
Naples, Museo di San Martino

93

**Pl. 4. Drawing, pen and ink, blue wash, and pencil,
late 1600s–1700s**
See no. 182

182

**Pl. 5. Drawing, pen and ink and blue wash,
late 1600s–1700s**
See no. 182

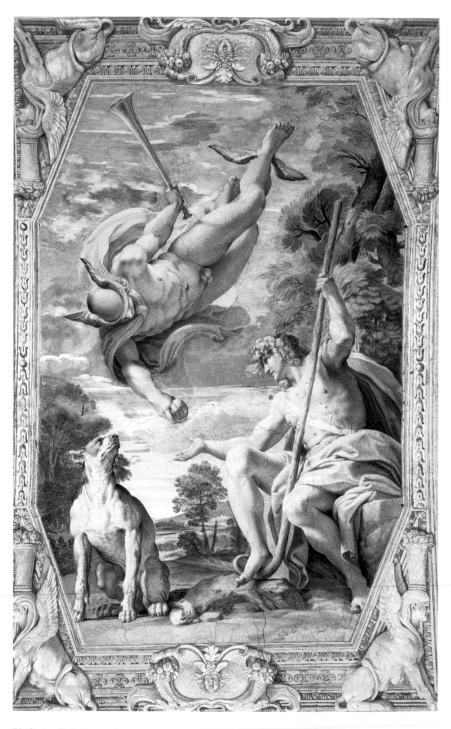

Pl. 6. Annibale Carracci
Mercury and Paris, fresco, circa 1600
Rome, Galleria Farnese

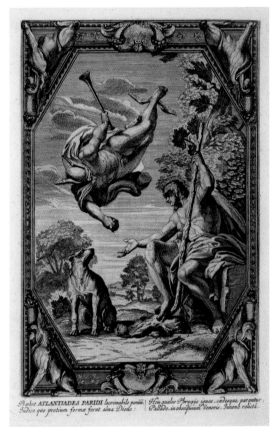

Pl. 7. Karl Remshard (after Pietro Aquila after Annibale Carracci)
Atlantiades Paridi (Mercury and Paris), engraving, 23.4 × 15.2 cm (9¼ × 6 in.), circa 1700
From Annibale Carracci, *Galeriae Farnesianae icones romae in aedibus sereniss. ducis Parmensis* (Augsburg: Johann Ulrich Krausen, 1700)

Pl. 8. Backlit view of a pricked cartoon after the engraving shown in pl. 7, late 1600s–early 1700s
See no. 183

Pl. 9. Attributed to Carmine Gentili
Plate from Castelli decorated after the engraving shown in pl. 7, tin-glazed earthenware, 24.7 cm (9¾ in.) diam., 1690s–1760s
Naples, Museo di San Martino

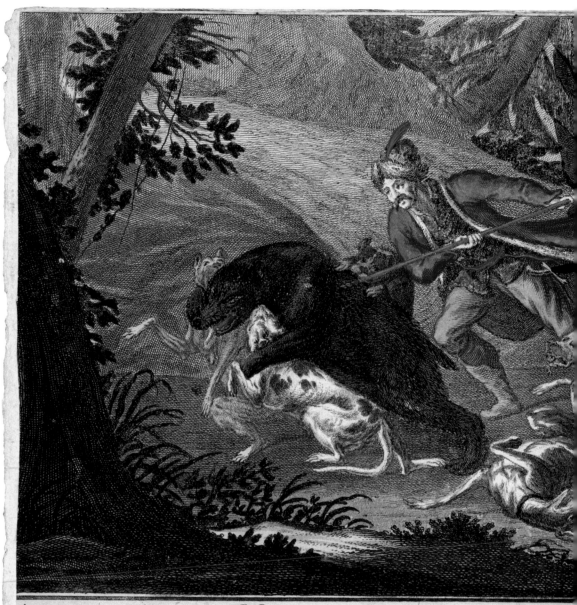

vix usquam reperitur sævior Ursis,
...ecat amplexu, dilaceratque canes;
...i succurrit præsenti morte sarissâ
...nata, succumbunt, quotquot adire parant.
...v. Sac. Cæs. Maj.

Ursorum Insectatio
Die Bären-Hatz.

Da ge...
Es...
Das ih...
Bj...

Johann Elias Rüdinger delineavit.

Pl. 10. Pricked watercolored engraving, 1700s
See no. 206

Pl. 11. Sheet of a musical score, 1700s
See no. 206 verso

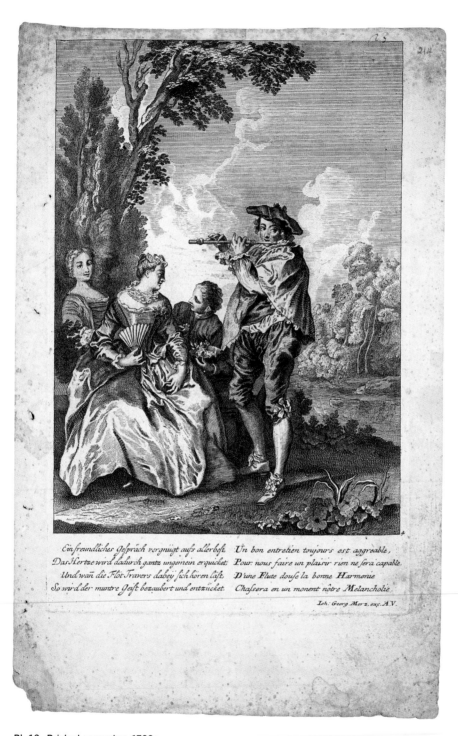

Ein freundliches Gespräch vergnügt aufs allerbest, Un bon entretien toujours est aggreable,
Das Hertze wird dadurch gantz ungemein erquicket; Pour: nous faire un plaisir rien ne sera capable.
Und wan die Flöt Travers dabey sich hören laßt, D'une Flute douse la bonne Harmonie
So wird der muntre Geist bezaubert und entzücket. Chassera en un moment nôtre Melancholie.

Joh: Georg Merz, exc. A.V.

Pl. 12. Pricked engraving, 1700s
See no. 214

Pl. 13. Backlit view of the engraving shown in pl. 12

Pl. 14. Attributed to Carmine Gentili
Plate from Castelli decorated after the engraving shown in
pl. 12, tin-glazed earthenware, 24 cm (9½ in.) diam.,
1690s–1760s
Naples, Museo di San Martino

Pl. 15. Pricked engraving, early 1700s
See no. 217

Pl. 16. Bartolomeo Terchi
Plaque from Bassano Romano decorated after the
engraving shown in pl. 15, tin-glazed earthenware,
53 × 51 cm (20⅞ × 20⅛ in.), 1739
Bassano Romano, Comunale

Pl. 17. Pricked engraving, late 1600s–early 1700s
See no. 232

Pl. 18. Attributed to Carmine Gentili
Plate from Castelli decorated after the engraving shown in
pl. 17, tin-glazed earthenware, 41.6 cm (16⅜ in.) diam.,
1690s–1760s
Naples, Museo di San Martino

Pl. 19. Pricked drawing, pencil, black chalk or crayon, and watercolor, 1874
See no. 270

Pl. 20. Backlit detail of the pricked repeating palmettes in the drawing shown in pl. 19

Verso: Attached to the right edge is the remnant of a paper flange.

Watermark: Partial mark of an anchor within a circle, with the letter *V* below. For discussion of this watermark, see no. 27.

178. Pricked cartoon, 1700s

12.8 cm (5 in.) diam. Good, slight staining and foxing.

Circular substitute cartoon of a dancing girl in peasant dress; very faintly pricked for transfer, possibly under several sheets of paper, and later lightly delineated in pencil, with a circular outline in pen and ink; moderately rubbed with black pounce.

179. Pricked drawing, 1700s (fig. 52)

26.2 × 19.1 cm (10¼ × 7½ in.). Good, slight staining, some wear along the creases.

Drawing in red chalk of an emblem comprising an oval frame that has flourishing scrolls, a rampant lion finial, and a banderole displaying the words "*CAROLUS SAPROCCUS*" and encloses a crescent mounted on a pedestal above an elephant standing in profile on three mounds; pricked for transfer, except the words on the banderole; lightly rubbed with black pounce. After the left half of the design was drawn on the left side of the recto, the right half of the sheet was folded under the left and the symmetrical elements of the drawing were pricked; the symmetrical elements of the right half of the design were then drawn on the basis of the pricking. The crescent and its pedestal and the nonsymmetrical elements (rampant lion, elephant) were sketched and pricked while the sheet was unfolded.

180. Pricked cartoon, 1700s

13.3 × 14.3 cm (5¼ × 5⅝ in.). Fragile, water damage, some tearing along the pricking, some losses to the top edge.

Oval substitute cartoon after the engraving *Orpheus and Eurydice* by Agostino Carracci (1557–1602) (Bartsch 18.107.123); very faintly pricked for transfer, possibly under several sheets of paper; heavily rubbed with black pounce.

This image appears on a Castelli plate in the Walters Art Gallery, Baltimore (mid-1700s, 18.5 cm [7¼ in.] diam.; von Erdberg and Ross 1952, 42–43 [entry no. 84]).

181. Pricked cartoon and business letter, late 1600s–early 1700s

27.9 × 20.3 cm (11 × 8 in.). Fair to poor, staining, ink damage, torn and incomplete.

Recto: Part of a substitute cartoon of the triumph of Neptune and Amphitrite, after the right half of an engraving by Philippe Thomassin (1562–1622) after a painting by Jacopo Zucchi (circa 1541–1589/1590) and published by Giovanni Giacomo de Rossi (1627–1691) (see fig. 76);

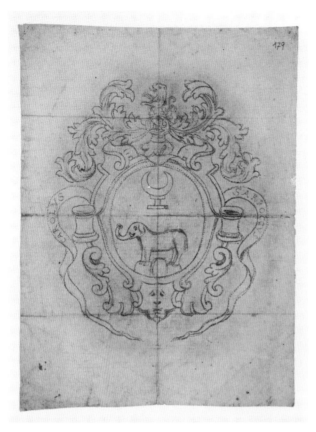

Fig. 52. Pricked drawing, 1700s
See no. 179

pricked for transfer; heavily rubbed with black pounce. Single pinholes near the edges of the sheet suggest that it and another piece of paper were pinned together at one time. No. 238 was the source for this cartoon, because they display the same pricking and many of the single pinholes match.

The engraving served as the source for the decoration on several extant ceramics: slightly different versions of Neptune on a team of hippocampi and accompanied by Nereids appear on a Castelli plate by Francesco Antonio I Grue that is in the Musée du Louvre, Paris (circa 1650–1673, 24.7 cm [9¾ in.]; Giacomotti 1974, 471 [entry no. 1383]; Giacomotti 1977, fig. 5) and on a plate attributed to Ferdinando Maria Campani (circa 1702–1771), probably while he was working in Siena, that is in the Ashmolean Museum, Oxford (circa 1730–1740, 32.5 cm [12¾ in.] diam.;

Wilson 1989, 76–77 [entry no. 34]); Neptune on a team of hippocampi, two Tritons, and two Nereids appear on a plate from the Terchi factory in Siena by Ferdinando Maria Campani (circa 1702–1771) that is in the Kunstgewerbemuseum, Berlin (see fig. 77; circa 1740, 32.6 cm [12⅞ in.] diam.; Pelizzoni and Zanchi 1982, 82 [entry no. 69]); and Neptune on a team of hippocampi appears on a plate from the factory in what is now Holič, Slovakia (circa 1750, 25 cm [9⅞ in.] diam.; Christie's, London, 2 October 1989, lot 29).

Verso: Part of a business letter that includes an order for teacups and saucers, with a notation in a different hand naming Stefano Cappelletti, both handwritten in pen and ink.

182. Drawings, late 1600s–1700s (pls. 4, 5)

42 × 60 cm (16½ × 23⅝ in.). Good, some foxing, slight losses along the creases.

Elegantly rendered drawings in pen and ink and blue wash of, on the left half of the sheet, a cistern with a basin lightly sketched in ink and pencil below the spout and, on the right half, a vase. Decorating the surfaces are garlands, gadrooning, human figures, putti, and leaf embellishments, and the forms are reminiscent of metalwork shapes and of seventeenth-century Ligurian maiolica cisterns.

Watermark: Cross above three vertically stacked circles enclosing, respectively, top to bottom, a crescent, a heart or a single leaf, and the letter *D*, with the letter *I* in the lower right corner of the sheet and a curious leg-shaped mark in the lower left corner.

183. Pricked cartoon, late 1600s–early 1700s (pl. 8)

26.4 × 19.3 cm (10⅜ × 7⅝ in.). Fair; slight insect and other staining and foxing.

Recto: Substitute cartoon of Mercury with the apple of Discord and Paris with his dog, after an engraving after the fresco executed by Annibale Carracci (1560–1609) on the vault of the Galleria Farnese, Rome (pl. 6); pricked for transfer; heavily rubbed with black pounce. Single pinholes near the edges of the sheet suggest that it and another piece of paper were pinned together at one time. The cartoon was cut radially five times so that it could be fitted onto a concave surface.

Numerous prints copying the Galleria Farnese frescoes have been produced. The size and disposition of the figures in this cartoon suggest that it may have been pricked either from one of a series of forty aquatints executed by Carlo Cesi (1626–1686) after the Carracci frescoes and published by Arnold van Westerhout (1651–1725) (*Annibale Carracci e i suoi incisori* 1986, 130 [entry no. 4]) or from one of a series of engravings by Karl Remshard (1678–1735) after Pietro Aquila (circa 1650–1692) after the Carracci frescoes; the latter seems more likely given the truncation of Paris's right foot in both the cartoon and Remshard's engraving (pl. 7).

The image appears on a Castelli plate attributed to Carmine Gentili in the Museo di San Martino, Naples (pl. 9; 1690s–1760s, 24.7 cm [9¾ in.] diam.; Fittipaldi 1992, 1: 125 [entry no. 182], 2: 124 [no. 182]) that belongs to a service of plates that all display the same coat of arms. Six of the thirty-seven plates from this service in the Museo di San Martino's collection (Fittipaldi 1992, entry nos. 182, 188, 209–11, 224; for the other plates, see his entry nos. 166, 183–87, 189–95, 198–208, 216–19, 225, 230, 231) are decorated with images that appear in the Gentili/Barnabei archive (nos. 183, 207, 213, 214, 231, 235). For a brief discussion of this service, which mentions additional plates from the service in the Museo Nazionale della Ceramica "Duca di Martina," Naples, and describes the coat of arms as belonging to an unidentified Neapolitan noble family, see Arbace 1996, 152, 158 (entry no. 219).

Other ceramics decorated with this image include an *alzata* (footed dish) lacking the figure of Mercury holding the apple of Discord that is attributed either to Castelli or to Antonio Terchi (active 1726), probably while he was working in Bassano Romano, in the Kunstgewerbemuseum, Berlin (circa 1730–1750, 33.1 cm [13 in.] diam.; Hausmann 1972, 377–78 [entry no. 284]; Pelizzoni and Zanchi 1982, 117 [entry no. 115]); a plate by Ferdinando Maria Campani (circa 1702–1771), while he was working in Siena, in the Victoria and Albert Museum, London (circa 1735–1745, 33.4 cm [13⅛ in.] diam.; Pelizzoni and Zanchi 1982, 89 [entry no. 76]; Rackham 1940, 1: 390 [entry no. 1180], 2: pl. 189 [no. 1180]); and a Castelli plate that was offered for sale in 1976 (mid-1700s, 22.5 cm [8⅞ in.] diam.; Sotheby's, London, 8 April, lot 45).

Verso: Lightly rubbed with black pounce.

184. Pricked cartoon and drawings, late 1600s–early 1700s (fig. 53)

18.4 × 26.1 cm (7¼ × 10¼ in.). Good, some water damage.

Substitute cartoon after the engraving *Bear Hunt* from *Hunting Scenes IV* by Antonio Tempesta (1555–1630) (Bartsch 17.166.1132); pricked for transfer and later delineated in pen and ink; moderately rubbed with black pounce. Single pinholes along the bottom edge of the sheet and above the image suggest that it and another piece of paper were pinned together at one time. The two finely rendered pen-and-ink sketches of a horse's head to the left of the scene may be alternate renderings of the horse on the left of Tempesta's hunting scene. No. 219 (see fig. 65) is a partially pricked print of this Tempesta engraving, but this cartoon was not pricked from no. 219 because the prickings differ.

185. Pricked cartoon, late 1600s–early 1700s (fig. 54)

23 × 31.2 cm (9 × 12¼ in.). Good, some water damage.

Recto: Substitute cartoon of the triumph of Neptune and Amphitrite, after an engraving by Michel Dorigny (1617–1665) after a painting executed by Simon Vouet (1590–1649) for the vestibule of the Galerie de la

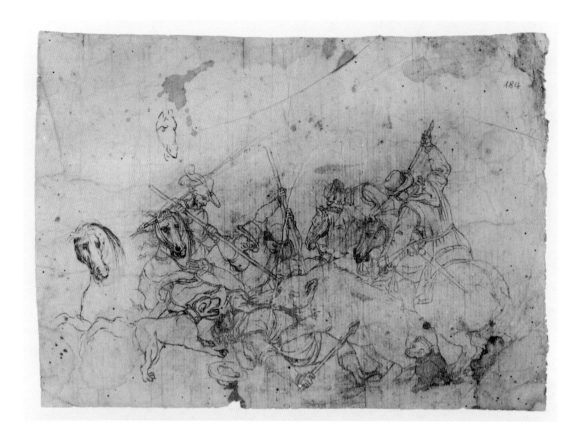

**Fig. 53. Pricked cartoon and drawings, late 1600s–
early 1700s**
See no. 184

Fig. 54. Pricked cartoon, late 1600s–early 1700s
See no. 185

Reine at the Château de Fontainebleau (Robert-Dumesnil 1967, 4: 287–89 [entry no. 98]; Fittipaldi 1992, 1: fig. 24); pricked for transfer and later delineated in pen and ink; lightly rubbed with black pounce. Single pinholes along the bottom and right edges of the sheet suggest that it and another piece of paper were pinned together at one time. This cartoon and no. 200 were pricked together from the same source, because they display the same pricking.

This image appears on a globular vase attributed to the Manardi workshop, Angarano, in the Musée des Beaux-Arts, Dijon (late 1600s–early 1700s, H: 43 cm [16⅞ in.], 24 cm [9½ in.] diam.; Barral 1987, 126–67 [entry no. 38]); a Castelli plaque attributed to the Gentili workshop in the Musée des Beaux-Arts, Lyon (1700s, 21 × 27 cm [8¼ × 10⅝ in.]; Blazy 1992, 54 [entry no. 38]); a Castelli plaque signed "*GENTILI P.*" in the Museo di San Martino, Naples (1700s, 23.2 × 32 cm [9⅛ × 12⅝ in.]; Fittipaldi 1992, 1: 138–39 [entry no. 248], 2: 153 [no. 248]); and a Castelli plate attributed to Carmine Gentili in the Museo Nazionale della Ceramica "Duca di Martina," Naples (circa 1740, 24.6 cm [9⅝ in.] diam.; Arbace 1996, 152, 158 [entry no. 219]).

This last belongs to a service of plates that all display the same coat of arms. Six of the thirty-seven plates from this service in the Museo di San Martino's collection (Fittipaldi 1992, entry nos. 182, 188, 209–11, 224; for the other plates, see his entry nos. 166, 183–87, 189–95, 198–208, 216–19, 225, 230, 231) are decorated with images that appear in the Gentili/Barnabei archive (nos. 183, 207, 213, 214, 231, 235). For a brief discussion of this service, which mentions additional plates from the service in the Museo Nazionale della Ceramica "Duca di Martina," Naples, and describes the coat of arms as belonging to an unidentified Neapolitan noble family, see Arbace 1996, 152, 158 (entry no. 219).

Verso: Attached to the right edge is the remnant of a paper flange.

Watermark: Partial mark of a six-pointed star within a double circle.

186. **Pricked cartoon, 1700s** (fig. 55)

26.5 × 28.9 cm (10⅜ × 11⅜ in.). Relatively fragile, some water damage, tears along the creases, holes in the sheet that apparently were repaired with a filler.

Substitute cartoon of David mourning the death of Saul and the execution of the Amalekite, after an engraving by Jan I Sadeler (1550–1600) after a drawing by Maarten de Vos (1532–1603) (Fittipaldi 1992, 1: fig. 30); pricked for transfer and later delineated and bordered with thick double lines in pen and ink; lightly rubbed with black pounce. Single pinholes near the edges of the sheet suggest that it and another piece of paper were pinned together at one time. "*Spolvero per matonella*" (Pricked cartoon for a tile) is handwritten in pencil at the lower left, probably by the dealer.

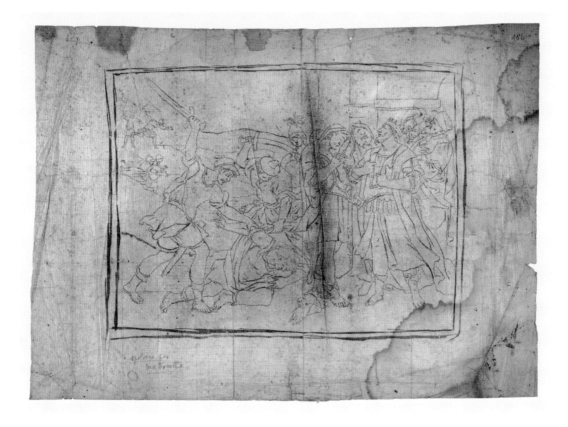

Fig. 55. Pricked cartoon, 1700s
See no. 186

Another pricked cartoon after this print is among the Gentili papers at the Istituto Statale d'Arte "F. A. Grue" per la Ceramica, Castelli, but its pricking differs from that of no. 186.

In the collection of Paparella Treccia, Pescara, is an oval Castelli plaque by Francesco Saverio II Maria Grue, inscribed "*Ingenus Candor*" (Natural moral purity) and signed "*SG*," that is decorated with this scene sans several of the battling figures and set in a landscape (1700s, 30 × 22 cm [11¾ × 8⅝ in.]; Levy 1964, pl. LXXXI; Jestaz 1973, 112, figs. 5, 6). Apparently from the same series as this are the following three ceramics: a Castelli plaque in the collection of Paparella Treccia, Pescara, inscribed "*Sapiens Senectus*" (Wise old age) and attributed to Francesco Saverio II Maria Grue, that is decorated after print no. 46 in the series *Story of David* by Philipp Galle (1537–1612) (1700s, 30 × 22 cm [11¾ × 8⅝ in.]; Levy 1964, pl. LXXX; Jestaz 1973, figs. 1, 2); a Castelli plaque by Francesco Saverio II Maria Grue, inscribed "*Nimia Lenitas*" (Great gentleness) and signed "*SG*," in the Museo di Palazzo Venezia, Rome (1700s; inv. no. 8386); and a Castelli plate depicting David's entry into Jerusalem attributed to Candeloro Cappelletti (1689–1772) in the Museo di San Martino, Naples (1700s, 41.2 cm [16¼ in.] diam.; Fittipaldi 1992, 1: 148 [entry no. 288], 2: 173 [no. 288]).

Watermark: Six-pointed star within a double circle, with the letter *M* above and the letter *V* below.

187. Pricked cartoon and business letter, 17[46?]

19.9 × 27.9 cm (7⅞ × 11 in.). Two large cuts in the sheet extend downward from the top edge, a large tear in the lower half was repaired with what appears to be glue.

Recto: Substitute cartoon of a reclining woman shielding her face with drapery and a child holding a bird, possibly a Madonna and child; pricked for transfer; rubbed with black pounce. What may be pinholes perforate the sheet along the top and bottom edges.

Verso: Letter from Carmine Gentili, handwritten in pen and ink and bearing the dateline Castelli, 17[46?], in which he mentions a maiolica order: "*Per le mani delli stessi venditore gli rimetto la consaputa donzana de piattini e chiccare secondo li comandi di V.S.*" (Following your instructions, I gave the seller back those twelve saucers and teacups). "*Carmine Gentili*" is handwritten in pencil at the top of the letter, presumably by the dealer.

Watermark: Bird in profile above three hills and flanked on each side by the letter *V*, all enclosed within a circle.

188. Pricked cartoon, late 1600s–1700s

19.8 × 13.3 cm (7¾ × 5¼ in.). Good, slight staining, slight ink damage.

Recto: Drawing or, more likely, a substitute cartoon delineated in brush and ink after pricking of an emblem with a putto holding a shield

that displays a dragon above a crescent moon; very faintly pricked for transfer, possibly under several sheets of paper; rubbed with black pounce. The sheet was cut radially twelve times so that it could be fitted onto a concave surface.

Not only is the pricking very faint but the ink seems to have seeped through the pricked holes to the verso, which suggests that the image was first pricked and then drawn.

Verso: Lightly rubbed with graphite to delineate the pricked image.

Watermark: Partial mark of a bird within a circle.

189. Pricked cartoon, 1700s

27 × 30.2 cm (10⅝ × 11⅞ in.). Good, a small piece of paper covers the tear in the sheet, some water damage to the lower half, tears along the edges.

Recto: Roughly circular substitute cartoon of the triumph of Galatea, after the central grouping of an image by Antoine Coypel (1661–1722) engraved by Coypel and Charles I Simonneau (1645–1728) in 1694 (Wildenstein 1964, fig. 46); pricked for transfer and later delineated in pen and light black ink (possibly ballpoint); heavily rubbed with black pounce. The putto holding a torch is an unpricked rendering in pen and ink of a putto from the upper right of Coypel's engraving.

The figures of this cartoon were taken from the same source as those of no. 174 and of five additional pricked cartoons that are among the Gentili papers at the Istituto Statale d'Arte "F. A. Grue" per la Ceramica, Castelli. The pricking of no. 189 does not match the pricking of any of these other cartoons. A smaller scale version of the image on no. 189 (Galatea, a putto, three Nereids, and a Triton) appears on one of the Istituto's cartoons (Arbace 1998, 63–64 [entry no. II/4]). See no. 174 for discussion of the Istituto's cartoons.

This image, with three putti in clouds added in the upper left and four Tritons rearranged from the print source added below, appears on a Castelli plate by Carmine Gentili in the Museo Civico, Padua (1700s, 48.8 cm [19¼ in.] diam.; Polidori 1949, pl. 29 top).

Verso: Small paper patch.

Watermark: Six-pointed star within a double circle.

190. Pricked cartoon, late 1600s–early 1700s

25.7 × 36.3 cm (10⅛ × 14¼ in.). Fragile; tears along the edges, creases, and pricking; some of the holes in the sheet were apparently repaired with a filler.

Substitute cartoon after the engraving *The Fall of Jericho* by Antonio Tempesta (1555–1630) (Bartsch 17.130.245); pricked for transfer and later delineated in pen and ink; very lightly rubbed with black pounce. Single pinholes along the top and bottom edges of the sheet suggest that it and another sheet of paper were pinned together at one time.

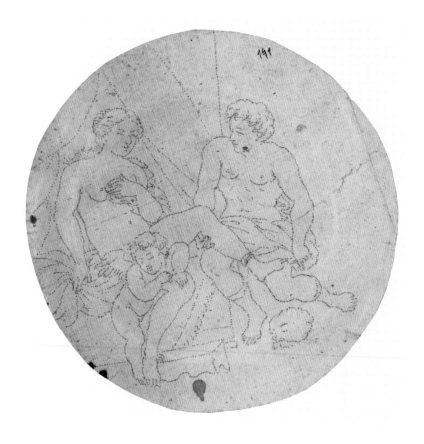

Fig. 56. Pricked cartoon, 1700s
See no. 191 verso

Watermark: Six-pointed star within a double circle, with what appears to be a cross above.

191. **Pricked cartoon, 1700s** (fig. 56)

18.2 cm (7⅛ in.) diam. Good, slight staining.

Circular substitute cartoon of Venus and Anchises attended by Cupid, after an engraving after the fresco executed by Annibale Carracci (1560–1609) on the vault of the Galleria Farnese, Rome; pricked for transfer; moderately rubbed with black pounce. Pinholes perforate the sheet along the perimeter. This cartoon and no. 172 were taken from the same source and have the same dimensions but display different prickings; the mask in the foreground does not appear in no. 172.

Numerous prints copying the Galleria Farnese frescoes have been produced. The size and disposition of the figures in this cartoon suggest that it may have been pricked from one of a series of forty aquatints executed by Carlo Cesi (1626–1686) after the Carracci frescoes and published by Arnold van Westerhout (1651–1725) (*Annibale Carracci e i suoi incisori* 1986, 129 [entry no. 2]).

Similar images appear on a small Castelli plate attributed to Giacomo II Gentili in the Museo di San Martino, Naples (1700s, 17.9 cm [7 in.] diam.; Fittipaldi 1992, 1: 143 [entry no. 270], 2: 162 [no. 270]), and on a Castelli plaque attributed to Liborio Grue in the Musée Rolin, Autun (1750–1755, 23.7 × 32.2 cm [9⅜ × 12⅝ in.]; Blazy 1992, 15 [entry no. 5]).

Watermark: Anchor within a circle. This mark is similar to a group of marks of Venetian provenance dating from the late 1400s through the late 1500s (Mošin 1973, 17).

192. **Pricked drawing, 1700s**

7.8 × 8.9 cm (3⅛ × 3½ in.). Good, slight staining.

Drawing in pen and ink of the left half of a blank shield against crossed cannons bordered by a cartouche and surmounted by a bird beneath a large crown; pricked for transfer; lightly rubbed with black pounce. To obtain the right half of the design, the drawing was pricked while the right half of the sheet was folded under the left; the sole nonsymmetrical element, the bird's head, is unpricked. The image of this cartoon is very similar to but smaller than that of no. 196 (see fig. 57).

193. **Pricked cartoon, 1700s**

26.4 × 38.8 cm (10⅜ × 15¼ in.). Good, slight staining and foxing.

Substitute cartoon of the triumph of Diana, with six huntresses acting as her attendants; pricked for transfer, with some parts lightly outlined in pen and ink; lightly rubbed with black pounce. Single pinholes near the edges of the sheet suggest that it and another piece of paper were pinned together at one time.

The same image appears on an Italian urn "in Renaissance style" that

was offered for sale in 1996 (1800s, H: 71.1 cm [28 in.]; Sotheby's, New York, 2 November, lot 113).

Watermark: Six-pointed star within a double circle.

194. Pricked cartoon and business letter, circa 1735

19.9 × 13.8 cm (7⅞ × 5⅜ in.). Good.

Recto: Substitute cartoon of a warrior, wearing a plumed helmet and holding a staff, turning back over his proper left shoulder and seated on a rearing horse; pricked for transfer; heavily rubbed with black pounce. Single pinholes near the edges of the sheet suggest that it and another piece of paper were pinned together at one time.

Verso: Part of a letter from Carmine Gentili, handwritten in pen and ink, with the dateline Castelli, 8 February 173[5?].

195. Pricked drawing, 1700s

18.5 × 15 cm (7¼ × 5⅞ in.). Fair, some insect staining and foxing, slight staining, some ink bleeding through.

Drawing in pen and ink of an elaborately decorated shield and of the left half of its surrounding decoration, which comprises two sets of six cannons, two sets of four flags, and a crowned cartouche; pricked for transfer, with some divergence of the pricking from the drawing; lightly rubbed with black pounce. To obtain the right half of the symmetrical elements (the outline of the shield, the outline of the central decorations, the surrounding decoration), the drawing was pricked while the right half of the sheet was folded under the left; the nonsymmetrical elements (the remaining shield markings) were pricked from the recto while the sheet was unfolded.

196. Pricked drawing, 1700s (fig. 57)

10.2 × 13.5 cm (4 × 5¼ in.). Fair, some insect staining and foxing.

Drawing in pen and ink of the left half of a blank shield against crossed cannons bordered by a cartouche and surmounted by a bird beneath a large crown; pricked for transfer; lightly rubbed with black pounce. To obtain the right half of the design, the drawing was pricked while the right half of the sheet was folded under the left; the sole nonsymmetrical element, the bird's head, is unpricked. "*Sig. Massei*" is handwritten in pen and ink at the upper right. The sheet was cut radially sixteen times so that it could be fitted onto a concave surface. The image of this cartoon is very similar to but larger than that of no. 192.

Watermark: Partial mark of a Spanish coat of arms surmounted by a crown and circumscribed by two necklaces with elaborate links, pendants, and a golden fleece above the word CELAN[?]. It is identified as Italian and appears on documents dated to 1747 (Churchill 1985, CCXXVII [no. 262]) and to 1761–1763 (on the manuscript of the sale of a paper mill at Subiaco, a commune about 50 km [32 mi.] east of Rome; Heawood 1950, pl. 124 [entry no. 803]).

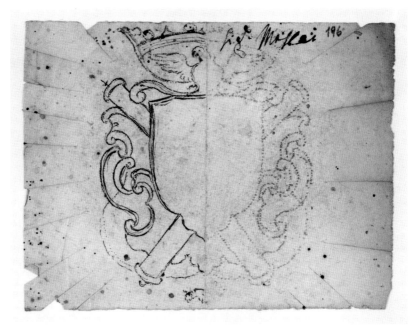

Fig. 57. Pricked drawing, 1700s
See no. 196

197. **Pricked cartoon, 1700s**

19.4 × 26.4 cm (7⅝ × 10⅜ in.). Good, loss to the top edge.

Substitute cartoon of a triumph with a god in a chariot surrounded by at least eight other mythological figures and two putti; pricked for transfer; moderately rubbed with black pounce. Single pinholes near the edges of the sheet suggest that it and another piece of paper were pinned together at one time.

198. **Pricked cartoon, business letter, and envelope, 1688**

20.7 × 29.4 cm (8⅛ × 11⅝ in.). Fair, some insect and other staining, some wear along the creases.

Substitute cartoon after the engraving *Moses Ordering the Israelites to Attack the Ethiopians* by Antonio Tempesta (1555–1630) (Bartsch 17.129. 239); pricked for transfer over part of a letter dated 7 May 1688 and an address for delivery to Giovanni Stefano Urbani, Teramo, both handwritten in pen and ink; heavily rubbed with black pounce. This cartoon was pricked from no. 230, because they display the same pricking and the single pinholes near the edges of the sheets match where they still exist on no. 230.

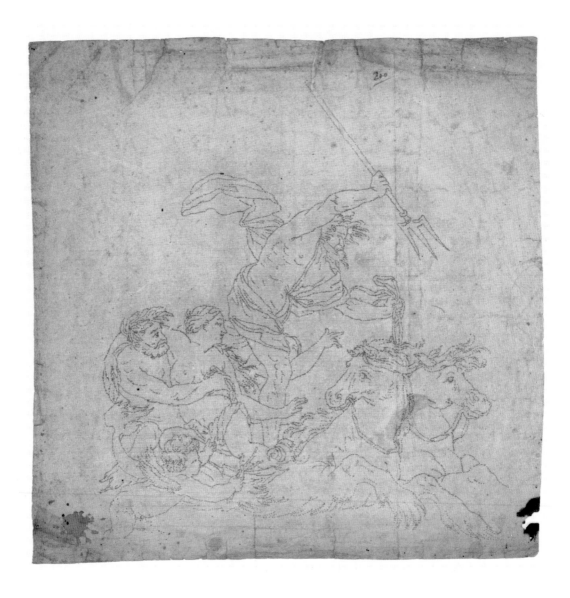

Fig. 58. Pricked cartoon, 1700s
See no. 200 verso

Watermark: Mostly illegible mark including a six-pointed star within a double circle.

199. **Pricked cartoon, late 1600s–early 1700s**

13.1 × 15.5 cm (5⅛ × 6⅛ in.). Good, some water damage.

Oval substitute cartoon of a woman using a distaff seated by two recumbent male peasants, after the eighth in a series of sixteen *Pastorals* designed by Abraham Bloemaert (1564–1651) and engraved by Cornelis Bloemaert (1603–circa 1684) (Hollstein 1949– , 2: 77 [entry no. 213]); pricked for transfer and later lightly delineated in pen and ink.

The same image appears on a small plate attributed to Carmine Gentili in the Museo di San Martino, Naples (1690s–1760s, 17.5 cm [6⅞ in.] diam.; Fittipaldi 1992, 1: 119 [entry no. 154], 2: 111 [no. 154]).

200. **Pricked cartoon, 1700s** (fig. 58)

26.3 × 26.8 cm (10⅜ × 10½ in.). Fragile, tears along the edges.

Substitute cartoon of the triumph of Neptune and Amphitrite, after an engraving by Michel Dorigny (1617–1665) after a painting executed by Simon Vouet (1590–1649) for the vestibule of the Galerie de la Reine at the Château de Fontainebleau (Robert-Dumesnil 1967, 4: 287–89 [entry no. 98]; Fittipaldi 1992, 1: fig. 24); pricked for transfer; heavily rubbed with black pounce. Single pinholes near the edges of the sheet suggest that it and another piece of paper were pinned together at one time. This cartoon and no. 185 were pricked together from the same source, because they display the same pricking.

This image appears on a globular vase attributed to the Manardi workshop, Angarano, in the Musée des Beaux-Arts, Dijon (late 1600s–early 1700s, H: 43 cm [16⅞ in.], 24 cm [9½ in.] diam.; Barral 1987, 126–67 [entry no. 38]); a Castelli plaque attributed to the Gentili workshop in the Musée des Beaux-Arts, Lyon (1700s, 21 × 27 cm [8¼ × 10⅝ in.]; Blazy 1992, 54 [entry no. 38]); a Castelli plaque signed "*GENTILI P.*" in the Museo di San Martino, Naples (1700s, 23.2 × 32 cm [9⅛ × 12⅝ in.]; Fittipaldi 1992, 1: 138–39 [entry no. 248], 2: 153 [no. 248]); and a Castelli plate attributed to Carmine Gentili in the Museo Nazionale della Ceramica "Duca di Martina," Naples (circa 1740, 24.6 cm [9⅝ in.] diam.; Arbace 1996, 152, 158 [entry no. 219]).

This last belongs to a service of plates that all display the same coat of arms. Six of the thirty-seven plates from this service in the Museo di San Martino's collection (Fittipaldi 1992, entry nos. 182, 188, 209–11, 224; for the other plates, see his entry nos. 166, 183–87, 189–95, 198–208, 216–19, 225, 230, 231) are decorated with images that appear in the Gentili/Barnabei archive (nos. 183, 207, 213, 214, 231, 235). For a brief discussion of this service, which mentions additional plates from the service in the Museo Nazionale della Ceramica "Duca di Martina,"

Naples, and describes the coat of arms as belonging to an unidentified Neapolitan noble family, see Arbace 1996, 152, 158 (entry no. 219).

Watermark: Partial mark of a six-pointed star within a double circle above the letter *V*.

201. Pricked cartoon, late 1600s–early 1700s

19.2 × 27.2 cm (7½ × 10¾ in.). Good, some staining and foxing, tears along the left edge.

Substitute cartoon after the illustration engraved by Antonio Tempesta (1555–1630) for canto 17 of *Gerusalemme liberata II* by Torquato Tasso (1544–1595) (Bartsch 17.177.1224); pricked for transfer; heavily rubbed with black pounce. Single pinholes near three edges of the sheet suggest that it and another piece of paper were pinned together at one time.

202. Pricked engraving and calculations, 1700s (fig. 59)

18.5 × 21 cm (7¼ × 8¼ in.). Good, some losses to the edges, some water damage.

Recto: Engraving by Carlo Nolli (d. after 1770) after a drawing by Luigi Vanvitelli (1700–1773) of a symmetrical decorative motif including a pair of sphinxes holding floral swags and flanking a masked female head surmounted by a basket of fruit and with a pendent wreath beneath, with the notations "*L. Vanvitelli in. del.*" and "*C. Nolli inc.*" inscribed below; pricked for transfer, except the wreath and the basket of fruit. Single pinholes near three edges of the sheet suggest that it and another piece of paper were pinned together at one time.

Verso: Mathematical calculations written in pen and ink.

Watermark: Mostly illegible image of an animal, possibly a rooster, within a circle.

203. Pricked engraving, 1700s

8.4 × 10.6 cm (3¼ × 4⅛ in.). Good.

Engraving of a scene within an oval frame of a putto holding a clock and a young shepherd gazing at a bare-breasted woman sleeping under a tree, with the notation "*N. Bonnartalaigle*" (probably the Parisian engraver Nicolas Bonnart [1636–1718]) inscribed below; pricked for transfer. Pairs of pinholes at the left and right edges of the sheet suggest that it and another piece of paper were pinned together at one time.

204. Engraving, 1700s

16.9 × 23.4 cm (6⅝ × 9¼ in.); print 9.8 × 13 cm (3⅞ × 5⅛ in.). Good, some losses to the right edge that have been stabilized.

Engraving by Giovanni Battista Galestruzzi (circa 1615–after 1669) of Venus Marina in an oval frame, with the notation "*Gio. B. Galestruzzi fece*" inscribed below; from Leonardo Agostini's *Le gemme antiche figurate* (1657, pl. 16).

Fig. 59. Pricked engraving, 1700s
See no. 202

Fig. 60. Pricked engraving, 1700s
See no. 205

205. Pricked engraving, 1700s (fig. 60)

12.1 × 28.8 cm (4¾ × 11⅜ in.). Good, slight insect and other staining.

Engraving of decorative motifs including four scrolls of acanthus leaves, a shell, and a flower; only the scroll at the far right is pricked for transfer. Single pinholes along the bottom and right edges of the sheet suggest that it and another piece of paper were pinned together at one time.

206. Pricked engraving and musical score, 1700s (pls. 10, 11)

20.5 × 27.9 cm (8⅛ × 11 in.). Good, some staining and foxing.

Recto: *Ursorum Insectatio/Die Bären-Hatz*, a watercolored engraving by Johann Christian Leopold (1699–1755) after a drawing by Johann Elias Ridinger (1698–1767), with a four-line verse in Latin and in German and the notations "[*Cum Pri]v. Sac. Caes. Maj.*," "*Iohann Elias Rüdinger delineavit*," and "*Iohann Christian Leopold excudit Aug. Vind.*" inscribed below (Thienemann 1979, addendum 2, 4 [entry no. 1331]); mounted on a thick sheet of paper for strength; pricked for transfer. This engraving was the source for no. 208, because the single pinholes near the edges of the sheets match and the two display the same pricking.

The central figures of this engraving appear on a Castelli plaque attributed to the Gentili workshop in the Raccolta Acerbo, Loreto Aprutino (1750–1800, 30.5 × 21.5 cm [12 × 8½ in.]; Arbace 1993, 266–67 [entry no. 268]).

Verso: The sheet backing the print displays part of a musical composition. William Prizer (personal communication, 1998) surmises that the music

is part of a trio sung by the characters *"Zin.," "Na.,"* and *"Cal."* from an eighteenth-century opera.

207. **Pricked engraving and drawing, late 1600s–early 1700s**

19 × 25.5 cm (7½ × 10 in.). Fair to poor, heavy staining and foxing, losses to all edges.

Recto: *Jupiter Assuming the Form of Diana in Order to Seduce Callisto*, one of fifty-two sheets illustrating Ovid's *Metamorphoses* designed by Hendrick Goltzius (1558–1617) and engraved by his workshop (Bartsch 3.106.56); mounted on several strips of paper (including two letters) for strength; very faintly pricked for transfer.

The image appears on two Castelli plates in the Museo di San Martino, Naples, one attributed to Carlo Antonio Grue (1670s–1720s, 24.5 cm [9⅝ in.] diam.); Fittipaldi 1992, 1: 126 [entry no. 188], 2: 125 [no. 188]), the other to Carmine Gentili (1690s–1760s, 28.5 cm [11¼ in.]; Fittipaldi 1992, 1: 74–75 [entry no. 56], 2: 41 [no. 56]).

The former belongs to a service of plates that all display the same coat of arms. Six of the thirty-seven plates from this service in the Museo di San Martino's collection (Fittipaldi 1992, entry nos. 182, 188, 209–11, 224; for the other plates, see his entry nos. 166, 183–87, 189–95, 198–208, 216–19, 225, 230, 231) are decorated with images that appear in the Gentili/Barnabei archive (nos. 183, 207, 213, 214, 231, 235). For a brief discussion of this service, which mentions additional plates from the service in the Museo Nazionale della Ceramica "Duca di Martina," Naples, and describes the coat of arms as belonging to an unidentified Neapolitan noble family, see Arbace 1996, 152, 158 (entry no. 219).

Verso: Rough sketch of a decorative scroll in pen and ink.

208. **Pricked cartoon and business letter, 1788** (fig. 61)

19.7 × 28 cm (7¾ × 11 in.). Good, slight staining.

Recto: Substitute cartoon after the central figures of the engraving *Ursorum Insectatio/Die Bären-Hatz* by Johann Christian Leopold (1699–1755) after a drawing by Johann Elias Ridinger (1698–1767) (see pl. 10; Thienemann 1979, addendum 2, 4 [entry no. 1331]); pricked for transfer over a letter to Signor Giuseppe, handwritten in pen and ink and headed Castelli, 28 October 1788. Single pinholes along the edges of the sheet suggest that it and another piece of paper were pinned together at one time. The letter reads,

Ritrovandomi mezza donzana di mattonelle d'un foglio di qualità, e ben fatigate al proprio gusto di V.S. quale V.S. mi ne parlò quando fù costà, delche non perdei tempo di servirla; delle quali quattro sono di cacciagione, e altre due sono di storie Sacre, del costo di esse Le rimetterò alla considerazione di V.S.; ...di tanto mando il Presende apposta conn'altre rotondini, che sono di commessione del Sig. D. Alessandro de Alexandrij.

Fig. 61. Pricked cartoon, 1788
See no. 208 verso

(Finding myself with a half-dozen tiles of one leaf/sheet of quality, and having worked hard to meet your desires, which you discussed with me when I was with you and to which I did not lose time attending. Four of these depict game and another two depict sacred scenes. The value of these I will leave to your consideration;...meanwhile I send you the present one with other round ones [?] that are part of the commission belonging to Alessandro de'Alexsandrij.)

See no. 18 for discussion of the term *foglio* (leaf or sheet). "*Autogr. di Dom. Berardo Gentili*" is handwritten in pencil at the lower right, presumably by the dealer. This cartoon was pricked from no. 206, because the single pinholes near the edges of the sheets match and the two display the same pricking.

The central figures of this engraving appear on a Castelli plaque attributed to the Gentili workshop in the Raccolta Acerbo, Loreto Aprutino (1750–1800, 30.5 × 21.5 cm [12 × 8½ in.]; Arbace 1993, 266–67 [entry no. 268]).

Verso: Lightly rubbed with graphite to delineate the pricked image.

Watermark: Bird in profile facing a single star on the left and standing on a perch above three hills, within a simple cartouche with scrolls above and below; all above the letters *G M*, which are above the word *SOLMONA*.

209. Engraving, late 1600s (fig. 62)

29.2 × 21.3 cm (11½ × 8⅜ in.); print 18.9 × 15.9 cm (7⅜ × 6¼ in.). Good, slight foxing and insect staining, slight losses to the edges that have been stabilized.

Engraving by H. Sweerds of a cow and a goat lying in front of a wall and a ram standing under a tree, after the aquatint *Cow, Ram, and Goat* of circa 1665 by Johann Heinrich Roos (1631–1685) (Bartsch 1.142.19-I), with the notations "*H Sweerds exc*" and "*Beestboekje door J. H. Roos. I^e deel.*" inscribed, respectively, at the bottom edge of the print and on the wall at the upper left; mounted on a paper backing.

This image, with the addition of a flute player and buildings in the background, appears on a Castelli roundel in the Musée des Beaux-Arts, Dijon (fig. 63; 1700s, 25 cm [9⅞ in.] diam.; Barral 1987, 148–49 [entry no. 49]; Blazy 1992, 33 [entry no. 20], which also mentions other versions in the Galleria Nazionale delle Marche, Urbino, and the Musée des Beaux-Arts et Archéologie, Blois). The rough approximation of the scene on the roundel in the Musée des Beaux-Arts, Dijon, with the print suggests that the source was copied onto the roundel freehand.

Watermark: Part of a mostly illegible mark including a crowned shield appears on the engraving.

210. Pricked engraving, 1600s

25.5 × 18 cm (10 × 7⅛ in.). Good, losses to the right edge.

Recto: Allegorical engraving of peasants in a landscape, with the word

Fig. 62. Engraving, late 1600s
See no. 209

Fig. 63. Roundel from Castelli decorated after the engraving shown in fig. 62, tin-glazed earthenware, 25 cm (9⅞ in.) diam., 1700s
Dijon, Musée des Beaux-Arts

"*MERIDIES*" (Midday) at the top edge and "*Opportuna dies operi, duroque labori est, / Tunc desudando passim se quisque fatigat*" (Suitable is the day for work, and for hard labor, / Then in exerting himself here and there each man exhausts himself) inscribed below; mounted on paper backing; pricked for transfer.

The engraving has been identified as a conflation of two drawings signed by Hendrick Goltzius (1558–1617) and datable to 1596: *Saturn* in the Rijksprentenkabinet, Amsterdam (Reznicek 1961, 1: 296 [entry no. 143], 2: fig. 281), and *Jupiter* in the Prentenkabinet der Rijksuniversiteit, Leiden (Reznicek 1961, 1: 297 [entry no. 144], 2: fig. 282) (Fittipaldi 1992, 1: 55).

The image appears on a Castelli plate attributed to Francesco Antonio I Grue in the Museo di San Martino, Naples (1600s, 35.2 cm [13⅞ in.] diam.; Fittipaldi 1992, 1: 55 [entry no. 9], 2: 13 [no. 9]) and on a Castelli roundel by Francesco Antonio I Grue in the collection of Paparella Treccia, Pescara (1600s, 39.5 cm [15½ in.] diam.; Moccia 1968, 33 [entry no. 31]).

Verso: Very lightly rubbed with graphite to delineate the pricked image. Attached to the right edge is the remnant of a paper flange.

211. Engraving, 1600s

22 × 28.2 cm (8⅝ × 11⅛ in.). Good, some water damage.

Recto: Engraving by Justus Sadeler (1583–circa 1620) after Johannes Bol (1534–1593) of couples picnicking on the lawn and courting in the gazebo before a castle and boating in the castle's moat, with the word "*VER*" (Spring) at the top edge and the lines

Ver geniale novis uti dat primord[i]a rebus,
Et vario teneram flore colorat humum;
Talis et ipsa capit fecundaque semina reddit,
Semina prolifici florida virgo sinus.
(Even as the genial spring gives beginnings to new things,
And with variegated flowers colors the soft earth,
Such too is the beautiful maiden herself as she takes and makes fruitful
 the seeds,
The seeds of her prolific bosom.)

and the notation "*Ioan Bol inventor Iustus Sadeler excudit*" inscribed below; mounted on paper backing.

Verso: Attached to the right edge is the remnant of a paper flange.

Watermark: Illegible image within a circle.

212. Pricked engraving, 1600s–1700s

22 × 29 cm (8⅝ × 11⅜ in.). Good, some losses to the edges, edges frayed.

Part of an engraving by Pietro Aquila (1650–1692) after the frescoes executed by Annibale Carracci (1560–1609) in the Camerino Farnese,

Rome, showing three details—an oval with an allegorical female figure holding a cornucopia and standing beside a crane, an oval with a winged male figure holding a wreath and staff, and part of a spandrel-like area with decorative scrolls and a male figure—and with the notations "*Annibal Carraccius pinx. in Aedibus farnesianis*" and "*Io. Iacobus de Rubeis formis Romae ad Templ.*" inscribed below; only the crane and the winged male figure are pricked for transfer. This sheet and no. 218 were cut from one of the series of twelve prints with a frontispiece published by Giovanni Giacomo de Rossi (1627–1691) (*Annibale Carracci e i suoi incisori* 1986, 78 [entry no. 11]).

213. **Pricked engraving, late 1600s** (fig. 64)

27.8 × 18.1 cm (11 × 7⅛ in.). Good, slight staining, some foxing.

Oval engraving by Valentin Lefebvre (circa 1641–circa 1680) of Neptune triumphant on a chariot drawn by a team of hippocampi, seen from below, after a fresco executed by Giovanni Battista Ponchino (circa 1500–1570) in 1553–1555 for the Sala del Consiglio dei Dieci, Palazzo Ducale, Venice (Villot 1844, 193 [entry no. 42]; Turner 1996, s.v. "Ponchino, Giambattista"); pricked for transfer. Two single pinholes near the edges of the sheet suggest that it and another piece of paper were pinned together at one time.

This image appears on a Castelli plate attributed to Carmine Gentili in the Museo di San Martino, Naples (1690s–1760s, 28.7 cm [11¼ in.] diam.; Fittipaldi 1992, 1: 132–33 [entry no. 224], 2: 141 [no. 224]) that belongs to a service of plates that all display the same coat of arms. Six of the thirty-seven plates from this service in the Museo di San Martino's collection (Fittipaldi 1992, entry nos. 182, 188, 209–11, 224; for the other plates, see his entry nos. 166, 183–87, 189–95, 198–208, 216–19, 225, 230, 231) are decorated with images that appear in the Gentili/Barnabei archive (nos. 183, 207, 213, 214, 231, 235). For a brief discussion of this service, which mentions additional plates from the service in the Museo Nazionale della Ceramica "Duca di Martina," Naples, and describes the coat of arms as belonging to an unidentified Neapolitan noble family, see Arbace 1996, 152, 158 (entry no. 219).

Watermark: Hard-to-read mark of a row of three crescents of diminishing sizes. It is similar to marks found on the sheets of works printed in Venice in the 1600s (Heawood 1950, esp. pl. 136 [entry nos. 863, 865].

214. **Pricked engraving, 1700s** (pls. 12, 13)

36 × 23 cm (14⅛ × 9 in.); print 30.1 × 19.6 cm (11⅞ × 7¾ in.). Fair; some staining and foxing, especially at the edges.

Engraving by Johann Georg Merz of three women and a male flutist in a landscape, after an engraving by Charles-Nicolas II Cochin (1715–1790) after the painting *Par une tendre chansonnette* by Nicolas Lancret (1690–

Fig. 64. Pricked engraving, late 1600s
See no. 213

circa 1745) (Wildenstein 1924, 92–93 [entry no. 328], fig. 91), with a four-line verse in German and in French and the notation "*Ioh. Georg Merz, exc. A. V.*" inscribed below; only the group of figures is pricked for transfer. Single pinholes surrounding the image suggest that it and another piece of paper were pinned together at one time.

The pricking of the group of figures of this print matches that of a pricked cartoon that is among the Gentili papers at the Istituto Statale d'Arte "F. A. Grue" per la Ceramica, Castelli (Arbace 1998, 94 [entry no. II/25], 96 [no. II-26 (*sic*)]), indicating that the two sheets were placed together and then pricked at the same time

This image appears on a Castelli plate attributed to Carmine Gentili in the Museo di San Martino, Naples (pl. 14; 1690s–1760s, 24 cm [9½ in.] diam.; Fittipaldi 1992, 1: 130 [entry no. 210], 2: 132 [no. 210]) that belongs to a service of plates that all display the same coat of arms. Six of the thirty-seven plates from this service in the Museo di San Martino's collection (Fittipaldi 1992, entry nos. 182, 188, 209–11, 224; for the other plates, see his entry nos. 166, 183–87, 189–95, 198–208, 216–19, 225, 230, 231) are decorated with images that appear in the Gentili/Barnabei archive (nos. 183, 207, 213, 214, 231, 235). For a brief discussion of this service, which mentions additional plates from the service in the Museo Nazionale della Ceramica "Duca di Martina," Naples, and describes the coat of arms as belonging to an unidentified Neapolitan noble family, see Arbace 1996, 152, 158 (entry no. 219).

Other ceramics decorated with this image include a Castelli plaque by Carmine Gentili, with an added balustrade and fountain in the background, in the Kunstgewerbemuseum, Berlin (circa 1730–1750, 20.3 × 26.8 cm [8 × 10½ in.]; Hausmann 1972, 369–70 [entry no. 279]); a Castelli roundel attributed to Francesco Saverio II Maria Grue, with only the figure of the flute player in a landscape, that was offered for sale in 1989 (1700s, 27.6 cm [10⅞ in.] diam.; Christie's, Rome, 29 November, lot 57; Agnellini 1992, 163); and a Castelli plaque attributed to Giacomo II Gentili in the Raccolta Acerbo, Loreto Aprutino (1700s, 26.5 × 20 cm [10⅜ × 7⅞ in.]; Arbace 1993, 194 [entry no. 186]).

215. **Engraving, 1700s**

24 × 35 cm (9½ × 13¾ in.); print 21.9 × 31.2 cm (8⅝ × 12¼ in.). Good, some staining.

Engraving by Martin Engelbrecht (1684–1756) of David and the fallen Goliath, with 1 Samuel 17:49 in Latin and in German and the notations "*C.P.S.C. Maj.*" and "*Mart. Engelbrecht excud. A. V.*" inscribed below.

216. **Engraving, 1600s**

21.2 × 34.2 cm (8⅜ × 13½ in.); print 16.8 × 22.2 cm (6⅝ × 8¾ in.). Good, tears along the left edge.

Engraving by Govert van der Leeuw (Gabriel de Leone) (1645–1688) of a cow, a donkey, two goats, seven sheep, and a dog in an italianate landscape, with the notation "*G. Leone. f.*" inscribed below.

217. **Pricked engraving, early 1700s** (pl. 15)

36.5 × 24 cm (14⅜ × 9½ in.). Brittle, tears along the pricking, losses to the edges.

Engraving by Arnold van Westerhout (1651–1725) after a mosaic by Giuseppe Conti (1600s–1700s) after a painting by Carlo Maratti (1625–1713) of a Madonna and child in a cartouche with the banner "*SPES NOSTRA SALVE*" (Hail, O our Hope) above and a tablet bearing an inscription to Pope Innocent XII by "*Ioseph Conti Romanus*" below, with the notations "*[Carol]us Maratti pinxit*" and "*Arnoldus Von Westerhout Antuerp…Etrurie Sculptor f[ecit]*" inscribed below; mounted on a printed paper backing that is dated 1711; pricked for transfer. Pinholes near the edges of the sheet suggest that it and another piece of paper were pinned together at one time.

Two pricked cartoons after this engraving are among the Gentili papers at the Istituto Statale d'Arte "F. A. Grue" per la Ceramica, Castelli (Arbace 1998, 114–15 [entry nos. III/12, III/13]). The pricking of one of the Istituto's cartoons appears to match that of no. 217, indicating that the two sheets were placed together and then pricked at the same time

This image appears on two plaques, one attributed to Carmine Gentili and published by Levy as in a private collection, Milan (1690s–1760s, 32 × 23 cm [12⅝ × 9 in]; Levy 1964, pl. 328), the other signed "*IO BARTOLOMEO TERCHI IN BASSANO FECI 1739*" and located on a bridge in the lower part of Bassano Romano (pl. 16; 1739, 53 × 51 cm [20⅞ × 20⅛ in.]; Pelizzoni and Zanchi 1982, 101 [entry no. 92]). The plaque in Bassano Romano does not have the cartouche and adds trees in the background, while the plaque in the private collection in Milan substitutes clouds for the cartouche along the sides and bottom and includes four putti, two at the upper right and two at the upper left.

There are two other plaques of the same subject that have the figure of Saint Joseph added behind and to the right of the Madonna and the words "*EGO MATER GRATIAE, ET PULCHRAE DILECTIONIS DILIGENTES ME DILIGO*" (I, the mother of grace and of noble love, love those who love me) within a cartouche in the lower fourth of the plaque. One of these plaques includes three putti in the upper left corner, a detail that might well link it to the plaque in the private collection in Milan which surely does copy the Maratti source (1700–1750, 32.5 × 23 cm [12¾ × 9 in.]; Christie's, Rome, 28 November 1990, lot 67). The other plaque, which is in the Bowes Museum, Barnard Castle, England, has the signature "*B GENTILI PIN*" and the date 1767 but no putti (1767, 33 × 25 cm [13 × 9⅞ in.]; Howard Coutts, personal communication, 1977). Given the similarities of these latter two plaques to each other, it is clear that either one copies the other or

Fig. 65. Pricked engraving, late 1600s–1700s
See no. 219

they are taken from the same source, which may or may not be the Maratti original or an engraving after it.

218. Pricked engraving, 1600s–1700s

13.5 × 18 cm (5¼ × 7⅛ in.). Good, some losses to the right and left edges.

Recto: Part of an engraving by Pietro Aquila (1650–1692) after the frescoes executed by Annibale Carracci (1560–1609) in the Camerino Farnese, Rome, showing part of a frieze with Hercules and the hydra to the left and the young Hercules choking the serpent to the right; only the two figures of Hercules are pricked for transfer; rubbed with graphite. This sheet and no. 212 were cut from one of the series of twelve prints with a frontispiece published by Giovanni Giacomo de Rossi (1627–1691) (*Annibale Carracci e i suoi incisori* 1986, 78 [entry no. 11]).

Verso: Rubbed with graphite to delineate the pricked image to the right.

219. Pricked engraving, late 1600s–1700s (fig. 65)

13 × 19.4 cm (5⅛ × 7⅝ in.). Good, some staining and foxing.

Recto: *Bear Hunt* from *Hunting Scenes IV* by Antonio Tempesta (1555–1630) (Bartsch 17.166.1132); partially pricked for transfer. No. 184

(see fig. 53) is a substitute cartoon after this engraving with a different pricking.

Verso: Illegible notation in pen and ink. At the lower right corner is a small paper patch.

220. Pricked engraving, 1700s

27 × 38 cm (10⅝ × 15 in.); print 21.6 × 27.1 cm (8½ × 10⅝ in.). Good, some staining and foxing.

Recto: Engraving of an allegorical scene of a barefooted old man dressed in a robe and a turban who is holding a scroll inscribed "*Omnia mea me comporto*" (I carry all of my possessions with me) and walking away from a small pile of riches (chest, ewer, basin, chalice), three sheep, a cow, and a goat; only the animals and the riches are pricked for transfer. Single pin-holes around the pricked image suggest that the sheet and another piece of paper were pinned together at one time.

Verso: Lightly rubbed with graphite to delineate the pricked image.

221. Pricked engraving and drawings, 1600s–1700s

15 × 21 cm (5⅞ × 8¼ in.); print 10.7 × 15.2 cm (4¼ × 6 in.). Fair, some staining, heavy foxing.

Recto: Engraving of a male peasant sleeping face down on a block of stone bearing the lines

> *Otia delectant faciuntque laboribus aptos,*
> *Robore quae firmant languida membra novo*
> *Ast ignava quies frangit torpedine corpus.*
> *Enervatque animum, nec sinit esse probum.*
> *Ergo mihi socors segni topore sepultus,*
> *Non homo, sed vivus triste cadaver erit.*
> —*H. de Roij*
> (Leisure is pleasing and makes one fit for labor,
> It strengthens weak limbs with renewed vigor.
> But idle repose weakens the body with sluggishness.
> And it enervates the soul, nor does it allow the soul to be worthy.
> Therefore, to me a lazy person overcome by slothful torpor will be,
> Not a human being, but a melancholy living corpse.)

with the notations "*Abraham Blomaert Inven. I. C. fecit,*" "*Romae Superior permiss*[*n?*] *1629,*" and "*Abra. Blom. in.*" inscribed below; mounted on another sheet for strength; pricked for transfer. Single pinholes outside the border around the engraving suggest that this sheet and another piece of paper were pinned together at one time. The incorrect attribution "*Jacques Callot*" is handwritten in pencil at the right edge of the mount, presumably by the dealer.

The original sketch by Abraham Bloemaert (1564–1651) of the reclining

figure appears on a sheet of drawings formerly in the collection of V. Bloch, The Hague (Colnaghi, London, 18 April–26 May 1950, lot 30).

Verso: Two small sketches of a crown in pen and ink.

222. **Pricked engraving, 1600s–1700s**

14.5 × 21.5 cm (5¾ × 8½ in.); print 9.9 × 14.4 cm (3⅞ × 5⅝ in.). Fair, some insect and other staining.

Recto: Engraving by Balthazar Moncornet (circa 1600–1668) of a recumbent cow, with the notation "*Moncornet ex.*" inscribed at the lower left, after the engraving *Recumbent Cow* by Paulus Potter (1625–1654) (Bartsch 1.42.3-I); pricked for transfer; rubbed with black pounce. Single pinholes outside the border around the engraving on three sides suggest that this sheet and another piece of paper were pinned together at one time. Attached to the right edge is the remnant of a paper flange. "*Moncornet*" is handwritten in pencil at the lower left, presumably by the dealer.

Verso: Attached to the right edge are the remnants of two paper flanges.

223. **Engraving, late 1600s–early 1700s** (fig. 66)

17.4 × 26 cm (6⅞ × 10¼ in.); print 14.8 × 22.7 cm (5⅞ × 8⅞ in.). Good, some water damage.

Engraving of a foliate cartouche around the inscribed name "GIACOMO ANTONIO MANINI." Giacomo Antonio Mannini (1646–1732), a student of Andrea Monticelli (1640–1716) and Domenico Santi (1621–1694), was a painter and an engraver of decorative subjects who was active in Bologna, Modena, Parma, and Siena.

224–26. **Booklet, late 1600s–early 1700s**

Three-leaf booklet with an engraving on each recto and blank versos (see the next three entries). Near the top edge, string has twice been threaded through the sheets to bind them together.

224. **Booklet leaf** (fig. 67)

31 × 22 cm (12¼ × 8⅝ in.); print 19.4 × 9.6 cm (7⅝ × 3¾ in.). Good, some water damage, tears along the bottom edge.

Engraving of foliate scrolls surrounding a shield inscribed "CARLO BUFFAGNOTTI INVENTOR FECE," with a man's head, in profile and wearing a top hat, lightly sketched in pencil at the right. A student of Domenico Santi (1621–1694), Carlo Antonio Buffagnotti (circa 1660–after 1710) was active in Bologna as a painter and an engraver; he specialized in scenographic and other theatrical decorations. The sketch appears to be by Felice Barnebei. It is interesting that he would make this casual addition to a document dating from well over a hundred years before his day.

Watermark: A man's head in profile within an oval.

Fig. 66. Engraving, late 1600s–early 1700s
See no. 223

225. **Booklet leaf** (fig. 68)

31 × 22 cm (12¼ × 8⅝ in.); print 19.4 × 9.6 cm (7⅝ × 3¾ in.). Good, some staining, edges somewhat frayed.

Engraving of foliate scrolls.

Watermark: A man's head in profile within an oval.

226. **Booklet leaf** (fig. 69)

31 × 22 cm (12¼ × 8⅝ in.); print 19.4 × 9.6 cm (7⅝ × 3¾ in.). Good, some staining, edges somewhat frayed.

Engraving of foliate scrolls.

227. **Engraving, late 1600s–early 1700s** (fig. 70)

19 × 22.7 cm (7½ × 8⅞ in.); print 14 × 18.8 cm (5½ × 7⅜ in.). Good, some insect and other staining, some losses to the top edge.

Recto: Engraving by Gabriel Ehinger (1652–1736) after Johann Heinrich Schönfeld (1609–circa 1682) of a peasant couple, the man playing a flute and the woman a tambourine, seated beside a wall with two goats and a landscape in the background, with the notations "*H. Schönfeldt Invent.*" and "*Gabr. Ehinger Sculp.*" inscribed below. Apparently signed

CARLO BVF
FAGNOTTI
INVENTOR
FECE

Fig. 67. Booklet page, late 1600s–early 1700s
See no. 224

Fig. 68. Detail of booklet page, late 1600s–early 1700s
See no. 225

Fig. 69. Detail of booklet page, late 1600s–early 1700s
See no. 226

Fig. 70. Engraving, late 1600s–early 1700s
See no. 227

below in pen and ink by Giovanni Grue. "*Giovanni Grue*" is handwritten in pencil at the lower left, presumably by the dealer.

Verso: Illegible monogram handwritten in pen and ink.

228. Pricked engraving, 1649

27 × 41.5 cm (10⅝ × 16⅜ in.). Good, some water damage, tears along the right edge, sheet torn in half.

Recto: *Bacchanal with Two Fauns and Children Carrying the Drunken Silenus*, an engraving executed after a drawing by Giovanni Andrea Podestà (died circa 1674) and published in 1649 by Giovanni Giacomo de Rossi (1627–1691) (Bartsch 20.170.2); pricked for transfer. "*Andrea Podestà*" is handwritten in pencil on the paper flange at the lower left, presumably by the dealer.

Verso: Attached to the right edge is the remnant of a paper flange.

Watermark: Fleur-de-lis within a circle.

229. Engraving, late 1600s–early 1700s

25.7 × 34 cm (10⅛ × 13⅜ in.); print 24.5 × 29.7 cm (9⅝ × 11¾ in.). Fair, one large tear in the sheet that has been repaired with a paper patch, some losses to the print.

Recto: Engraving of the rape of Europa with two Tritons and a putto on a dolphin surrounding the bull, two putti hovering above, and four figures on the shore in the background; mounted on a paper backing.

Verso: Paper patch at the center of the sheet.

230. Pricked engraving, late 1600s

21 × 24 cm (8¼ × 9½ in.). Fragile, some water damage, tears in the sheet, losses to the edges.

Moses Ordering the Israelites to Attack the Ethiopians by Antonio Tempesta (1555–1630) (Bartsch 17.129.239); pricked for transfer. This engraving was the source for no. 198, because the two display the same pricking and the single pinholes near the edges of the sheets match where they still exist on no. 230.

231. Pricked engraving, late 1600s–early 1700s (fig. 71)

20.5 × 33 cm (8⅛ × 13 in.). Fragile; water damage; losses to the lower right corner; tears, especially along the bottom edge and the pricking.

Recto: Engraved frontispiece to *Hunting Scenes VI* by Antonio Tempesta (1555–1630) (Bartsch 17.167.1140); pricked for transfer. The preponderance of wear, consisting mainly of tears in the paper, occurs in the areas of the two seated huntsmen with their horses and dogs; these portions of the print are what one finds reproduced on ceramics.

This engraving is the source for the decoration on many extant maiolica objects. The huntsman and his dog and horse from the left side of the print appear on a Ligurian plate that in 1990 was in the collection of

Fig. 71. Pricked engraving, late 1600s–early 1700s
See no. 231

Fig. 72. Attributed to Carmine Gentili
Plate from Castelli decorated after the lower left side of the engraving shown in fig. 71, 37.6 cm (14¾ in.) diam., ca. 1750–1755
Naples, Museo di San Martino

Fig. 73. Attributed to Carmine Gentili
Saucer from Castelli decorated after the lower right side of the engraving shown in fig. 71, 13.9 cm (5½ in.) diam., 1700–1750
Hamburg, Museum für Kunst und Gewerbe

Mario Panzano, Genoa, and on a Castelli plate by Aurelio Grue, with the addition of buildings and a landscape in the background and the arms of Cardinal Don Tommaso Ruffo, Archbishop of Ferrara, that is in the collection of Keith Humphris, London (circa 1725, 29 cm [11⅜ in.] diam.; Christie's, London, 2 October 1989, lot 41). The huntsman from the right side of the print appears on the top of the lid of a large Castelli urn decorated with scenes of King David attributed to Francesco Saverio II Maria Grue in the Raccolta Acerbo, Loreto Aprutino (1700s, 33 cm [13 in.] diam.; Arbace 1993, 262 [entry no. 266]) as well as on an unpublished roundel in the Museo delle Ceramiche, Castelli; and the huntsman and his dog and horse from the right side occur on a Castelli saucer by Carmine Gentili in the Museum für Kunst und Gewerbe, Hamburg (fig. 73; 1700–1750, 13.9 cm [5½ in.] diam.; Rasmussen 1984, 301–2 [entry no. 202]). Both huntsmen and their dogs and horses, along with buildings and a seashore in the background, appear on a Castelli plaque by the Grue workshop that was offered for sale in 1984 (1700–1750, 21.5 × 28.7 cm [8½ × 11¼ in.]; Sotheby's, London, 12 June, lot 21). Of the four Castelli plates attributed to Carmine Gentili and decorated after this engraving that are in the Museo di San Martino, Naples, the lower left-hand portion of the print appears alone on one (fig. 72; circa 1750–1755, 37.6 cm [14¾ in.] diam.; Fittipaldi 1992, 1: 128 [entry no. 197], 2: 128 [no. 197]) and is incorporated into a larger allegorical scene on another signed "*GENTILI*" (1690s–1760s, 27.5 cm [10⅞ in.] diam.; Fittipaldi 1992, 1: 132 [entry no. 211], 2: 132 [no. 211]), while the lower right-hand portion of the print appears alone on one (circa 1750–1755, 23.9 cm [9⅜ in.] diam.; Fittipaldi 1992, 1: 134 [entry no. 233], 2: 143 [no. 233]) and is incorporated into a larger allegorical scene on another (early 1700s, 28 cm [11 in.] diam.; Fittipaldi 1992, 1: 150 [entry no. 295], 2: 179 [no. 295]).

This last belongs to a service of plates that all display the same coat of arms. Six of the thirty-seven plates from this service in the Museo di San Martino's collection (Fittipaldi 1992, entry nos. 182, 188, 209–11, 224; for the other plates, see his entry nos. 166, 183–87, 189–95, 198–208, 216–19, 225, 230, 231) are decorated with images that appear in the Gentili/Barnabei archive (nos. 183, 207, 213, 214, 231, 235). For a brief discussion of this service, which mentions additional plates from the service in the Museo Nazionale della Ceramica "Duca di Martina," Naples, and describes the coat of arms as belonging to an unidentified Neapolitan noble family, see Arbace 1996, 152, 158 (entry no. 219).

Verso: Attached to the right edge is the remnant of a paper flange, and the center of the sheet has been reinforced with two paper patches.

232. **Pricked engraving, late 1600s–early 1700s** (pl. 17)
27.5 × 17.5 cm (10⅞ × 6⅞ in.). Good; some losses to the sheet; tears, especially along the creases.

Recto: Part of an engraving of an allegorical scene of Jupiter and the eagle hovering above three male figures watching Geography direct the hand of a compass toward the word "*ILLUMINATI*," with an unidentified cardinal's coat of arms at the far right, another unidentified shield at the lower right, and the notations "*Gio Iacomo de Rossi le stampa in Roma*," "*Petr Beretin Corton del.*," and "*K. Audran Paris inc. Romae*" inscribed at the bottom; executed to commemorate the foundation of the Accademia degli Illuminati and published by Giovanni Giacomo de Rossi (1627–1691), this print was engraved by Gérard Audran (1640–1703) after a drawing by Pietro da Cortona (1596–1669) that depicts the harpy Celaeno prophesying to Aeneas and his companions (Virgil, *Aeneid* 3.192–258) (Magland 1977, 24–25, fig. 5; Biscontini Ugolini and Petruzzellis Scherer 1992, 148, 150); pricked for transfer; mounted on a thick paper backing that has blocked the pricked holes.

A number of ceramics from Castelli decorated after this engraving exist. In the Civiche Raccolte d'Arte Applicata, Castello Sforzesco, Milan, are a rectangular plaque (1750–1800, 27 × 35.5 cm [10⅝ × 14 in.]; Biscontini Ugolini and Petruzzellis Scherer 1992, 148–49 [entry no. 55]) and an oval plaque (1750–1800, 24 × 29 cm [9½ × 11⅜ in.]; Biscontini Ugolini and Petruzzellis Scherer 1992, 150–51 [entry no. 56]). Elsewhere there are a plaque by Francesco Antonio II Saverio Grue in the Musée des Arts Décoratifs, Paris (early 1700s, 28 × 35 cm [11 × 13¾ in.]; Blazy 1992, 60 [entry no. 44]); a roundel attributed to Carmine Gentili in the Museo Capitolare, Atri (1690s–1760s; Capitolo Cattedrale di Atri 1976, 24 [entry no. 36]); a plaque in the Galleria Nazionale delle Marche, Urbino (cited in Blazy 1992, 60 [entry no. 44]); a plaque in a private collection (late 1660s–1700s, 20 × 26.5 cm [7⅞ × 10⅜ in.]; Magland 1977, fig. 4); two plaques, the larger of which is unpublished (inv. no. 400; Magland 1977, 37 n. 1), in the Museo Civico "Gaetano Filangieri," Naples (1700s, 27 × 20 cm [10⅝ × 7⅞ in.]; Acton 1961, 35, pl. 27); a roundel attributed to Carmine Gentili in the collection of Gaetano Bindi, Pescara (1690s–1760s, 33 cm [13 in.] diam.; Moccia 1968, 47 [entry no. 157]); and two plates in the Museo di San Martino, Naples, one attributed to Carmine Gentili (pl. 18; 1690s–1760s, 41.6 cm [16⅜ in.] diam.; Fittipaldi 1992, 1: 122–23 [entry no. 167], 2: 118 [no. 167]) and the other attributed to Candeloro Cappelletti (1689–1772) (1700s, 41.4 cm [16¼ in.] diam.; Fittipaldi 1992, 1: 147 [entry no. 285], 2: 173 [no. 285]).

Verso: Handwritten in pencil at the top center is "*Stampa ritagliata nelle dimensioni della mattonella da illustrare*" (The print is cut in the size of a tile to be decorated).

233. Pricked engraving, late 1600s–early 1700s

15 × 21 cm (5⅞ × 8¼ in.); print 11.8 × 15.6 cm (4⅝ × 6⅛ in.). Good, water damage, tears along the edges.

Engraving of two peasants, one standing and leaning on a staff, the

other crouched by a basket and a dog, after the figures at the right of the painting of three peasants in a landscape by Abraham Bloemaert (1564–1651) that was published in *Exhibition of Sixteenth, Seventeenth, and Eighteenth Century Old Masters* (Lasson Gallery 1975, fig. 11), with the lines "*En vice curriculi blandus mihi fungitur Hylax / Blanditiis minuens taedia longa viae*" (See! Affectionate Hylax [a dog; Virgil, *Eclogues* 8.107] performs for me the function of a vehicle, / Abating with his ingratiating behavior the protracted wearisomeness of the journey) below; pricked for transfer. Three edges of the sheet were reinforced with strips of paper. Single pinholes near the top and right edges of the sheet suggest that it and another piece of paper were pinned together at one time. "*Callot?*" is handwritten in pencil at the lower right, presumably by the dealer.

The standing figure from this source and a second figure from another Bloemaert engraving appear on a small Castelli plate that was offered for sale in 1993 (circa 1740, 17.8 cm [7 in.] diam.; Sotheby's, London, 15 June, lot 116).

234. Engraving and drawing, late 1600s–early 1700s

20 × 16.5 cm (7⅞ × 6½ in.); print 19.6 × 14.6 cm (7¾ × 5¾ in.). Good, insect staining, foxed overall.

Recto: *Man and Woman by a Wall* by Abraham II Genoels (1640–1723) (Bartsch 4.338.24).

Verso: Sketch of a barren tree in pen and ink; at the right, part of a letter was used to reinforce the engraving's border. "*Abraham Genoels (1640–1723) a Rome 1674/1682*" is handwritten in pencil at the bottom, presumably by the dealer.

235. Pricked engraving, late 1600s–early 1700s (fig. 74)

15 × 21 cm (5⅞ × 8¼ in.); print 11.7 × 15.3 cm (4⅝ × 6 in.). Good, some water damage, losses to the edges.

Engraving of three cardplayers seated on the ground under a tree, the ninth in a series of sixteen *Pastorals* designed by Abraham Bloemaert (1564–1651) and engraved by Cornelis Bloemaert (1603–circa 1684) (Hollstein 1949–, 2: 77 [entry no. 212–15]); pricked for transfer; rubbed with black pounce; mounted on a paper backing that blocks the pricked holes.

A complete set of the original print series is in the Kupferstich-Kabinett, Dresden (the cardplayers is inv. no. A29657 in A1275.2), and another copy of the cardplayers exists in the Gemeentearchief, Rotterdam (inv. no. 3282). Like no. 235, these prints of the cardplayers are pricked for transfer.

Among the maiolica objects that have been decorated after this engraving is a plate attributed to Carmine Gentili in the Museo di San Martino, Naples (fig. 75; 1690s–1760s, 23.7 cm [9⅜ in.] diam.; Fittipaldi 1992, 1: 130 [entry no. 209], 2: 132 [no. 209]) that belongs to a service of plates

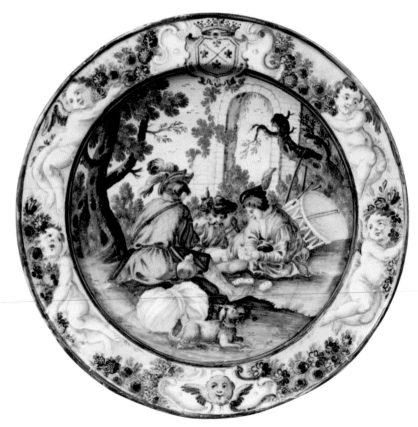

Fig. 74. Pricked engraving, late 1600s–early 1700s
See no. 235

Fig. 75. Attributed to Carmine Gentili
Plate from Castelli decorated after the engraving shown
in fig. 74, 23.7 cm (9⅜ in.) diam., 1690s–1760s
Naples, Museo di San Martino

that all display the same coat of arms. Six of the thirty-seven plates from this service in the Museo di San Martino's collection (Fittipaldi 1992, entry nos. 182, 188, 209–11, 224; for the other plates, see his entry nos. 166, 183–87, 189–95, 198–208, 216–19, 225, 230, 231) are decorated with images that appear in the Gentili/Barnabei archive (nos. 183, 207, 213, 214, 231, 235). For a brief discussion of this service, which mentions additional plates from the service in the Museo Nazionale della Ceramica "Duca di Martina," Naples, and describes the coat of arms as belonging to an unidentified Neapolitan noble family, see Arbace 1996, 152, 158 (entry no. 219).

Other ceramics decorated after this engraving include a Ligurian plate in the Cassa di Risparmio, Genoa, without the figure in the background (circa 1680, 44 cm [17⅜ in.] diam.; Hess 1992, 316–17 [entry no. 175]); a Castelli plate in blue and white with touches of manganese in the Museo Nazionale della Ceramica "Duca di Martina," Naples (circa 1690–1710, 46.4 cm [18¼ in.] diam.; Arbace 1996, 136, 138 [entry no. 179]); a small Castelli plate by Carlo Antonio Grue that was offered for sale in 1989 (circa 1700, 17.5 cm [6⅞ in.] diam.; Semenzato, Florence, 5 October, lot 1540); a Castelli saucer painted in the manner of the Gentili, without the figure in the background, in the Musée du Petit Palais, Paris (1700s, 18.6 cm [7⅜ in.] diam.; Join-Diéterle 1984, 300–1 [entry no. 107]); a Castelli saucer probably by Carmine Gentili in the Museum für Kunst und Gewerbe, Hamburg (1700–1750, 14.3 cm [5⅝ in.] diam.; Rasmussen 1984, 302–3 [entry no. 203]); the cover of a Siena potpourri bowl painted in the manner of Bartolomeo Terchi (1691–circa 1768), which shows the scene in reverse, that was offered for sale in 1994 (circa 1730, 34 cm [13⅜ in.] diam.; Christie's, London, 28 February, lot 121); and a Castelli plate from the Gentili workshop in the Raccolta Acerbo, Loreto Aprutino (circa 1750–1775, 16.5 cm [6½ in.] diam.; Arbace 1993, 184–85 [entry no. 173]). The decoration of yet another work—a small cup attributed to Carlo Antonio Grue in the Museo di San Martino, Naples—appears to be based loosely on this Bloemaert print (late 1600s, 7.3 cm [2⅞ in.] diam.; Fittipaldi 1992, 1: 74 [entry no. 55], 2: 55 [no. 55]).

236. **Pricked engraving, late 1600s–early 1700s**

26 × 18.5 cm (10¼ × 7¼ in.); print H: 22 cm (8⅝ in.). Fragile, torn and incomplete.

Recto: Right third of *Alexander Crossing the Mountains* by Antonio Tempesta (1555–1630) (Bartsch 17.143.552); mounted on a paper backing for reinforcement; pricked for transfer.

The pricking of the figures of this print matches that of a pricked cartoon after the same portion of the print that is among the Gentili papers at the Istituto Statale d'Arte "F. A. Grue" per la Ceramica, Castelli, indicating that the two sheets were placed together and then pricked at the same time; the Istituto's cartoon does not include some of the background

elements that are pricked on no. 236. "*Gesualdo Fuina*" is handwritten in pencil on the paper on which the cartoon was mounted, presumably in the 1940s.

Verso: The bottom and left edges are reinforced with paper strips.

237. Pricked engraving, 1600s–1700s

21 × 23 cm (8¼ × 9 in.). Fragile, some water damage, torn and incomplete.

Part of an engraving of scenes from the life of Bacchus (each scene is annotated in Italian), with "[?]*aius Romanus Inventor* / [?]*it Anno 1598*" inscribed below; one figure, that of Bacchus on a goat, is very faintly pricked for transfer.

Watermark: Partial mark of three hills within a circle.

238. Pricked engraving, late 1600s–early 1700s (fig. 76)

36 × 46.5 cm (14⅛ × 18¼ in.). Good; some water damage; some losses, especially to the top; tears in the sheet.

Engraving of the triumph of Neptune and Amphitrite by Philippe Thomassin (1562–1622) after a painting by Jacopo Zucchi (circa 1541–1589/1590) and published by Giovanni Giacomo de Rossi (1627–1691), with the lines

Perillustri ac generosissimo equiti domino Cassiano Puteo ut inter ceteras dotes bonarum artium summo cultori, sic & ingeniorum Patrono, hanc G[ala?]team, Opus olim Poaetarum, & nunc in picturam, quae mutae Poaeseos genus est versam, tam suo quam ipsarum a[rtiu?]m nomine Philippus Thomassinus D.D.

(To the most illustrious and eminent knight, Lord Cassiano dal Pozzo [secretary to Cardinal Barberini], who among other qualities is the most distinguished cultivator of the liberal arts as well as a patron of literary talent, Philippe Thomassin gives and dedicates as a gift this G[ala?]tea, a work of poets for a long time past, and now turned into a picture, which is a kind of mute poetry, [doing so] in his own name as well as in that of the arts themselves.)

and the notations "*Gio. Iacomo Rossi formis Rome 1649 alla Pace*" and "*Jacobus Zucca inv.*" inscribed below; mounted on a thick paper backing; pricked for transfer, except for the background landscape, the eight flying putti, the figure of Neptune and the large shell in the foreground, and the ship and four of the figures in the water in the background. Single pinholes across the horizon in the print and at the lower right suggest that this sheet and another piece of paper were pinned together at one time. No. 181 was pricked from the right-hand portion of this engraving, because the sheets display the same pricking and many of the single pinholes match.

The engraving served as the source for the decoration on several extant ceramics. Slightly different versions of Neptune on a team of hippocampi and accompanied by Nereids appear on a Castelli plate by Francesco Antonio I Grue that is in the Musée du Louvre, Paris (circa 1650–1673, 24.7 cm

[9¾ in.]; Giacomotti 1974, 471 [entry no. 1383]; Giacomotti 1977, fig. 5), and on a plate attributed to Ferdinando Maria Campani (circa 1702–1771), probably while he was working in Siena, that is in the Ashmolean Museum, Oxford (circa 1730–1740, 32.5 cm [12¾ in.] diam.; Wilson 1989, 76–77 [entry no. 34]). Neptune on a team of hippocampi, two Tritons, and two Nereids appear on a plate from the Terchi factory in Siena by Ferdinando Maria Campani (circa 1702–1771) that is in the Kunstgewerbemuseum, Berlin (fig. 77; circa 1740, 32.6 cm [12⅞ in.] diam.; Pelizzoni and Zanchi 1982, 82 [entry no. 69]). Neptune on a team of hippocampi appears alone on a plate from the factory in what is now Holič, Slovakia (circa 1750, 25 cm [9⅞ in.] diam.; Christie's, London, 2 October 1989, lot 29).

239. Pricked engraving and cartoon, probably late 1800s

31.1 × 42 cm (12¼ × 16½ in.); print 13.6 × 10.9 cm (5⅜ × 4¼ in.). Good.

Engraving of a bearded old man, seated and wearing an overcoat, with the notations "*Barchetta dis*" and "*G. S. Gallieni Inc.*" inscribed below; mounted on the left half of a sheet of paper; the right half of the mounting sheet was folded under and then the print was roughly pricked for transfer, producing a substitute cartoon of the print on the left half of the sheet; the verso of the substitute cartoon, which is on the same side as the recto of the engraving, was rubbed with graphite to delineate the pricked image.

240. Pricked cartoon, probably late 1800s

31.5 × 44 cm (12⅜ × 17⅜ in.). Good, some insect staining along the right edge of the verso.

Recto: Substitute cartoon of grotesques with *a candelieri* urns and framing motifs for the decoration of the rim of a plate or bowl; pricked for transfer. The cartoon, which is for half (180 degrees) of the rim, displays the same pricking as nos. 256 and 257, and the pairs of pinholes above and to the right and left of the image on the three sheets match; nos. 266–68, which together once formed a single cartoon for half (180 degrees) of the rim, also display the same pricking as nos. 240, 256, and 257.

The source seems to be the image of a Cafaggiolo plate depicting Saint George and bearing the mark of Jacopo di Stefano (circa 1490–after 1576), now in the Victoria and Albert Museum, London (see fig. 11; circa 1510, 32 cm [12⅝ in.] diam.; Rackham 1940, 1: 106 [entry no. 308], 2: pl. 51 [no. 308]), that was published in Alfred Darcel's *Recueil de faïences italiennes des XVᵉ, XVIᵉ et XVIIᵉ siècles* (1869, pl. 32) (see fig. 87). Both this cartoon and the image in Darcel's book measure 33 cm (13 in.) in diameter. This is one of fourteen cartoons in the Gentili/Barnabei archive for which Darcel's illustrations were the source: nos. 240, 256, 257, and 264–68 copy the rim of the plate reproduced in plate 32; nos. 247 and 248 the rim of the plate in plate 30; and nos. 252–54 and 260 the plate in plate 66.

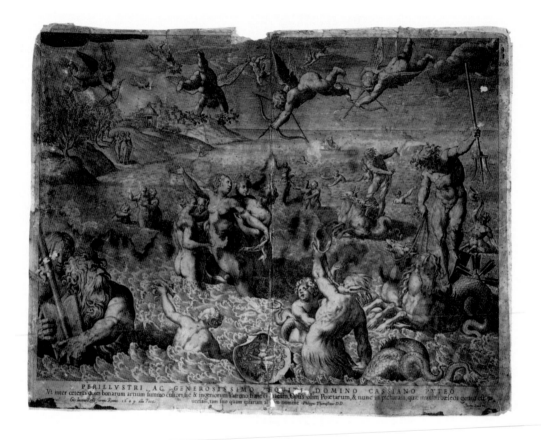

Fig. 76. Pricked engraving, late 1600s–early 1700s
See no. 238

Fig. 77. Ferdinando Maria Campani
Plate from Siena decorated after the engraving shown in
fig. 76, 32.6 cm (12⅞ in.) diam., ca. 1740
Berlin, Kunstgewerbemuseum

Verso: Partially rubbed with graphite to delineate the pricked image. A coat of arms above the words "R. *PROVVEDITORATO AGLI STUDII IN NAPOLI*" is stamped in green ink near the center of the top edge. "*(Felice Barnabei)*" is handwritten in pencil at the lower right, presumably by the dealer.

Watermark: The name AND[RE]A CAMERA to the left of an anchor with a rope within a double circle. It probably dates to the late nineteenth century and is attributable to the La Briglia papermill at Amalfi, given its similarity to known La Briglia watermarks, specifically to one, dated to 1884, of an anchor with a rope within a double circle with the name *I. CAMERA* to the left (Mošin 1973, pl. 353 [entry no. 2817], see also pl. 355 [entry no. 2820]).

241. Pricked cartoon, probably late 1800s

5 × 4 cm (2 × 1⅝ in.). Good.

Recto: Oval substitute cartoon of a portrait bust of a woman.

Verso: Rubbed with orange pounce to delineate the face of the pricked image.

242. Tracing, probably late 1800s (fig. 78)

18.5 × 11.5 cm (7¼ × 4½ in.). Good.

Traced drawing of what may be a seated beggar in long robes, executed in what appears to be ballpoint pen on thin glassine or tracing paper. A single pinhole perforates the sheet just beyond each of the four corners of the frame around the image. This drawing was traced from the same source from which nos. 263 and 263 bis were pricked.

243. Pricked cartoon and document, 1872

31.5 × 22 cm (12⅜ × 8⅝ in.). Good, some staining and foxing, some losses to the top edge that have been stabilized.

Recto: Substitute cartoon of a young pipe player with a wreath in his hair seated on a bank above some flowering plants and a recumbent goat; pricked for transfer over the results of a high-school Greek exam, handwritten in pen and ink, signed by Felice Barnabei and four others, and bearing the dateline Naples, 24 July 1872, on a sheet with a coat of arms above the words "R. *PROVVEDITORATO AGLI STUDII IN NAPOLI*" stamped in green ink at the upper left; pricked for transfer. "*Felice Barnabei*" is handwritten in pencil at the center near the right edge, presumably by the dealer. This cartoon and nos. 245 and 273 were taken from the same source and display the same pricking, and the pairs of pinholes above and below the image on these three documents match. Nos. 243 and 273 are the halves of what was once a single sheet.

Verso: Rubbed with graphite to delineate the pricked image.

Watermark: Anchor with a rope within a double circle. Another part of this watermark appears on no. 273. For discussion of this watermark, see no. 240.

242

Felice Barnabei

Fig. 78. Tracing, probably late 1800s
See no. 242

244. Pricked cartoons, probably late 1800s

25.5 × 19.4 cm (10 × 7⅝ in.). Good, some foxing.

Recto: Four identical substitute cartoons, two reversed, of a Madonna and child; pricked for transfer. The matching pairs of pinholes above and below each image indicate that the sheet was folded twice and then secured with one pin at the top and a second pin at the bottom for pricking. "*Felice Barnabei*" is handwritten in pencil at the bottom, presumably by the dealer.

Verso: One of the cartoons has been rubbed with black pounce from its recto. The word BATH within a scrolled box is embossed in one corner.

245. Pricked cartoons and document, circa 1872

21.5 × 31.7 cm (8½ × 12½ in.). Good, some foxing.

Recto: Two identical but reversed substitute cartoons of a young pipe player with a wreath in his hair seated on a bank above some flowering plants and a recumbent goat; pricked for transfer. The images were produced by pricking from the source while the right half of the sheet was folded under the left. This cartoon and nos. 243 and 273 were taken from the same source and display the same pricking, and the pairs of pinholes above and below the image on these three documents match.

Verso: Statement about a high-school Latin exam, handwritten in pen and ink. Stamped in green ink at the upper right of the sheet is a coat of arms above the words "*R. PROVVEDITORATO AGLI STUDII IN NAPOLI.*" "*Texte de Felice Barnabei*" is handwritten in pencil at the lower right, presumably by the dealer.

Watermark: The name AND CAMERA. For discussion of this watermark, see no. 240.

246. Pricked cartoon, probably late 1800s

14 × 9.7 cm (5½ × 3⅞ in.). Good.

Octagonal substitute cartoon of a woman holding an infant on her left knee seated next to an older child who is reaching across her toward the infant; pricked for transfer; rubbed with orange pounce. "*Buono*" (Good) handwritten in pen and ink at the upper left. "*F. Barnabei*" is handwritten in pencil at the lower edge, presumably by the dealer.

247. Pricked cartoon, probably late 1800s

22 × 32 cm (8⅝ × 12⅝ in.). Good, slight staining.

Substitute cartoon of putti and battling Tritons for the decoration of the rim of a plate or bowl, with "*PARS.I*" handwritten in pencil above; pricked for transfer. Two pairs of pinholes above the image suggest that the sheet was pinned to the print or to an original drawing for pricking. The cartoon, which is for half (180 degrees) of the rim, differs from that of no. 248, although the two apparently match up to produce one complete (360 degrees) rim decoration. Nos. 247 and 248 are the halves of what was once a single sheet.

The source seems to be the image of a Cafaggiolo plate depicting Diana and Endymion and bearing the mark of Jacopo di Stefano (circa 1490– after 1576), now in the Fundaçao Gulbenkian, Lisbon (circa 1510, 26 cm [10¼ in.] diam.; Cora and Fanfani 1982, 26 [entry no. 5]), that was published in Alfred Darcel's *Recueil de faïences italiennes des XV^e, XVI^e et XVII^e siècles* (1869, pl. 30). The scale and disposition of the figures of this cartoon and of the lower half of the image in Darcel's book appear to match, and they both measure 25.5 cm (10 in.) in diameter, indicating that the former was probably taken directly from the latter. This is one of fourteen cartoons in the Gentili/Barnabei archive for which Darcel's illustrations were the source: nos. 240, 256, 257, and 264–68 copy the rim of the plate reproduced in plate 32; nos. 247 and 248 the rim of the plate in plate 30; and nos. 252–54 and 260 the plate in plate 66.

Watermark: Scrollwork enclosing a rampant lion above three stars, with the name ENRICO MAGNANI below. Another part of this watermark appears on no. 248. A watermark comprising scrollwork enclosing a bird above what may be a castle on three hills, all with the name GIOR MAGNANI above the words AL MASSO below, appears on paper used by a Major Denham in North Africa in 1822–1823 (Heawood 1950, pl. 504 [entry no. 3748]).

248. Pricked cartoon, probably late 1800s

22 × 32 cm (8⅝ × 12⅝ in.). Good.

Substitute cartoon of putti and battling Tritons for the decoration of the rim of a plate or bowl, with "*P. II*" handwritten in pencil above; pricked for transfer. Two pairs of pinholes suggest that the sheet was pinned to the print or original drawing for pricking. The cartoon, which is for half (180 degrees) of the rim, differs from that of no. 247, although the two apparently match up to produce one complete (360 degrees) rim decoration. Nos. 247 and 248 are the halves of what was once a single sheet.

The source seems to be the image of a Cafaggiolo plate depicting Diana and Endymion and bearing the mark of Jacopo di Stefano (circa 1490– after 1576), now in the Fundaçao Gulbenkian, Lisbon (circa 1510, 26 cm [10¼ in.] diam.; Cora and Fanfani 1982, 26 [entry no. 5]), that was published in Alfred Darcel's *Recueil de faïences italiennes des XV^e, XVI^e et XVII^e siècles* (1869, pl. 30). The scale and disposition of the figures of this cartoon and of the upper half of the image in Darcel's book appear to match, and they both measure 25.5 cm (10 in.) in diameter, indicating that the former was probably taken directly from the latter. This is one of fourteen cartoons in the Gentili/Barnabei archive for which Darcel's illustrations were the source: nos. 240, 256, 257, and 264–68 copy the rim of the plate reproduced in plate 32; nos. 247 and 248 the rim of the plate in plate 30; and nos. 252–54 and 260 the plate in plate 66.

Watermark: The words AL MASSO. Another part of this watermark appears on no. 247.

249. Pricked cartoon, probably late 1800s

30.2 × 21.8 cm (11⅞ × 8⅝ in.). Good, extensive insect staining along the left edge.

Recto: Substitute cartoon of a portrait bust of a woman in profile, within an incomplete cartouche surmounted by the name "*FRANCESCA CLE* [?]"; pricked for transfer. This rather crudely executed cartoon and no. 261 display the same pricking, and the pairs of pinholes above and below the image match.

Verso: Partially rubbed with graphite to delineate the pricked image.

Watermark: The name *AND[RE]A CAMERA*. For discussion of this watermark, see no. 240.

250. Pricked cartoon, probably late 1800s

21.1 × 29.1 cm (8¼ × 11½ in.). Good.

Recto: Substitute cartoon on newsprint paper of the Holy Family with the young Saint John; pricked for transfer. Pairs of pinholes above and below the image suggest that this sheet and another piece of paper were pinned together at one time. "*F. Barnabei*" is handwritten in pencil at the lower right, presumably by the dealer.

A small preparatory study in pen and ink attributed to Carlo Antonio Grue for the Madonna from this group was in the collection of the late Lello Moccia, Pescara (early 1700s, 13.5 × 10 cm [5¼ × 3⅞ in.]; Battistella 1989, 262, fig. 1). This image seems to have been popular among the potters of Castelli during the early eighteenth century, and it is interesting that at the end of the nineteenth century, Felice Barnabei chose to render it in a pricked cartoon.

Among the extant Castelli plaques decorated with very similar images are two by Carlo Antonio Grue, one in the Kunstgewerbemuseum, Berlin (circa 1700, 20.4 × 26.6 cm [8 × 10½ in.]; Hausmann 1972, 269–71 [entry no. 270]), and the other in the Museo delle Ceramiche, Castelli (an unpublished plaque, which has touches of gold, from the collection of Giovanni Fuschi); one attributed to Carlo Antonio Grue and Aurelio Grue in the Raccolta Acerbo, Loreto Aprutino (early 1700s, 25.5 × 19 cm [10 × 7½ in.]; Arbace 1993, 68–69 [entry no. 59]); one in the Musée Municipal, Nevers (1700s, 20 × 27 cm [7⅞ × 10⅝ in.]; Blazy 1992, 86 [entry no. 19]); one attributed to Liborio Grue in the Museo Capitolare, Atri (1700s; Capitolo Cattedrale di Atri 1976, 23 [entry no. 23]); one signed "*GENTILI P.*" in a private collection, Neuilly (1725–1750, 19.6 × 24.6 cm [7¾ × 9⅝ in.]; Blazy 1992, 56 [entry no. 40]); one attributed to Carmine Gentili and inscribed "*IESUS, IOSEPH, ET MARIA / SINT NOBIS PORTUS, & VIA / I.A. X[RIS]TOFARI A' CASTELLIS F.F. / A.D. M.DCC.XXVIII*" that was offered for sale in 1996 (1728, 37 × 25 cm [14⅝ × 9⅞ in.]; Finarte, Milan, 6 March, lot 150; for information on the patron, I. A. Cristofari, see "Una placca settecentesca in cerca d'autore" 1993, 44); and one that was offered for sale in 1992 (circa 1750, 21.5 × 30 cm [8½ × 11¾ in.]; Christie's, London,

21 September, lot 207). The plaque inscribed to Cristofari and those at Nevers and Neuilly are closest to the image on no. 249, since they all display the unusual detail of Joseph's staff sprouting flowers at the top.

Verso: Rubbed with graphite to delineate the pricked image.

251. **Drawing, probably late 1800s** (fig. 79)

19.5 × 13.7 cm (7⅝ × 5⅜ in.). Good; some staining and foxing; some losses to the top edge and the right, especially along the middle crease, that have been stabilized.

Drawing in pencil of an old man holding a rosary and wearing a nightgown, nightcap, and slippers. *"(F. Barnabei)"* is handwritten in pencil at the lower right, presumably by the dealer.

252. **Pricked cartoon, probably late 1800s**

41.2 × 29 cm (16¼ × 11⅜ in.). Good.

Substitute cartoon on newsprint paper of the Three Graces, after an engraving by Marcantonio Raimondi (circa 1480–circa 1534) after an ancient marble bas-relief in the Vatican (see fig. 83; Bartsch 14.255.340); pricked for transfer. This cartoon and nos. 253, 254, and 260 display the same pricking, and the pairs of pinholes to the right and left within the image and above and below outside the image match. *"(F. Barnabei)"* is handwritten in pencil at the lower right, presumably by the dealer.

The source seems to be the image of a Gubbio roundel signed by Giorgio Andreoli (circa 1465–after 1553) and dated 1525 (see fig. 84; 1525, 30.5 cm [12 in.] diam.; Rackham 1940, 1: 226 [entry no. 673], 2: pl. 106 [no. 673]) published in Alfred Darcel's *Recueil de faïences italiennes des XVᵉ, XVIᵉ et XVIIᵉ siècles* (1869, pl. 66) (see fig. 85) while the roundel was in the possession of Mr. Andrew Fountaine, a nineteenth-century collector and a descendant of the famed Sir Andrew Fountaine. The roundel, arguably the most beautiful of several decorated with this image, was first recorded as acquired by M. Roussel in Rome in 1848. It was then acquired, through another collector, by Mr. Fountaine, from whose collection it was acquired by the Victoria and Albert Museum, London, at Mr. Fountaine's celebrated Christie's sale of 1884. Not only are the dimensions of Darcel's illustration and of the four pricked cartoons in the Gentili/Barnabei archive identical (29.8 cm [11¾ in.] diam.) but the substitute cartoons display various elements idiosyncratic to the published illustration and the maiolica objects, that do not appear either in Raimondi's engraving or in the ancient bas-relief (e.g., the round fruit in the palm trees, the villages in the background, and the garlands of leaves trailing across the buttocks and pudenda of the three figures). Apparently we are faced with a convoluted instance of a substitute cartoon pricked from the illustration (here, from Darcel's book) of an actual maiolica piece (Andreoli's) which itself had been decorated after another source (Raimondi's engraving) after another source (an ancient bas-relief).

Fig. 79. Drawing, probably late 1800s
See no. 251

Given the extremely regular pricking and the newsprint material, nos. 252–54 and 260 were probably executed by Felice Barnabei rather than by anyone in a seventeenth- or eighteenth-century workshop. This attribution implies an interest on the part of Felice Barnabei in the maiolica Three Graces that accords with a statement he made in a letter of the 1860s that, while in London, he had *"sono stato pure più volte al Museo di Kensington ed...ivi ho studiato sui più magnifici lavori di Mastro Giorgio da Gubbio"* (repeatedly visited the Kensington Museum [now the Victoria and Albert Museum] and...there studied the magnificent works of Maestro Giorgio of Gubbio) (Barnabei 1991, 418 [no. 5]).

This is one of fourteen cartoons in the Gentili/Barnabei archive for which Darcel's illustrations were the source: nos. 240, 256, 257, and 264–68 copy the rim of the plate reproduced in plate 32; nos. 247 and 248 the rim of the plate in plate 30; and nos. 252–54 and 260 the plate in plate 66.

253. Pricked cartoon, probably late 1800s

41.2 × 29 cm (16¼ × 11⅜ in.). Good.

Substitute cartoon on newsprint paper of the Three Graces, after an engraving by Marcantonio Raimondi (circa 1480–circa 1534) after an ancient marble bas-relief in the Vatican (see fig. 83; Bartsch 14.255.340); pricked for transfer. This cartoon and nos. 252, 254, and 260 display the same pricking, and the pairs of pinholes to the right and left within the image and above and below outside the image match. Given the extremely regular pricking and the newsprint paper, these cartoons were probably executed by Felice Barnabei.

The source seems to be the image of a Gubbio roundel signed by Giorgio Andreoli (circa 1465–after 1553) and dated 1525, now in the Victoria and Albert Museum, London (see fig. 84; 1525, 30.5 cm [12 in.] diam.; Rackham 1940, 1: 226 [entry no. 673], 2: pl. 106 [no. 673]), that was published in Alfred Darcel's *Recueil de faïences italiennes des XVᵉ, XVIᵉ et XVIIᵉ siècles* (1869, pl. 66) (see fig. 85). Both this cartoon and the image in Darcel's book measure 29.8 cm (11¾ in.) in diameter. For additional discussion, see the entry for no. 252. This is one of fourteen cartoons in the Gentili/Barnabei archive for which Darcel's illustrations were the source: nos. 240, 256, 257, and 264–68 copy the rim of the plate reproduced in plate 32; nos. 247 and 248 the rim of the plate in plate 30; and nos. 252–54 and 260 the plate in plate 66.

254. Pricked cartoon, probably late 1800s

41.2 × 29 cm (16¼ × 11⅜ in.). Good, slight foxing.

Substitute cartoon on newsprint paper of the Three Graces, after an engraving by Marcantonio Raimondi (circa 1480–circa 1534) after an ancient marble bas-relief in the Vatican (see fig. 83; Bartsch 14.255.340); pricked for transfer. This cartoon and nos. 252, 253, and 260 display the same pricking, and the pairs of pinholes to the right and left within the

image and above and below outside the image match. Given the extremely regular pricking and the newsprint paper, these cartoons were probably executed by Felice Barnabei.

The source seems to be the image of a Gubbio roundel signed by Giorgio Andreoli (circa 1465–after 1553) and dated 1525, now in the Victoria and Albert Museum, London (see fig. 84; 1525, 30.5 cm [12 in.] diam.; Rackham 1940, 1: 226 [entry no. 673], 2: pl. 106 [no. 673]), that was published in Alfred Darcel's *Recueil de faïences italiennes des XVe, XVIe et XVIIe siècles* (1869, pl. 66) (see fig. 85). Both this cartoon and the image in Darcel's book measure 29.8 cm (11¾ in.) in diameter. For additional discussion, see the entry for no. 252. This is one of fourteen cartoons in the Gentili/Barnabei archive for which Darcel's illustrations were the source: nos. 240, 256, 257, and 264–68 copy the rim of the plate reproduced in plate 32; nos. 247 and 248 the rim of the plate in plate 30; and nos. 252–54 and 260 the plate in plate 66.

255. Pricked cartoon, probably late 1800s

20.7 × 15.6 cm (8⅛ × 6⅛ in.). Good.

Recto: Substitute cartoon on newsprint paper of a portrait bust of a young woman in profile wearing peasant garb and a cap; pricked for transfer. A pair of pinholes above the image suggests that this sheet and another piece of paper were pinned together at one time. This cartoon and no. 271 were taken from the same source and display the same pricking.

Verso: Rubbed with graphite to delineate the pricked image.

256. Pricked cartoon, probably late 1800s

27.5 × 41 cm (10⅞ × 16⅛ in.). Good.

Recto: Substitute cartoon on newsprint paper of grotesques with *a candelieri* urns and framing motifs for the decoration of the rim of a plate or bowl; pricked for transfer. The cartoon, which is for half (180 degrees) of the rim, displays the same pricking as nos. 240 and 257, and the pairs of pinholes above and to the right and left of the image on the three sheets match; nos. 266–68, which together once formed a single cartoon for half (180 degrees) of the rim, also display the same pricking as nos. 240, 256, and 257.

The source seems to be the image of a Cafaggiolo plate depicting Saint George and bearing the mark of Jacopo di Stefano (circa 1490–after 1576), now in the Victoria and Albert Museum, London (see fig. 11; circa 1510, 32 cm [12⅝ in.] diam.; Rackham 1940, 1: 106 [entry no. 308], 2: pl. 51[no. 308]), that was published in Alfred Darcel's *Recueil de faïences italiennes des XVe, XVIe et XVIIe siècles* (1869, pl. 32) (see fig. 87). Both this cartoon and the image in Darcel's book measure 33 cm (13 in.) in diameter. This is one of fourteen cartoons in the Gentili/Barnabei archive for which Darcel's illustrations were the source: nos. 240, 256, 257, and 264–68 copy the rim of the plate reproduced in plate 32; nos. 247 and

248 the rim of the plate in plate 30; and nos. 252–54 and 260 the plate in plate 66.

Verso: "*(Felice Barnabei)*" is handwritten in pencil at the lower right, presumably by the dealer.

257. Pricked cartoon, probably late 1800s

27.5 × 41 cm (10⅞ × 16⅛ in.). Good.

Substitute cartoon on newsprint paper of grotesques with *a candelieri* urns and framing motifs for the decoration of the rim of a plate or bowl; pricked for transfer. The cartoon, which is for half (180 degrees) of the rim, displays the same pricking as nos. 240 and 256, and the pairs of pinholes above and to the right and left of the image on the three sheets match; nos. 266–68, which together once formed a single cartoon for half (180 degrees) of the rim, also display the same pricking as nos. 240, 256, and 257.

The source seems to be the image of a Cafaggiolo plate depicting Saint George and bearing the mark of Jacopo di Stefano (circa 1490–after 1576), now in the Victoria and Albert Museum, London (see fig. 11; circa 1510, 32 cm [12⅝ in.] diam.; Rackham 1940, 1: 106 [entry no. 308], 2: pl. 51 [no. 308]), that was published in Alfred Darcel's *Recueil de faïences italiennes des XVe, XVIe et XVIIe siècles* (1869, pl. 32) (see fig. 87). Both this cartoon and the image in Darcel's book measure 33 cm (13 in.) in diameter. This is one of fourteen cartoons in the Gentili/Barnabei archive for which Darcel's illustrations were the source: nos. 240, 256, 257, and 264–68 copy the rim of the plate reproduced in plate 32; nos. 247 and 248 the rim of the plate in plate 30; and nos. 252–54 and 260 the plate in plate 66.

258. Pricked cartoon, late 1600s–early 1700s (fig. 81)

18 cm (7⅛ in.) diam. Good, some staining.

Recto: Circular substitute cartoon after *Neptune Plotting the Destruction of Man*, one of fifty-two sheets illustrating Ovid's *Metamorphoses* designed by Hendrick Goltzius (1558–1617) and engraved by his workshop (fig. 80; Bartsch 3.105.40); pricked for transfer; rubbed with black pounce. Eleven roughly equidistant pinholes perforate the sheet along the edge. Only the two couples in the foreground of Goltzius's design appear in this cartoon, and the original disposition of the two groups relative to one another has been altered so that the pricked design fits into a circular format.

The entire print appears on a Castelli plaque attributed to the Grue workshop that was offered for sale in 1992 (circa 1740, 19 × 27.5 cm [7½ × 10⅞ in.]; Christie's, London, 21 September, lot 206). The central portion of the print was used to decorate a Castelli plate attributed to Carlo Antonio Grue in the Museum für Kunst und Gewerbe, Hamburg (circa 1700, 28.8 cm [11⅜ in.] diam.; Rasmussen 1984, 288–90 [entry no. 194]); and three figures from the foreground appear on a Castelli bowl

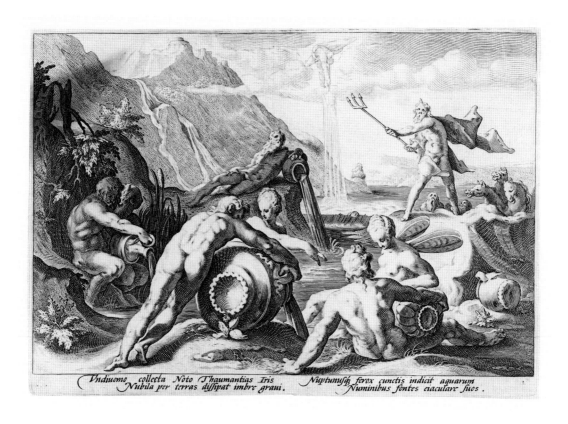

Vndiuomo collecta Noto Thaumantias Iris
Nubila per terras dissipat imbre graui.

Nuptunusq̃ ferox cunctis indicit aquarum
Numinibus fontes eiaculare suos.

Fig. 80. Hendrick Goltzius and workshop
Neptune Plotting the Destruction of Man, engraving,
16.8 × 25 cm (6⅝ × 9⅞ in.), 1589
London, British Museum

Fig. 81. Pricked cartoon after the engraving shown in fig. 80, late 1600s–early 1700s
See no. 258 verso

Fig. 82. Attributed to Carmine Gentili
Plate from Castelli decorated after the cartoon shown in fig. 81, 16.3 cm (6⅜ in.) diam., ca. 1720–1730
Naples, Museo di San Martino

attributed to Francesco Antonio II Saverio Grue in the Museo Civico, Baranello (early 1700s; Benini 1985, 38–39), and on a small Castelli plate attributed to Carmine Gentili in the Museo di San Martino, Naples (fig. 82; circa 1720–1730, 16.3 cm [6⅜ in.] diam.; Fittipaldi 1992, 1: 125 [entry no. 181], 2: 123 [no. 181]).

Verso: "*Carmine Gentili*" is handwritten in pencil at the bottom, presumably by the dealer.

259. Pricked cartoon, probably late 1800s

39.5 × 27.5 cm (15½ × 10⅞ in.). Good, slight foxing, tears along the edges.

Substitute cartoon on newsprint paper of a Madonna and child surrounded by clouds, both crowned, the child's hand lifted in benediction; pricked for transfer; lightly rubbed with black pounce. Pairs of pinholes at the top corners and the bottom center of the sheet suggest that it and another piece of paper were pinned together at one time.

260. Pricked cartoon, probably late 1800s (fig. 86)

30.2 cm (11⅞ in.) diam. Good, slight foxing.

Circular substitute cartoon of the Three Graces, after an engraving by Marcantonio Raimondi (circa 1480–circa 1534) after an ancient marble bas-relief in the Vatican (fig. 83; Bartsch 14.255.340); pricked for transfer; rubbed with orange pounce. This cartoon and nos. 252–54 display the same pricking, and the pairs of pinholes to the right and left within the image match. Given the extremely regular pricking and the newsprint paper, these cartoons were probably executed by Felice Barnabei.

The source seems to be the image of a Gubbio roundel signed by Giorgio Andreoli (circa 1465–after 1553) and dated 1525, now in the Victoria and Albert Museum, London (fig. 84; 1525, 30.5 cm [12 in.] diam.; Rackham 1940, 1: 226 [entry no. 673], 2: pl. 106 [no. 673]), that was published in Alfred Darcel's *Recueil de faïences italiennes des XVᵉ, XVIᵉ et XVIIᵉ siècles* (1869, pl. 66) (fig. 85). Both this cartoon and the image in Darcel's book measure 29.8 cm (11¾ in.) in diameter. For additional discussion, see the entry for no. 252. This is one of fourteen cartoons in the Gentili/Barnabei archive for which Darcel's illustrations were the source: nos. 240, 256, 257, and 264–68 copy the rim of the plate reproduced in plate 32; nos. 247 and 248 the rim of the plate in plate 30; and nos. 252–54 and 260 the plate in plate 66.

Watermark: A grape leaf and a bunch of grapes within a serrated circle with a crown above and two foliate sprays below, with the words *DI. MINORI* below and to the left.

261. Pricked cartoon, probably late 1800s

30.2 × 20.7 cm (11⅞ × 8⅛ in.). Good, very slight staining.

Substitute cartoon of a portrait bust of a woman in profile, within an incomplete cartouche surmounted by the name "*FRANCESCA CLE* [?]";

pricked for transfer; rubbed with orange pounce. This rather crudely executed cartoon and no. 249 display the same pricking, and the pairs of pinholes above and below the image match. *"(Felice Barnabei)"* is handwritten in pencil at the lower right, presumably by the dealer.

Watermark: The name AND CAMERA. For discussion of this watermark, see no. 240.

262. Pricked cartoon, probably late 1800s

20.5 × 14.7 cm (8⅛ × 5¾ in.). Good.

Recto: Substitute cartoon on newsprint paper of a seated man wearing long robes and either a crown or a headdress and holding a staff in one hand and resting his forehead on the knuckles of the other hand; pricked for transfer. Pairs of pinholes above and below the image suggest that this sheet and another piece of paper were pinned together at one time.

Verso: Rubbed with graphite to delineate the pricked image.

263. Pricked cartoons, probably late 1800s

20.5 × 29.1 cm (8⅛ × 11½ in.) unfolded. Good.

Two identical and reversed substitute cartoons on newsprint paper of what may be a seated beggar in long robes; pricked for transfer; the verso of the cartoon on the left, which is on the same side as the recto of the cartoon on the right, was rubbed with graphite to delineate the pricked image. The left half of the sheet was folded under the right, and then the cartoons were pricked from the original; nos. 263 and 263 bis display the same pricking, and the pairs of pinholes above and below the images match. Except for slight variations in the backgrounds, the images of nos. 263 and 263 bis are identical to the image of no. 242 (see fig. 78). Given that no. 242 is unpricked, nos. 263 and 263 bis probably were pricked from the same source as that from which no. 242 was traced. Presumably the source was pinned under a thin sheet of paper and traced to obtain no. 242 at one time and at another time was pinned over a folded sheet of newsprint and pricked to obtain nos. 263 and 263 bis.

263 bis. Pricked cartoon, probably late 1800s

20.5 × 14.5 cm (8⅛ × 5¾ in.). Good.

Substitute cartoon on newsprint paper of what may be a seated beggar in long robes; pricked for transfer. This cartoon and no. 263 display the same pricking, and the pairs of pinholes above and below the images match. Except for slight variations in the backgrounds, the images of nos. 263 bis and 263 are identical to the image of no. 242 (see fig. 78). Given that no. 242 is unpricked, nos. 263 and 263 bis probably were pricked from the same source as that from which no. 242 was traced. Presumably the source was pinned under a thin sheet of paper and traced to obtain no. 242 at one time and at another time was pinned over a folded sheet of newsprint and pricked to obtain nos. 263 and 263 bis.

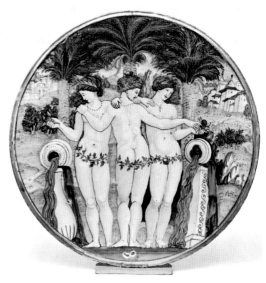

Fig. 83. Marcantonio Raimondi (after an ancient marble bas-relief)
The Three Graces, engraving, 32.6 × 22.2 cm (14¼ × 8¾ in.), early 1500s
Vienna, Graphische Sammlung Albertina

Fig. 84. Giorgio Andreoli
Roundel from Gubbio decorated after the engraving shown in fig. 83, 30.5 cm (12 in.) diam., 1525
London, Victoria and Albert Museum

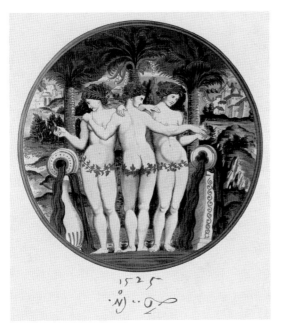

Fig. 85. Carle Delange and C. Borneman
Illustration of the roundel shown in fig. 84
From Alfred Darcel, *Recueil des faïences italiennes des XVᵉ,
XVIᵉ et XVIIᵉ siècles* (Paris: Impr. de E. Martinet, 1869),
pl. 66

**Fig. 86. Backlit view of a pricked cartoon after the
illustration shown in fig. 85, probably late 1800s**
See no. 260

264. Pricked cartoon, probably late 1800s

15 × 21.7 cm (5⅞ × 8½ in.). Good.

Recto: Substitute cartoon on newsprint paper of grotesques with *a candelieri* urns and framing motifs for the decoration of the rim of a plate or bowl; pricked for transfer. The cartoon, which is for one-eighth (45 degrees) of the rim, displays the same pricking as no. 265. A pair of pinholes near the top edge indicates that no. 264 and another piece of paper were pinned together at one time.

The source seems to be the image of a Cafaggiolo plate depicting Saint George and bearing the mark of Jacopo di Stefano (circa 1490–after 1576), now in the Victoria and Albert Museum, London (see fig. 11; circa 1510, 32 cm [12⅝ in.] diam.; Rackham 1940, 1: 106 [entry no. 308], 2: pl. 51 [no. 308]), that was published in Alfred Darcel's *Recueil de faïences italiennes des XVᵉ, XVIᵉ et XVIIᵉ siècles* (1869, pl. 32) (see fig. 87). The size as well as the scale and disposition of the figures in this cartoon and in the image in Darcel's book match. This is one of fourteen cartoons in the Gentili/Barnabei archive for which Darcel's illustrations were the source: nos. 240, 256, 257, and 264–68 copy the rim of the plate reproduced in plate 32; nos. 247 and 248 the rim of the plate in plate 30; and nos. 252–54 and 260 the plate in plate 66.

Verso: Rubbed with graphite to delineate the pricked image.

265. Pricked cartoon, probably late 1800s

7.5 × 13.4 cm (3 × 5¼ in.). Good.

Recto: Substitute cartoon on newsprint paper of grotesques with *a candelieri* urns and framing motifs for the decoration of the rim of a plate or bowl; pricked for transfer; heavily rubbed with orange pounce. The cartoon, which is for one-eighth (45 degrees) of the rim, was cut to follow the shape of the rim and displays the same pricking as no. 264.

The source seems to be the image of a Cafaggiolo plate depicting Saint George and bearing the mark of Jacopo di Stefano (circa 1490–after 1576), now in the Victoria and Albert Museum, London (see fig. 11; circa 1510, 32 cm [12⅝ in.] diam.; Rackham 1940, 1: 106 [entry no. 308], 2: pl. 51 [no. 308]), that was published in Alfred Darcel's *Recueil de faïences italiennes des XVᵉ, XVIᵉ et XVIIᵉ siècles* (1869, pl. 32) (see fig. 87). The size as well as the scale and disposition of the figures in this cartoon and in the image in Darcel's book match. This is one of fourteen cartoons in the Gentili/Barnabei archive for which Darcel's illustrations were the source: nos. 240, 256, 257, and 264–68 copy the rim of the plate reproduced in plate 32; nos. 247 and 248 the rim of the plate in plate 30; and nos. 252–54 and 260 the plate in plate 66.

Verso: Lightly rubbed with orange pounce.

266. Pricked cartoon, probably late 1800s

7.5 × 13.4 cm (3 × 5¼ in.). Good.

pattern. The drawing was pricked together with no. 269, for which it served as the source.

Watermark: Part of a watermark including the letter *P*.

271. Pricked cartoon, probably late 1800s

13.7 × 11.2 cm (5⅜ × 4⅜ in.). Good.

Substitute cartoon on newsprint paper of a portrait bust of a young woman in profile wearing peasant garb and a cap; pricked for transfer; rubbed with orange pounce. The sheet was roughly cut around the image, and the cartoon was cut radially eight times so that it could be fitted onto a concave surface. This cartoon and no. 255 were taken from the same source and display the same pricking.

272. Drawing, circa 1898

21.2 × 18.1 cm (8⅜ × 7⅛ in.). Good, very slight staining.

Drawing in pencil on graph paper of the head of a game dog holding a duck in its jaws, with two impressions of a coat of arms above the words "*CAMERA DEI DEPUTATI*" stamped in blue ink at mid-sheet, one at the right edge and the other at the left, and several numbers handwritten in pen and ink below. "*Ve[r]so 1898/1900 (Felice Barnabei)*" is handwritten in pencil at the upper right, presumably by the dealer.

Watermark: Each half of the sheet displays the words *CAMERA DEI DEPUTATI*.

273. Pricked cartoon, circa 1872

31.5 × 21.5 cm (12⅜ × 8½ in.). Good, slight foxing.

Recto: Substitute cartoon of a young pipe player with a wreath in his hair seated on a bank above some flowering plants and a recumbent goat; pricked for transfer. This cartoon and nos. 243 and 245 were taken from the same source and display the same pricking, and the pairs of pinholes above and below the image on these three documents match. Nos. 243 and 273 are the halves of what was once a single sheet.

Verso: Rubbed with graphite to delineate the pricked image. Green ink (from the stamped insignia on no. 243) is blotted at the upper right corner of the sheet. "*(Felice Barnabei c. 1870)*" is handwritten in pencil at the lower right, presumably by the dealer.

Watermark: The name *AND CAMERA*. Another part of this watermark appears on no. 243. For discussion of this watermark, see no. 240.

274. Drawings, 1874 (fig. 89)

43.7 × 28.5 cm (17¼ × 11¼ in.). Good, some foxing, some insect staining along the creases.

Drawing, executed in pencil and watercolored in dark blue, light blue, orange, and ocher, of a circular design comprising an orange-and-white striped shield that surmounts a seraph's head and is surmounted by a

Fig. 87. Carle Delange and C. Borneman
Illustration of the plate shown in fig. 11
From Alfred Darcel, *Recueil de faïences italiennes des XVe,
XVIe et XVIIe siècles* (Paris: Impr. de E. Martinet, 1869),
pl. 32

**Fig. 88. Pricked cartoon after the rim decoration in the
illustration shown in fig. 87, probably late 1800s**
See no. 268 verso

268. **Pricked cartoon, probably late 1800s** (fig. 88)

7.5 × 23.4 cm (3 × 9¼ in.). Good.

Substitute cartoon on newsprint paper of grotesques with *a candelieri* urns and framing motifs for the decoration of the rim of a plate or bowl; pricked for transfer; rubbed with orange pounce. The cartoon, which is for one-fourth (90 degrees) of the rim, was cut to follow the shape of the rim. Nos. 266–68 once formed a single cartoon for half (180 degrees) of the rim, and each displays the same pricking as the corresponding section of nos. 240, 256, and 257.

The source seems to be the image of a Cafaggiolo plate depicting Saint George and bearing the mark of Jacopo di Stefano (circa 1490–after 1576), now in the Victoria and Albert Museum, London (see fig. 11; circa 1510, 32 cm [12⅝ in.] diam.; Rackham 1940, 1: 106 [entry no. 308], 2: pl. 51 [no. 308]), that was published in Alfred Darcel's *Recueil de faïences italiennes des XVe, XVIe et XVIIe siècles* (1869, pl. 32) (fig. 87). The size as well as the scale and disposition of the figures in this cartoon and in the image in Darcel's book match, and both the pattern whose components are nos. 266–68 and the image in Darcel's book measure 33 cm (13 in.) in diameter. This is one of fourteen cartoons in the Gentili/Barnabei archive for which Darcel's illustrations were the source: nos. 240, 256, 257, and 264–68 copy the rim of the plate reproduced in plate 32; nos. 247 and 248 the rim of the plate in plate 30; and nos. 252–54 and 260 the plate in plate 66.

269. **Pricked cartoon, 1874**

6.5 × 13.8 cm (2½ × 5⅜ in.). Good.

Substitute cartoon on newsprint paper of two repeating palmettes; pricked for transfer; rubbed with orange pounce. The cartoon, which is for one-eighth (45 degrees) of the rim of a plate or bowl, was cut to follow the shape of the rim. This cartoon was pricked together with no. 270, which served as the design source.

270. **Pricked drawing, 1874** (pls. 19, 20)

43.5 × 28.8 cm (17⅛ × 11⅜ in.). Good, insect staining along the right edge.

Drawing in pencil and possibly also either black chalk or crayon on thick paper of part of the face or the reverse of a plate or bowl; the rim is divided into eighths, one of which is filled with a pattern of two repeating palmettes that has been partially watercolored in dark blue, light blue, green, yellow, red, and black and pricked for transfer; orange pounce appears along the right-hand border of the watercolored pattern. A few practice sketches in watercolor appear outside the rim area, the monogram *CT* or *TC* with the date 1874 was drawn in pencil near the center of the plate or bowl, and "*Tutti i contorni devono essere fatti col nero*" (All of the outlines should be done in black) is handwritten in pencil at the lower right. Pinholes perforate the sheet above and to the right of the watercolored

Recto: Substitute cartoon on newsprint paper of grotesques with *a candelieri* urns and framing motifs for the decoration of the rim of a plate or bowl; pricked for transfer; rubbed with orange pounce. The cartoon, which is for one-eighth (45 degrees) of the rim, was cut to follow the shape of the rim. Nos. 266–68 once formed a single cartoon for half (180 degrees) of the rim, and each displays the same pricking as the corresponding section of nos. 240, 256, and 257.

The source seems to be the image of a Cafaggiolo plate depicting Saint George and bearing the mark of Jacopo di Stefano (circa 1490–after 1576), now in the Victoria and Albert Museum, London (see fig. 11; circa 1510, 32 cm [12⅝ in.] diam.; Rackham 1940, 1: 106 [entry no. 308], 2: pl. 51 [no. 308]), that was published in Alfred Darcel's *Recueil de faïences italiennes des XV^e, XVI^e et XVII^e siècles* (1869, pl. 32) (see fig. 87). The size as well as the scale and disposition of the figures in this cartoon and in the image in Darcel's book match, and both the pattern whose components are nos. 266–68 and the image in Darcel's book measure 33 cm (13 in.) in diameter. This is one of fourteen cartoons in the Gentili/Barnabei archive for which Darcel's illustrations were the source: nos. 240, 256, 257, and 264–68 copy the rim of the plate reproduced in plate 32; nos. 247 and 248 the rim of the plate in plate 30; and nos. 252–54 and 260 the plate in plate 66.

Verso: Lightly rubbed with orange pounce.

267. **Pricked cartoon, probably late 1800s**

7.5 × 13.4 cm (3 × 5¼ in.). Good.

Substitute cartoon on newsprint paper of grotesques with *a candelieri* urns and framing motifs for the decoration of the rim of a plate or bowl; pricked for transfer; rubbed with orange pounce. The cartoon, which is for one-eighth (45 degrees) of the rim, was cut to follow the shape of the rim. Nos. 266–68 once formed a single cartoon for half (180 degrees) of the rim, and each displays the same pricking as the corresponding section of nos. 240, 256, and 257.

The source seems to be the image of a Cafaggiolo plate depicting Saint George and bearing the mark of Jacopo di Stefano (circa 1490–after 1576), now in the Victoria and Albert Museum, London (see fig. 11; circa 1510, 32 cm [12⅝ in.] diam.; Rackham 1940, 1: 106 [entry no. 308], 2: pl. 51 [no. 308]), that was published in Alfred Darcel's *Recueil de faïences italiennes des XV^e, XVI^e et XVII^e siècles* (1869, pl. 32) (see fig. 87). The size as well as the scale and disposition of the figures in this cartoon and in the image in Darcel's book match, and both the pattern whose components are nos. 266–68 and the image in Darcel's book measure 33 cm (13 in.) in diameter. This is one of fourteen cartoons in the Gentili/Barnabei archive for which Darcel's illustrations were the source: nos. 240, 256, 257, and 264–68 copy the rim of the plate reproduced in plate 32; nos. 247 and 248 the rim of the plate in plate 30; and nos. 252–54 and 260 the plate in plate 66.

Fig. 89. Detail of drawings, 1874
See no. 274

rooster and is flanked on each side by a putto standing on clouds and half of the word "*ROMA*," with 1874 in Roman numerals below and the phrase (in English) "*DO WELL AND DOUBT NOT*" above. This drawing may have served as the design source for no. 275 or, less likely, no. 275 may have been used to copy the image onto no. 274; the image on each measures 14.7 cm (5¾ in.) in diameter. A cluster of pinholes near the top edge of the sheet suggests that it and another piece of paper were pinned together at one time. An additional, larger scale pencil sketch of the right-hand putto's head and shoulder appears at the upper right.

Watermark: Part of a mark including the letter *M*.

275. **Pricked cartoon, 1874**

15.5 cm (6⅛ in.) diam. Good.

Circular substitute cartoon on newsprint paper of a striped shield that surmounts a seraph's head and is surmounted by a rooster and is flanked on each side by a putto standing on clouds and half of the word "*ROMA*," with 1874 in Roman numerals below and the phrase (in English) "*DO WELL AND DOUBT NOT*" above; pricked for transfer; rubbed with orange pounce. The pairs of pinholes above and below the shield suggest that no. 275 was pinned to another sheet at one time. No. 275 may have been used to copy the image onto no. 274 or, more likely, no. 275 may have been pricked from a tracing of no. 274; the image on each measures 14.7 cm (5¾ in.) in diameter.

173

Works Cited

Acton, Francesco. 1961. *Il Museo civico "Gaetano Filangieri" di Napoli.* Naples: Tipografia Gennaro d'Agostino.

Agnellini, Maurizio, ed. 1992. *Maioliche: Storia e produzione italiana dalla metà del Quattrocento ai primi decenni del Novecento.* Milan: Giorgio Mondadori.

Agostini, Leonardo. 1657. *Le gemme antiche figurate.* Illus. Giovanni Battista Galestruzzi. Rome: Leonardo Agostini.

Annibale Carracci e i suoi incisori. 1986. Exh. cat. Rome: Ecole Française de Rome.

Arbace, Luciana. 1993. *Maioliche di Castelli: La Raccolta Acerbo.* Ferrara: Belriguardo.

———. 1996. *La maiolica italiana.* Naples: Electa Napoli.

———, ed. 1998. *Nella bottega dei Gentili: Spolveri e disegni per le maioliche di Castelli.* Exh. cat. Sant'Atto, Teramo: Edigrafital.

Barnabei, Felice. 1991. *Le "memorie di un archeologo."* Ed. Margherita Barnabei and Filippo Delpino. Rome: De Luca Edizioni d'Arte.

Barral, Claudie. 1987. *Faïences italiennes: Catalogue raisonné du Musée des beaux-arts de Dijon.* Dijon: Musée des Beaux-Arts.

Bartsch, Adam. 1803–1821. *Le peintre graveur.* 21 vols. in 14. Vienna: J. V. Degen.

Battistella, Franco. 1989. "Appunti sulla produzione sei-settecentesca delle officine ceramiche di Castelli." *Rivista abruzzese* 42: 261–67.

Benini, Mirella. 1985. *Ceramica del Seicento.* Novara: Istituto Geografico de Agostini / Sotheby's.

Biscontini Ugolini, Grazia, and Jacqueline Petruzzellis Scherer, eds. 1992. *Maiolica e incisione: Tre secoli di rapporti iconografici.* Exh. cat. Vincenza: Neri Pozza.

Blazy, Guy, ed. 1992. *Les plaques en faïence de Castelli.* Exh. cat. Saint-Omer: Musée de l'Hôtel Sandelin.

Capitolo Cattedrale di Atri, ed. 1976. *Le antiche ceramiche d'Abruzzo nel Museo capitolare di Atri.* Atri: Museo Capitolare.

Carracci, Annibale. 1700. *Galeriae Farnesianae icones romae in aedibus sereniss. ducis Parmensis.* Illus. Karl Remshard. Augsburg: Johann Ulrich Krausen.

Churchill, W. A. 1985. *Watermarks in Paper in Holland, England, France,*

etc. in the XVII and XVIII Centuries and Their Interconnection. Amsterdam: Menno Hertzberger, 1935; reprint, Nieuwkoop: Graaf.

Ciardi Dupré dal Poggetto, Maria Grazia, et al., eds. 1980. *Antiche maioliche popolari di Castelli.* Exh. cat. Castelli: Museo delle Ceramiche.

Cora, Galeazzo, and Angiolo Fanfani. 1982. *La maiolica di Cafaggiolo.* Florence: Centro Di.

Darcel, Alfred. 1869. *Recueil de faïences italiennes des XVe, XVIe et XVIIe siècles.* Ed. Henri Delange. Illus. Carle Delange and C. Borneman. Paris: Impr. de E. Martinet.

Fittipaldi, Teodoro. 1992. *Ceramiche: Castelli, Napoli, altre fabbriche.* 2 vols. Naples: Electa Napoli.

Giacomotti, Jeanne. 1974. *Catalogue des majoliques des Musées nationaux: Musées du Louvre et de Cluny, Musée national de céramique à Sèvres, Musée Adrien-Dubouché à Limoges.* Paris: Editions des Musées Nationaux.

———. 1977. "Introduction à l'étude de la majolique de Castelli, XVIIe–XVIIIe siècles." *Cahiers de la céramique, du verre et des arts du feu,* no. 59: 7–21.

Hausmann, Tjark. 1972. *Majolika: Spanische und italienische Keramik vom 14. bis zum 18. Jahrhundert.* Berlin: Mann.

Heawood, Edward. 1950. *Watermarks, Mainly of the Seventeenth and Eighteenth Centuries.* Hilversum, The Netherlands: Paper Publications Society.

Hess, Catherine. 1992. "Katalog: Keramik." In *Kunst in der Republik Genua 1528–1815.* Exh. cat. Frankfurt am Main: Schirn Kunsthalle Frankfurt.

Hollstein, F. W. H. 1940– . *Dutch and Flemish Etchings, Engravings, and Woodcuts, ca. 1450–1700.* 50 vols. to date. Amsterdam: Menno Hertzberger.

Jestaz, Bertrand. 1973. "Les modèles de la majolique historiée. II. XVIIe et XVIIIe siècles." *Gazette des beaux-arts,* ser. 6, 81: 109–28.

Join-Diéterle, Catherine. 1984. *Catalogue de céramiques: Musée du Petit Palais,* vol. 1, *Hispano-mauresques, majoliques italiennes, iznik, des collections Dutuit, Ocampo et Pierre Marie.* Paris: Musée du Petit Palais.

Lasson Gallery. 1975. *Exhibition of Sixteenth, Seventeenth, and Eighteenth Century Old Masters.* Exh. cat. London: Lasson Gallery.

Levy, Saul. 1964. *Maioliche settecentesche,* vol. 2, *Piemontesi, liguri, romagnole, marchigiane, toscane e abruzzesi.* Milan: Görlich.

Magland, Louis. 1977. "Sur quelques majoliques historiées de Castelli." *Cahiers de la céramique, du verre et des arts du feu,* no. 59: 22–37.

Maioliche del Museo civico di Pesaro. 1979. Pesaro: Museo Civico.

Mazzucato, Otto. 1982. "Documenti sui Gentili, boccalari di Castelli." *Faenza* 68: 100, pl. XLIV.

———. 1984. "Documenti dei Gentili." In *Castelli, ceramiche di cinque secoli.* Exh. cat. Teramo: n.p.

Moccia, Lello, ed. 1968. *Le antiche maioliche di Castelli d'Abruzzo.* Exh. cat. Rome: Officina Edizioni.

Mošin, Vladimir. 1973. *Anchor Watermarks.* Amsterdam: Paper Publications Society.

Pelizzoni, Elena, and Giovanna Zanchi. 1982. *La maiolica dei Terchi: Una famiglia di vascellari romani nel '700 tra Lazio e Impero austro-ungarico.* Florence: Centro Di.

"Una placca settecentesca in cerca d'autore." 1993. *CeramicAntica* 3, no. 3: 44–45.

Polidori, Giancarlo. 1949. *La maiolica antica abruzzese: Sotto gli auspici della Società ceramica "Richard Ginori."* Milan: Luigi Alfieri.

Proterra, Maria Rosanna, ed. 1996. *L'universo d'Abruzzo nelle maioliche di Castelli.* Colledara: Andromedea.

Rackham, Bernard. 1977. *Catalogue of Italian Maiolica.* Rev. ed. 2 vols. London: H.M.S.O.

Rasmussen, Jörg. 1984. *Italienische Majolika.* Hamburg: Museum für Kunst und Gewerbe Hamburg.

Reznicek, E. K. J. 1961. *Die Zeichnungen von Hendrick Goltzius, mit einem beschreibenden Katalog.* Trans. Maria Simon and Ingrid Jost. 2 vols. Utrecht: Haentjens Dekker & Gumbert.

Robert-Dumesnil, A. P. F. 1967. *Le peintre-graveur français, ou, catalogue raisonné des estampes gravées par les peintres et les dessinateurs de l'école française: Ouvrage faisant suite au peintre-graveur de M. Bartsch.* 11 vols. Paris: Gabriel Warée & Mme Huzard, 1835–1871; reprint, 11 vols. in 6, Paris: F. de Nobele.

Rotunda, D. P. 1973. *Motif-index of the Italian Novella in Prose.* Bloomington: Folklore Series, Indiana University Publications, 1942; reprint, New York: Haskell House.

Thienemann, Georg August Wilhelm. 1979. *Leben und Wirken des unvergleichlichen Thiermalers und Kupferstechers Johann Elias Ridinger.* Leipzig: R. Weigel, 1856; reprint, Amsterdam: Nico Israel.

Thompson, Stith. 1955–1958. *Motif-Index of Folk-Literature; a Classification of Narrative Elements in Folktales, Ballads, Myths, Fables, Mediaeval Romances, Exempla, Fabliaux, Jest-Books, and Local Legends.* Rev. ed. 6 vols. Bloomington: Indiana University Press.

Turner, Jane, ed. 1996. *The Dictionary of Art.* 34 vols. New York: Grove/Macmillan.

Villot, Frédéric. 1844. "Valentine Lefebre, peintre et graveur à l'eau-forte." *Le cabinet de l'amateur et l'antiquaire* 3: 169–97.

von Erdberg, Joan Prentice, and Marvin C. Ross. 1952. *Catalogue of the Italian Majolica in the Walters Art Gallery.* Baltimore: Walters Art Gallery.

Wildenstein, Daniel, ed. 1964. "L'oeuvre gravé des Coypel, II." *Gazette des beaux-arts*, ser. 6, 64: 141–52.

Wildenstein, Georges. 1924. *Lancret.* Paris: G. Servant.

Wilson, Timothy. 1989. *Italian Maiolica.* Oxford: Phaidon/Christie's.

Illustration Credits

All photographs of items in the Gentili/Barnabei archive are courtesy the Getty Research Institute for the History of Art and the Humanities, Research Library, ID no. 88-A274. © 1999 The Getty Research Institute for the History of Art and the Humanities.

The following sources have granted permission to reproduce illustrations in this book:

6, 7	©1997 Denise Simon. All rights reserved
9, fig. 6	© Photo RMN
9, fig. 7	© The British Museum
11, fig. 8	Giraudon/Art Resource, New York
11, fig. 9	The J. Paul Getty Museum, Los Angeles
12, fig. 10	Alinari/Art Resource, New York
12, fig. 11	© The Board of Trustees of the Victoria and Albert Museum. V&A Picture Library, neg. 68382
15	© The Board of Trustees of the Victoria and Albert Museum. V&A Picture Library, neg. JA1411
17, fig. 13	© The British Museum
17, fig. 14	Civiche Raccolte d'Arte Applicata, Castello Sforzesco, Milan. Photo: Foto Saporetti, Milan
18, fig. 15	Lynne Lawner. From *I modi: Nell'opera di Giulio Romano, Marcantonio Raimondi, Pietro Aretino e Jean-Frédéric-Maximilien de Waldeck*, ed. Lynne Lawner, trans. Nicola Crocetti (Milan: Longanesi, 1984), 81
18, fig. 16	Civiche Raccolte d'Arte Applicata, Castello Sforzesco, Milan. Photo: Foto Saporetti, Milan
23, 24	Leonardo Arte, Milan. From Felice Barnabei, *Le "memorie di un archeologo,"* eds. Margherita Barnabei and Filippo Delpino (Rome: De Luca Edizioni d'Arte, 1991), figs. 1, 178, 218
73, fig. 35	The Walters Art Gallery, Baltimore
74, fig. 37	© The Board of Trustees of the Victoria and Albert Museum. V&A Picture Library, neg. 72682
93	Soprintendenza per i Beni Artistici e Storici, Naples. Photo: Giuseppe Gaeta, Naples
96	Araldo De Luca, Rome

97, pl. 7	The Getty Research Institute for the History of Art and the Humanities, Research Library, ID no. 92-B26886
97, pl. 9	Soprintendenza per i Beni Artistici e Storici, Naples. Photo: Giuseppe Gaeta, Naples
101, pl. 14	Soprintendenza per i Beni Artistici e Storici, Naples. Photo: Giuseppe Gaeta, Naples
103	Dino Sartori, Il Sindaco, Comune di Bassano Romano
105	Soprintendenza per i Beni Artistici e Storici, Naples. Photo: Giuseppe Gaeta, Naples
128, fig. 63	© Musée des Beaux-Arts, Dijon. *Plaque ronde: Berger jouant du pipeau*, inv. D407
142, fig. 72	Soprintendenza per i Beni Artistici e Storici, Naples. Photo: Giuseppe Gaeta, Naples
142, fig. 73	Museum für Kunst und Gewerbe, Hamburg
146, fig. 75	Soprintendenza per i Beni Artistici e Storici, Naples. Photo: Giuseppe Gaeta, Naples
151	Staatliche Museen zu Berlin, Preussischer Kulturbesitz, Kunstgewerbe-museum. *Majolikateller: Triumph des Neptun*, neg. 2146 III
162	© The British Museum
163, fig. 82	Soprintendenza per i Beni Artistici e Storici, Naples. Photo: Giuseppe Gaeta, Naples
166, fig. 83	Graphische Sammlung Albertina, Vienna
166, fig. 84	© The Board of Trustees of the Victoria and Albert Museum. V&A Picture Library, neg. 65511
167, fig. 85	Casa Editrice Belriguardo, Ferrara. From Alfred Darcel and Henri Delange, *Maioliche italiane del XV e XVI secolo* (1869; reprint, Ferrara: Belriguardo, 1990), pl. 66
171, fig. 87	Casa Editrice Belriguardo, Ferrara. From Alfred Darcel and Henri Delange, *Maioliche italiane del XV e XVI secolo* (1869; reprint, Ferrara: Belriguardo, 1990), pl. 32

Index

Maiolica in the Making: The Gentili/Barnabei Archive
Catherine Hess

Catherine Hess is associate curator of sculpture and works of art at the J. Paul Getty Museum. A specialist in the decorative arts, she has lectured on subjects ranging from mannerist ceramics to Italian furniture to the history of collecting in Europe. She is the author of the catalog of the Museum's collection of Italian maiolica (J. Paul Getty Museum, 1988) and collaborated with David Harris Cohen in writing *Looking at European Ceramics: A Guide to Technical Terms* (J. Paul Getty Museum / British Museum Press, 1993). Her other publications include four co-authored books on the Museum's European glass, sculpture, and decorative arts collections, and her articles have appeared in *Burlington Magazine, The J. Paul Getty Museum Journal,* and *Semestrale del Museo delle ceramiche.* In 1992 she curated the ceramics for the exhibition *Kunst in der Republic Genua, 1528–1815* held at the Schirn Kunsthalle Frankfurt.

Bibliographies & Dossiers
The Collections of the Getty Research Institute
for the History of Art and the Humanities

In Print
Russian Modernism
Introduction by Jean-Louis Cohen
Compiled and annotated by David Woodruff and Ljiljana Grubišić
ISBN 0-89236-385-1

Irresistible Decay: Ruins Reclaimed
Michael S. Roth with Claire Lyons and Charles Merewether
ISBN 0-89236-468-8

Incendiary Art: The Representation of Fireworks in Early Modern Europe
Kevin Salatino
ISBN 0-89236-417-3

In Preparation
Making a Prince's Museum: Drawings for the Late-Eighteenth-Century Redecoration of the Villa Borghese in Rome
Carole Paul
ISBN 0-89236-539-0